CREATING
STILLNESS

CREATING STILLNESS

Mindful
Art Practices
and Stories
for Navigating
Anxiety, Stress,
and Fear

RACHEL ROSE

North Atlantic Books
Huichin, unceded Ohlone land
aka Berkeley, California

Published by
North Atlantic Books
Huichin, unceded Ohlone land
aka Berkeley, California

Cover art © Pobytov via Getty Images
Cover design by Jess Morphew
Book design by Happenstance Type-O-Rama

Printed in the United States of America

Creating Stillness: Mindful Art Practices and Stories for Navigating Anxiety, Stress, and Fear is sponsored and published by North Atlantic Books, an educational nonprofit based in the unceded Ohlone land Huichin (*aka* Berkeley, CA) that collaborates with partners to develop cross-cultural perspectives; nurture holistic views of art, science, the humanities, and healing; and seed personal and global transformation by publishing work on the relationship of body, spirit, and nature.

North Atlantic Books' publications are distributed to the US trade and internationally by Penguin Random House Publisher Services. For further information, visit our website at www.northatlantic books.com.

Library of Congress Cataloging-in-Publication Data
Names: Rose, Rachel, author.
Title: Creating stillness : mindful art practices and stories for
 navigating anxiety, stress, and fear / Rachel Rose.
Description: Berkeley, California : North Atlantic Books, [2023] | Includes
 index. | Summary: "Rachel Rose explores creativity as a tool to
 understand oneself and connect us to the broader community and world.
 Rose invites her readers to ruminate on the idea of stillness as a means
 to work closer towards a creativity that will inevitably lead to
 self-transformation, knowledge, and understanding"— Provided by
 publisher.
Identifiers: LCCN 2022032697 (print) | LCCN 2022032698 (ebook) | ISBN
 9781623177591 (trade paperback) | ISBN 9781623177607 (ebook)
Subjects: LCSH: Creative ability. | Self-acceptance. | Self-actualization
 (Psychology) | Mindfulness (Psychology)
Classification: LCC BF408 .R6647 2023 (print) | LCC BF408 (ebook) | DDC
 153.3/5—dc23/eng/20221116
LC record available at https://lccn.loc.gov/2022032697
LC ebook record available at https://lccn.loc.gov/2022032698

1 2 3 4 5 6 7 8 9 KPC 28 27 26 25 24 23

To Frederick, Finch, and Calliope,
my most beloved teachers and treasured muses.

Contents

Acknowledgments xi

Introduction 1

PART 1
Creative Companions: Knowing and Mindfulness

1 Partnering with Creativity 7
2 The Languages of Knowing 15
3 Creative Mindfulness 25
4 Creative Living 43

PART 2
Meditations and Creative Invitations

5 Surrender and the Beginner's Mind 57
 Creative Invitation: Movement and Abstract Art *68*

6 From Striving to Stillness 73
 Creative Invitation: Creating with Nature *82*

7 Cutting Through the Fog of Anxiety 87
 Creative Invitation: Finding Trust in Paper Cuts *97*

8 Exploring the In-Between 103
 Creative Invitation: Letting Go through Found Objects *112*

9 Rewriting the Script of Productivity 119
 Creative Invitation: Redefining Judgment with Found Poetry *129*

10 Welcoming Fear and Pain 135

 Creative Invitation: Sketching Your Way to Acceptance *145*

11 Imagination, Symbols, and Non-Reacting 151

 Creative Invitation: Symbolic Altars *161*

12 The Mark of Embodied Awareness 167

 Creative Invitation: Discovering Your Inner World
 through Mark-Making *178*

13 Rewriting Our Personal Stories 183

 Creative Invitation: Transforming Attachment
 with Creative Ritual *193*

14 The Impermanence of the Present 199

 Creative Invitation: Patience through Ephemeral Art *210*

Conclusion: Knowing Life through Art 215

 Notes 217

 Bibliography 221

 Index 227

 About the Author 237

Acknowledgments

THIS BOOK and the practices in it were born from and are only possible because of a community of support and wisdom behind me. A profound thanks to Carmen Richardson for dedicating her life to the Expressive Arts and for giving me (and so many others) the tools and opportunities to learn how to practice this with integrity and compassion for others. I am also appreciative of the faculty at the Prairie Institute for Expressive Arts Therapy, as well as my classmates. The teachings I gained from each of you are on the pages of this book as well as deep within me. Thank you to Patricia Leavy, first for her body of work and leadership that gave me permission to explore arts as a way of knowing, and then for her support and friendship cheering me on toward finding my own voice to contribute to the world. Thank you to Fyre Graveline for her wisdom, feedback, and the ongoing invitation to position this work in a context of respect and lineage.

Thank you to my editor, Shayna Keyles, who plucked me out of the Twitterverse and gave me a chance to share my work and myself with you all through this book. Much gratitude as well to everyone at North Atlantic Books for your work and support behind the scenes, as well as for showing us what ethical, compassionate work looks like in this world.

I have so much gratitude and respect for all the clients I have collaborated with over the years who have informed this work with their vulnerability, trust, and expressions. Thank you especially to those of you who see your own story glimmering in these pages; I hope that I have shared your stories with integrity and purpose here. Gratitude for each of the authors and artists you see quoted throughout this book. Your words, stories, research, and creations have helped this book come alive; I hope the connections I made here serve you and your

work as well. Thank you so much to all the beta readers who agreed to read parts of this book and share their ever-valuable feedback. Specifically, thanks to Lisa Hellier, Amy Ferris, Sara Clark, Kayla Huszar, Emma Thursby, Stacey Walyuchow, Lisa Rouleau, Lacey Shurmer, Jane Newman, Laura Roberts, and Cameron Ansorger. Thank you as well to incredible creative team Mia and Eric for photo support and for helping me find the perfect story.

I stand where I am today, and am the person I am, because of the contributions, sacrifices, and support of my parents who are unwavering in their love and support for me. Thanks as well to my sisters for challenging me to find my edge and do better in this world. To my three children, the lifeforce and muses that propel me into the moment and into the future, thank you for holding me in the ashram of life. Thank you as well to the network of support and childcare that held my children with care while I worked on this. Specifically, thank you to my children's teachers Melanie Nickel, Ryan Symington, Dave Werner, and Mrs. Campbell. Each of your contributions and care are immeasurable in the context of allowing me the space and bandwidth to do my own work. I am also thankful to live in a country where childcare and healthcare are valued and supported; without these supports my impact on this world would be limited.

Finally, thank you to my favorite person in the world, my husband Mike Whittington. You are so integral to me it's hard to imagine this book or work existing without you. The thoughts, heart, and spirit of this work are because of you and your unconditional support and belief in me. You help me see, know, and feel into myself with clarity so that I can find my way. I share the expressions and insights here with you, a timestamp in our lives and the ongoing story of each of us becoming who we are.

Introduction

SHE WHISPERS UNDER her breath that she lost her son twenty-five years ago. He mumbles something about the rejection from his first girlfriend he has never quite shaken. There are the stories of a lost mother, an ill mother, a broken mother. A failed marriage, a friendship turned sour, a love never found. Parents drowning in stress and keeping the cycle of pain alive for the next generation. Imposter syndrome, secret shames, and truths never once spoken out loud. Show me a person without a hole and I will tell you to take your shovel and dig deeper.

These are the holes that have been worn into our hearts, the missing and incomplete parts of ourselves, the great feelings of lack that pain us to touch. For some of us, a part went missing early on, maybe even started to take shape before we were born. For others, a chunk was taken out in an unexpected instant. Most of us have always felt a small, persistent pain deep down that we have learned to grow around over time. Whatever its shape or cause, when life leaves a hole in us, we are never the same. Perhaps we can each take solace in knowing that we are not alone, that the world is full of holes in many shapes and sizes. Our holes are what unify us, offering a sort of collective humbling where we each acknowledge that integral to being human is living with holes and remembering to see them in others.

Sometimes when I am walking down the street, I like to imagine that people's holes aren't hidden, that I can see the specific shapes and marks on each person I encounter. A man passes me on the left with a tiny abrasion on his arm, a woman walks toward me missing a slice so deep I can see straight through her, a child is just around the corner riddled with tiny pebble-sized voids in every part of them. I let this affect me, I let it wash over me, and I dream of how my

life and our world would change if we could see each other's holes. I think at the very least, it would require us to know our holes better and understand them as being fundamental to who we are. We could tell their stories in intimate moments like we do for the tattoos that peek out from underneath our clothes. We would glance at each other and offer a knowing look of compassion for how cold the wind must be as it whips through another's body in a certain way.

We have names for some of these holes, cultural cues signifying their shape and impact—grief, divorce, low self-esteem, loneliness, trauma, and shame. It's a first act of love to identify and name your hole, but to grant it further reverence, to let it be seen and known, is the ultimate act of recognition. Not healing, because some holes can't be undone; we can never bridge the gaps between life and death, loss, or past harm. Instead, all we can do is see our own unique hole, know it, and let the light shine through instead of burying it away in the dark; after all, it's in this light of being seen that we find our greatest strength. We can find a moment of stillness in which we accept the holes as they are, finding acceptance and peace.

The pain of each hole becomes compounded when we seek to heal or absolve our suffering only to discover that many of the tools we turn to are incomplete, or only partially sufficient for the job. We live in a culture that believes that we can, and should, be able to talk about and measure our way through everything. But some things are indescribable, even intangible, despite being abundantly real. The game is a setup, and we are expected to find our way through life with tools only partially sufficient for the job. A surgeon may be able to cut that cancer away with incredible precision, but they can't mend the anguish of a cancer diagnosis. Your therapist may provide a safe place to speak and heal, but if you are unable to find the words to start the conversation, the discussion is over before it has begun. What if, instead of feeling like a failure when the support we received didn't work, we make new tools available?

This book is about how creativity can become another tool, an ally, helping us to make meaning of our holes and to access deeper knowing from within. Creativity has the potential to be our friend, therapist, and witness, helping us to make ourselves anew or simply allow what's already within us to shine through with greater clarity. Creativity is but one key that has the potential to unlock millions of doors for us. Once we have this key in our hands, the world

opens to us in new ways. We find we can know ourselves and the world through color, shape, line, movement, texture, and words. We can create pockets of stillness in our lives, places where we hold ourselves with care, interest, and calm. I have used creative expression to walk through dozens of my own holes and have guided many others on their own path. Along the way, what I have found to be most useful is using creativity to help us practice mindfulness, help us find new ways to relate to ourselves, as well as our suffering, and find stillness in any moment.

I often think of the quote "we teach best what we most need to learn," from author Richard Bach.[1] The themes of creative knowing (a concept we will explore in greater detail in the pages to come), stillness, and mindfulness run through my work; together they have become inextricably bound to my own position and view of the world. I too am a student, always learning, exploring, and practicing, not in search of expertise but rather as an act of generosity to myself and as a way to give back to others.

The ideas in this book are not new or cutting edge. Rather, they are a call to remember that we once knew how to be, do, understand, and become through creativity. Creative expression was, and still is in many cultures and worldviews, essential to the health and positive functioning of both the individual and the community.[2] Yes, creativity can be expressed as art, showcasing beauty, skill, and craft, but it is also a way to express the elusive. Creativity is a language that connects us to one another and to ourselves, guiding us to understand our lives and the world. The only beauty, skill, and craft it requires of us is our intention.

Using creativity as a tool for understanding ourselves and the world, *creative knowing*, as I call it, requires a shift in how we make and how we express ourselves. It requires us to create without attachment to the outcome, to ride the waves of the process, and to pay attention to ourselves along the way. Many times, when we cast our gaze inward and welcome it into the creative process, we encounter strange connections. Artifacts, symbols, movements, messy marks, colors, textures, and so much more begin to speak to us in ways that our words have forgotten how. We must be prepared and acknowledge that creative expression may come to us in ways we can't imagine right now.

This book is a gentle invitation to help you create your own stories and meaning about your own holes through a series of creative projects. It is an

invitation to welcome stillness into your life through the creative process. As you walk this path, I will be sharing stories from my own life and creative practice along with others who I have supported and worked with. I will show you how we can usher some of our holes out into the light and see them with new eyes and understanding. We will explore different mediums and use them to pay mindful attention to our suffering, our hopes, our feelings, and our position in this world along the way. Through these processes, we will be returning to what the disciplines of Expressive Arts and mindfulness have long revered: we can make sense of things through more than our words and thoughts—we can know through creativity.

PART 1

Creative Companions: Knowing and Mindfulness

1

PARTNERING
WITH CREATIVITY

TODAY I SIT in my home surrounded by my handmade art on the walls and stacks of sketchbooks piled next to me, each page filled with marks, colors, and words rooted in my emotions and day-to-day life. I am privileged to spend my days immersed in creativity, teaching others to learn how creative expression can be a resource, helping them through life, but it wasn't always this way. I remember my first experience of creative knowing. I was freshly wounded, my mind locked in, telling and retelling myself the story of hurt again and again, when abruptly, and by surprise, my thoughts were interrupted by a strange impulse. I looked down at a paper shopping bag, ripped off its handle, and began rolling it in between my fingers. This was the moment; this is how it began. Radical shifts aren't supposed to be so mundane, but I would come to find out that nothing about the creative process is predictable. The moment I tore that bag was the moment I began creating with the intention toward knowing rather than making things that were beautiful. This is when everything changed for me.

Over the course of many hours, this paper bag was transformed into a curious flower filled with dark black pen marks and left to blossom on a barnacle-covered seashell. Imbued into it was the story of my hurt, and born from it was a knowing about peace, relationships, and boundaries.

Over the next few years, I began creating with urgency, producing alluring and new creative works that were unlike anything I had made before. I resolved

that whenever I identified a persistent struggle in my life, I would resist the urge to try to solve it with my mind; instead, I would welcome it into my creative practice. As each struggle presented itself, I would offer it gentle awareness and respond by making something in response to it. Along the way, I captured each process through expressive writing, allowing myself to bring it into stories, poems, and creative memoirs to help me make further sense of what I was experiencing and making. I had some idea of the challenges and struggles that would likely show up for me—things like the anxiety, anger, and control issues I have been facing my whole life. Other challenges were a surprise, encouraging me to explore them freshly as they evolved for me. Together, each creation and story combination chronicled the process of me coming to see and understand not only my own holes but my relationship to the world. With each new creation an insight also presented itself; I was accessing the part of myself I now know to be my creative knowing. (It's a concept you too will become personally familiar with through the invitations and stories in this book.)

This process of welcoming my struggles into my creative practice gave me firsthand experience that life can be intimately lived and understood through creativity. It solidified for me what I believed and had been educated to do— use the creative process to uncover new insight. I call this *creative knowing*, but you may know this as *artistic* or *aesthetic knowing*. Or you may just understand this intuitively through your own experience with creating and making. This type of knowing can take shape through any creative process as long as we are acting with intention and listening with gentle awareness. It's this inward gaze toward our creative process that allows us to emerge on the other side with insight, offering up a knowing that often takes form in color, shape, texture, or symbols. With each brush stroke, pencil line, threading of textures, or evocative word we write, the creative process is encouraging us to express what we know already and is helping us to make sense of the many unknowns that still haunt us.

Prior to that paper bag, I was in one place in my life, and now, since its creation, I find myself someplace new. The movement wasn't physical, but rather an internal shift filled with unlikely companions I found along the way. Paint and anxiety. Rocks and divorce. Woodpeckers and hope. Each of these strange connections was found when I turned my gaze inward and surrendered to the

creative process. I didn't expect to end up here, and my hope is that you, too, will find yourself in uncharted lands by the end of this book.

I, of course, know my own stories with the greatest depth and clarity, but within these pages, you will also find stories and examples of many creative journeys toward knowing from clients I have worked with, from history, and from the world at large. I have used pseudonyms for these clients and have changed identifying details in their stories with the intention of protecting their privacy, but each story remains rooted in real life and is shared as a practical example of the process in practice. We will use creative knowing as our key—to unlock the door to stillness and mindfulness. In this book, we will look at ten struggles within the context of a mindfulness principle, utilizing client examples as well as stories from history, myths, and research, all coming together to help us see how creativity is uniquely positioned to help us practice mindfulness. In addition to this, the ten stories will be paired with a personal narrative of my own in which I use the creative tools of expressive writing, poetry, and my own creations to demonstrate how I have invited my own personal struggles into a creative process. Each of these stories is deeply personal and unique to my own creative voice at work, but as humans, many of our conditions and sufferings will overlap. Our privileges may be different, my struggles wrapped up in a life story different from yours; nonetheless, my hope is that by sharing stories from my clients with you, along with my own reflections and creations, I can help and inspire you to connect with the tensions in your own life and produce your own curious body of work and insight.

Throughout this journey, I have also distilled practices and provided ideas and instruction that will help you begin creating for insight in your own life. This is a chance for you to cast your own gaze inward, cultivate awareness, and welcome your own personal knowing into the world through the creative process. Each of these invitations is rooted in my years of training as an Expressive Arts educator, my education in arts-based research methods and adult learning principles, and my personal practice with mindfulness. I have worked to distill the essence of these disciplines into practical, accessible, creative invitations that anyone can use for insight. Throughout my career I have shared these practices with clients, couples, and groups, each time deepening them, refining them, and working toward finding their essence.

The instructions and prompts provided throughout this book will encourage you to create in tiny and big ways. They will ask you to play with new mediums and express your own knowing through the unique fingerprints of your own creative process. Instead of teaching you techniques and skills like most art books do, here you will find invitations for processes to follow and opportunities to bring your imagination into new environments to see what will blossom. Each invitation will have you creating in the broadest sense using tools, mediums, and processes that go beyond traditional drawing or painting techniques. You will find yourself exploring the outdoors, searching your home for distinctive items, playing with symbols, deconstructing your paintings, exploring abstracts methods, slowing your pace down, and even (at times) destroying your creations. We are seeking insight, and this intention requires us to strip ourselves bare of the comfortable and open ourselves up to the new.

You don't have to be an artist; you don't even need to have created anything before. Skill is irrelevant to your expression, and expression is what we are ultimately doing here. My years of education, training, and work helping people go deeper with their art have shown me that everyone can do this work. Instead of repressing our thoughts, feelings, and experiences, we are expressing them through shape, line, color, texture, movement, and words. In this way, creative knowing is available to anyone willing to take the leap and open themselves up to the creative process.

Creative Mindfulness

The purpose of this creative odyssey we are taking together is to deepen our insight and awareness of ourselves and to learn how to create stillness in our lives; creative mindfulness is the method we are going to use to reach this destination. Through the creative process we learn that we can find stillness, an inner place of refuge, calm, and strength. In this way mindful art practices become a resource for us, helping us to intentionally create stillness in our lives, make sense of ourselves and the world, align our perspective, and determine fruitful action. When our lives feel chaotic and out of control, our suffering feels overwhelming, and our holes seem to be growing, we can turn to our creative practice as a place of safe harbor and create stillness for ourselves in which to find

nourishment and peace. We can learn to take our frenetic energy and uncertainty and move it into the creative realm where it transforms into something calmer and more resolute. Our problems and suffering don't change, but our relationship to them does. Our creativity becomes a place where the alchemy of transformation unfolds and we learn to welcome discomfort and let it rest within, creating stillness through our expressions and our intentions, and ultimately finding peace.

Many of us are aware of contemplative practices such as meditation, yoga, and tai chi, but the idea of creating or making art in a mindful way is relatively new to the western cultural consciousness prominent across the Americas, Europe, and Oceania, despite many examples throughout time and culture. Calligraphy, mark-making, chanting, drumming, poetry, and ritual ceremony, among many others, can be found in virtually every culture we have ever known, all used as a way of attuning to the moment through creation. Indeed, mindfulness is an ancient practice with many manifestations across time, space, cultures, and history. We owe much of our contemporary wisdom on mindfulness to Buddhism, which, as Wade Davis famously said, is "but 2500 years of observation as to nature of mind."[1] The roots of the practice are ancient, and modern evidence shows mindfulness practices benefit us enormously, improving our capacity to manage anxiety, depression, and pain while literally helping us to remodel and change our brains.[2] Mindfulness is not new, but rather an ancient practice that evolved alongside humans, helping us to connect to ourselves and one another. But as Theravada monk and author Bhante Gunaratana says, it is a "living activity," one that can only be understood through experience. It's not something we can talk or think our way into; rather, we must be willing to do it in order to know it.[3]

In contemporary western culture we are just now beginning to recognize and practice using creativity to help us cultivate awareness and stillness. You may be feeling a little uncertain, or even jaded, about this, having explored mindfulness in some way in the past and ended up feeling lost or unsuccessful. Unfortunately, with the proliferation of mindfulness in popular culture, we have tended to water down or pick and choose from the traditions of mindfulness as we see fit. This has resulted in practices being taught that ultimately undermine the purpose of mindfulness, leaving participants more

confused than ever. Art and creativity are no exception to this. Here we will be doing more than slowing down or practicing meditation through drawing; we will be doing this, but we will also be doing much more. The mindfulness practices you will learn here ask you to create in broad ways, not just through visual art. You will be welcoming your thoughts, feelings, and experiences to this process, not setting them to the side. For those who have participated in mindful art and creativity before, this may feel new or unexpected. Insight and knowing come through welcoming everything to process, not just the familiar or comfortable.

In this way it is important to remember that not all art-making or creative pursuits are inherently mindful. When we tether our creations to being judged solely by their final product or aesthetic value, we are overlooking the awareness that went into the process of creating it. As we will explore more thoughtfully later on, it's the process and everything that happens in the moments while we are creating that can help us cultivate awareness. After all, this is what mindfulness is all about—allowing our awareness of the present moment to help us cultivate a place of stillness from within. Creative mindfulness is more than just paying attention to our senses as we create; it's also paying attention to our thoughts and reactions while bringing an open, curious attitude to the process. We find perspective through the creative process; we begin to relate to ourselves and the world differently as we continually return to creativity as a resource and tool to be with no matter what each moment holds for us.

This method of creating may feel new, but just like when you learned to ride a bike, started a new job, or found yourself in a new relationship, on the other side of that initial discomfort is a whole new world waiting for you. We must think of this type of creativity as muscle deep within us: we may not even know it's there or how to use it right now, but each time we begin to flex, it grows stronger and feels less foreign to us. The more time we spend practicing it, the more natural it will feel. The more we stop thinking about creative mindfulness and the pursuit of creative knowing and actually step into doing, the more we will begin to make sense of how the practice unfolds and become more comfortable expressing ourselves in this way. When we first begin holding this space for ourselves it may feel scary. (After all, art lives inside of us in a vulnerable and emotional place.) For those of you who have experienced trauma, it is likely that

you will need a skilled guide such as a therapist to help you begin to feel safe in this unfamiliar terrain. It may feel scary to be close to something so raw when we ourselves are not well, but this vulnerable space is where we can hear the whispers of our inner voice trying to guide us.

This invitation toward a new way of knowing comes at a time when a movement is afoot in the modern world: we are awakening to the limitations of analytics and beginning to seek ways to find more holistic and complete ways of being, understanding, and solving the urgent problems of the world. This movement may feel new, but in many ways, it is simply a return to the ancient, a reclamation of old ways of being and knowing that once integrated our bodies, senses, and emotions. This book is also an offering to this movement, built on the deep lineage and wisdom stemming from the arts in all its forms as well as mindfulness.

A Path Forward

This book is an invitation to knowing—not knowing in the ways that you have been taught or expected to share, but a knowing that integrates your body, mind, and heart through what can only be called inspiration. This idea of knowing may feel abstract or uncertain to you right now, but through the invitations and teachings to come, you will start to find your own definition. In my own life, I am continuing to try to listen to the whisper of inspiration, knowing that it will seduce me at times into unknown and uncomfortable territory. The other thing I recognize is that when I do trust it and trudge through the mystery, I always come out on the other side with something worthy. It's never quite what I thought it would be, but it is always worth it. I hope you will trust me as we walk this path together. Explore this book in your own way; you may choose to read it cover to cover or flip around to find invitations or sections of particular interest to you.

In this part, "Creative Companions: Knowing and Mindfulness," we will begin by preparing you for your own inward journey toward creative knowing. Here in Chapter 1, we have begun looking at what creative mindfulness is in both practice and origin. Chapter 2, "The Languages of Knowing," will immerse you in the modern context of what it means to know something. Here we will

explore what creative knowing is and why it has become so underappreciated in our world. We will explore other types of knowing that are increasingly becoming recognized and repatriated, including Indigenous peoples', embodied, animals', and women's—each silenced and revered in its own unique way. By understanding the broader cultural context of creative knowing, we will be preparing for our own creative journey. In Chapter 3, "Creative Mindfulness," I will show you how to cultivate an open state of awareness through your expression and define what creative mindfulness is. The skills learned here will serve as a foundation for your own exploration. We will build on this mindset in Chapter 4, "Creative Living," as we begin to explore specific ways to embrace creativity in our lives and prepare for the creative invitations that lie ahead.

Part 2, "Meditations and Creative Invitations," is where we will begin our creative passage into knowing. Each chapter will introduce a hole or tension inherent in being human. Some will connect more with you than others, but each tension is likely something you have experienced and can draw on for insight. In this part of the book, some of the tensions we will explore are the experiences of stress, anxiety, fear, societal pressures, and feelings of not fitting in, among many others. These will be the anchors for our inquiry. Each chapter will introduce you to a tension and principle of mindfulness through client stories as well as examples from history, myth, and beyond. A case will then be made for how creativity is particularly well suited to promote insight, healing, and awareness. Here I model my own vulnerability and inquiry, and in many cases, my imagination, using a story to show you the magic and depth that can emerge through the creative process. Each chapter will conclude with a creative invitation for you. These are the instructions for you to follow to take your own leap and embark upon a process of creative inquiry.

I hope you will join me in this personal and interactive journey, breathing new life into yourself through the creative process, and uncovering knowing in its infinitely surprising shapes, sizes, and colors.

THE LANGUAGES
OF KNOWING

NEAR A PATCH of forest along the coastal waters of Nova Scotia, Canada, Fyre Graveline, an Indigenous knowledge keeper of Metis descent, walks the beach harvesting natural objects after a storm. Her intention is to gather shells, sticks, and feathers to use in an arts-based ceremonial teaching about Mother Earth with a group of students. Meanwhile, healer and author Resmaa Menakem wakes up in the morning in his Minneapolis home and takes a few moments to orient himself, looking around his space, twisting and moving, assuring his body that he is safe before his day begins.[1] Somewhere in the depths of the South Pacific Ocean, a male humpback whale sings a new distinctive song filled with grunts, moans, and whistling—a mating call that will soon spread around the world from pod to pod like a pop song through the ocean currents. And along the coast of Maine a world-renowned expert in arts-based research, Patricia Leavy, sits absorbed in front of her home computer, not lost in research, but rather in her latest novel in which the characters explore the boundaries of love and the legacy of trauma. Participating in a ceremony, moving your body, composing/singing a song, writing a novel—simple acts, but when we look deeper at each of these, we see a radical effort unfolding, each one a demonstration of knowing in practice, many actively muted and suppressed in the past, and all under increasing threat today.

We are each thrown into a complex world unique to ourselves that changes daily, and it is up to us to find our way through it. Every day, each of us participates in a sophisticated and often hidden process of integrating our thoughts, experiences, culture, emotions, senses, gut feelings, and beliefs—a process we call *knowing*—and that process can be as complex and unique as each of us individuals. In recent decades increasing attention has been placed on various ways of knowing; we are recognizing that the processes of how we come to experience and express ourselves are as diverse as life on this planet. Take, for example, the various ways one might know a tree. You might think most of us would have a common understanding of what a tree is with very little disagreement found around the world. But ask a botanist what a tree is, and it becomes the product of photosynthesis and an agent for purifying the air. Ask a child, and they will say a tree is their friend, a place to climb and in which to find solace. To one person a spruce tree, an important symbol in their cultural traditions, holds poignant memories of Christmas, and to another, it is simply a nuisance dropping needles that kill the lawn. To Fyre Graveline, a tree is not an object but rather "a living being and a beloved relative" providing needles to be used in a ceremonial smudge. In recognizing all these ways of knowing, we see the old improv maxim of "yes, and" is alive and well in the world. We can each see a tree, but each of us adds on our own special concoctions of knowing. Our understanding and relationship to the tree is deepened, creating a more dynamic, varied, and nuanced understanding of it.

If you are someone living in or under the influence of western culture, the historical precedent you live within is a legacy of Roman and Greek cultures as well as Christianity, which together prize the scientific worldview and cognitive analytical thinking above all else. In this perspective the mind is king, and the pursuit of knowledge primarily happens through science, which breaks down the world into singular and separate bits in order to understand them. In this way we have come to see "true knowledge" as unbiased, replicable, objective, and divorced from anything that may be indescribable or elusive, which has proven to be problematic. For example, this type of western scientific knowing has taught us that food is constructed of the basic components of calories, fats, and carbohydrates, when we break down the whole into various parts. In doing so we neglect to see the ways that vitamins, fibers, and microbes, as well

as other foods, interact with one another, let alone how they interact with the complex systems of our bodies. Here we see that our narrow focus on the parts has prevented us from seeing the whole and the impact of relationships and systems on one another.

In the west it can be easy to believe that the knowing that results from this worldview is the *only* type of knowing there is. When we hold a belief that knowledge can only result from the mind and objectifiable facts, we suppress and marginalize different ways of knowing. Perhaps you have had the experience of walking into a space with a friend and immediately feeling that you don't want to be there. Your heart begins to race, you notice a smell that is off-putting, and a twinge of fear and anxiety well up. You try to be objective, looking for evidence that something is wrong, but when you can't find anything concrete, you may struggle to rationalize to your friend why you should leave. So, you end up staying despite knowing that the place isn't safe; in reality, what you were trying to do was employ your somatic knowing, which comes from your senses and the body.[2] In countless moments throughout our days, we are overriding other forms of knowing we possess, opting instead to use our rational minds as the one true source to turn to.

It's important to note that western culture has offered, and continues to offer, us many triumphant gifts: saving lives through medicine and healthcare, connecting and simplifying our lives through technology, and helping us to feed ourselves through a sophisticated food supply chain. Yet, we don't need to look very hard to see that it also has its limitations. In healthcare we treat one symptom and cause others to arise; our focus on using our efficient cars causes detrimental environmental impacts; and our reliance on video calls (although convenient) means social cues and body language are cast aside, causing miscommunications. Recognizing and respecting varied ways of knowing means that we first concede that our analytical, technological ways of knowing have limitations while also maintaining that we don't have to choose or prioritize one type of knowing over the other. Instead, we can seek to observe, listen, and express our knowledge in diverse ways, thus expanding our understanding of the world and deepening our recognition of the impacts we make in it. It may be that the simplest way to begin understanding the concept of *knowing* is to see the many ways it manifests in the world. Take note in the following discussion

that these ways of knowing don't function in isolation from one another; rather, they manifest in concert with one another, a sort of cross-pollination that validates and recognizes knowing as an integrated process.

Indigenous Ways of Knowing

Fyre Jean Graveline lays out stones, feathers, shells, birch bark, and seeds next to a circular wooden tray. Today the tray will hold a sacred bundle filled with plants and medicine in its center, and the four directions will be recognized as the students participating in the ceremony each place an object on the tray. Fyre is a leader and educator in Indigenized Art Therapy and Expressive Art Therapy in Canada, and she told me this ceremony she created "is about calling forth a sacred time, place, and space to welcome in ancestors . . . and deepen then into a process not of creating something outward but of reflecting something, a knowing that is arriving." In this ceremony participants acknowledge that time is not linear but rather a weave of past, present, and future happening all at once. Each participant is understood to be a product of their own unique past circumstances as well as their responsibility to future generations, each person situated in a weave of time and space. Fyre suggests that the not knowing is just as important as the knowing that emerges in ceremony and that the insight that emerges isn't a possession to own but rather a gift for all, a place where the giving and receiving of knowledge is boundless.

Relationship and reciprocity are inherent values often found in Indigenous cultures around the world, profoundly shaping how one experiences life. For example, as Tiokasin Ghosthorse, a member of the Cheyenne River Lakota Nation of South Dakota and former Nobel peace prize nominee, says, "most Indigenous languages that I know of, don't have nouns . . ." This is different from English or other European languages that use "restrictive language" as he calls it.[3] In these non-Indigenous languages something can be owned and considered as separate from a person. For example, in western knowing a tree is a noun and therefore considered to be an object, which means a person can own or possess it, as we can clearly see by the way trees have been commodified and are seen to be a resource for human use. But if a tree was a verb or a completely different category of language, this shift would establish a relationship

or activity between us and the tree that would change our understanding of it. Ghosthorse suggests that when we understand ourselves as separate from Mother Earth, past, and future, it changes the way we come to know and understand the world. In this way we see that even the construction of language itself shapes how we know the world.

Indigenous languages and peoples are a diverse group that can't be characterized easily, but what they do share is the experience of living with calculated and ongoing suppression of their ways of knowing and being in this world. For example, it wasn't until 1951 that Indigenous peoples in Canada were legally allowed to practice ceremonies without fear of punishment.[4] As we consider cultural ceremonies and Indigenous ways of knowing globally, we must also consider that they exist today under the deep, painful reach of colonization. Respecting and honoring these ways of knowing doesn't mean we mimic, take, or try to emulate them (further subjecting them to harm) but rather that we respect, support protections for, and allow them to inform us as we open our understanding to the diversities at play in the world. As Fyre Graveline places a stone on her tray, we can consider this simple act a profound symbol of resurgence, where ceremony, time, space, connection, and Mother Earth are in relation to one another, holding space for a resilient type of knowing to emerge after years of colonial genocide and ongoing attempts at extinguishment.

Embodied and Women's Ways of Knowing

When Resmaa Menakem intentionally moves and twists each morning in his bed, he is engaging the wisdom and knowledge of his body to help him feel safe. Resmaa's work recognizes a type of knowing that is held deep within the body called *embodied knowing*. As a Black man, therapist, healer, and author, he helps people recognize the damage caused by racism, understanding how the body has been silenced and suppressed. Eschewing the conventional approach to dismantling racism through the mind, his practices tap into the body as a site of knowledge, asking people to move and listen to the emotions and wisdom that emanate from within.[5] Historically, in the west, knowledge has been centered on white men as the norm, extinguishing the diversity of the human condition. When we recognize that knowledge emanates from the body,

we are acknowledging the body in all its many forms—including race, ability, and expressions of gender—as a site of wisdom. Each of our bodies holds our own unique identities and histories; therefore, the knowledge that they hold is a singular experience.

In 1986 a team of female researchers, Mary Belenky, Blythe Clinchy, Nancy Goldberger, and Jill Tarule, forever changed our understanding of knowledge, publishing research that recognized something called *women's ways of knowing*. Their work found that women learn through emotions and relationships, integrating embodied knowing and acknowledging that power, race, and the legacy of sexual violence inflicted on women have a profound impact on women's ability to know their world and express themselves in it.[6] For example, in this work it was found that women's inner voice offered the strongest sense of knowing for them, even in the face of traditional forms of evidence or authority. Women's ways of knowing are one more expression of how the process of making sense of and shaping our world is beyond the mind, calling for more holistic and varied recognitions of what we know and how we know it.

Plants' and Animals' Ways of Knowing

One of the ways the western scientific word view has been short-sighted in its understanding of how knowing manifests is through our omission of plants and animals in the discussion. Plants and animals are central to Indigenous ways of knowing, but many people in the west hold an underlying assumption that knowledge is specific to humans. Of course, all living things come to know and understand the world they live in, and it turns out that the ways in which they gather and express that knowledge are incredibly skilled, nuanced, and intricate, as is the case with humans. For example, when a male humpback whale sings his mating song, it isn't simply a static fixed song he returns to year after year but rather a harmony partly created and partly remembered. Scientists have learned that humpback whale songs spread seasonally around the world each year; one pod hears the songs of another pod and then they listen and integrate it into their own song. The sharing of the songs is part infectious pop song and part game of underwater telephone.[7] This is just one example of countless many recognizing that culture exists

within animal groups, shaping their behaviors, hunting habitats, and mating practices among so much more.

And it's not just animals that have their own ways of knowing; plants do too. Scientist Suzanne Simard has gained notoriety recently for recognizing that trees communicate to one another and collaborate through complex chemical means to help collectively defend themselves against threats.[8] It is mind-blowing to think of all the ways of knowing unfolding in the world around us that we may simply be blind to. When we recognize that trees talk to one another and that humpback whales have unique cultural practices, we are recognizing that knowing isn't relegated to the human realm but rather that it manifests in varied and complex ways among all living creatures.

Art and Creativity as Ways of Knowing

Patricia Leavy has spent her career investigating how art and creative expression can help us answer questions about the human experience. Her work in academia helped to legitimize visual art, poetry, theater, dance, and fiction, among many other art forms, as tools for "illuminating the human experience," as she explains. I spoke with her and asked her what she has learned about art and creativity as a way of knowing; she said it can most simply be understood that they help us to "express the inexpressible . . . jarring us into awareness in an emotional and visceral way that is like no other." Patricia spent the first half of her career championing creativity as an accepted mode of expression and knowing, but she spends her time differently now. I asked her why she walked away from academia and now chooses to primarily spend her time writing novels. Her response was that she is always asking herself, "Is this a good use of my time?" and as she has reflected upon this, she has decided that writing fiction is the best thing she can do right now.

Patricia has spent the last decade writing something she calls social fiction, in which she explores healing trauma, finding meaningful relationships, and dealing with issues of self-esteem and grief, among others, through the genres of chick lit and romance. Her novels are subversive: though they feel like cozy beach reads, at their core they are helping the reader to grapple with these complex topics. She told me that each time she writes a novel, she is embarking on a

process of discovery, and along the way, she has found more empathy and compassion, helped to heal her own trauma, and worked through beliefs and values with more nuance and complexity in her life than she would have before. Her own process of knowing through the arts has allowed her to imagine new futures where a woman is president, where women find healing from their past sexual trauma, and where love conquers all. She is partly showing others the way and partly finding her own way. Patricia's work gives us all permission to find knowing through our own unique modes of creative expression and rest assured that it is legitimate and important in helping us make sense of the world.

Why Creative Knowing?

We live in a time of ballooning mental health needs, an escalating climate crisis, and the legacies of colonization and racism as well as new technologies that are rapidly transforming how we communicate and relate to one another. The world we have been thrown into requires us to make sense of it and learn to navigate it with urgency and in ways we have never done before. With so much competing for our attention, we would be wise to question what use creativity, art, song, and dance have in helping us find knowledge. Is engaging in creativity simply another indulgence or distraction from the work that needs to be done, or can it help us to solve our most urgent issues?

As we open to the possibility that we can know in varied ways and that expression and understanding manifest in ways that have been overlooked and suppressed, we come to realize that we have been painting the world in monochrome, leaving a rainbow of colors on the table unused. It's almost as if we are Dorothy from *The Wizard of Oz* living life in grayscale and then we step into the realm of possibility and we begin to see the world in Technicolor. Imagine how our world will transform when we begin to honor all the colors available to us. This is the color of knowing, an invitation to see the world in all the vivid nuance and shades that it holds. Recognizing and engaging with knowing in all its forms offers us more tools, languages, connections, and understanding; it doesn't compete with the black and white marks of the world made in the western view, but rather it complements, broadens, and changes our understanding of the world, offering us a broader spectrum of understanding and expression.

One example of how creative knowing can help us tackle these greater issues is that it helps us to truly experience our feelings. When we create, we are bringing forth embodied knowing, sensory knowing, and our relationships to help us feel and better understand our emotions. With our rational mind at the helm, we often override, suppress, or belittle the full breadth of our feelings. Creative knowing allows us to touch those feelings and pause in a place of stillness and awareness; from this place we can then intentionally choose to bring them out so we can make sense of them and better understand how they impact us. Acknowledging and experiencing our feelings may sound trivial or obvious, but as our mental health collectively falters, we can see how important it is for us to be well so that we can turn our attention to serving one another and the planet. As an example, getting familiar with our feelings allows us to face, head on, the grand task of reimaging race relations. Many thought leaders doing racial justice work have suggested that if we each began to feel our feelings, that the true impacts of harm could be recognized, allowing us to collectively become aware of how we have become numb to others' pain as we let our fear of facing our guilt and shame take hold. These invisible hands that have been holding us back would no longer prevent us from doing the actual work we need to do.[9] Before we can do this work, we each need to welcome our feelings out into the open, and creative knowing is a tool that takes us out of our mind and into the realm of our emotions, bodies, and spirit.

Another way that creative knowing can help us solve our problems is through what is known as *poiesis*, the ancient philosophical idea that human beings can actively make or create something that wasn't there before—literally shaping the world.[10] The idea of poiesis suggests that as human beings, we have a need to create and make, and when we do so, we feel agency, power, influence, and control in our world. In our current state of passively overconsuming goods and technology, making something—even if it's a loaf of bread, a simple doodle, a garden, or a new idea—brings something new into this world and is one of the simplest joys we can find. For those who have lived a life of silence, feeling that they have very little control in their lives, the act of making something new can be a newfound lifeforce. As each of us engages in poiesis, we find that we are shaping ourselves and the world, transforming it bit by bit and day by day. Our impact on the world begins with the simple act of creating something new,

taking us out of the passive realm and into an active state. This is how we begin to make our world anew, one person and one creative act at a time.

It might be helpful to think of this book as both an invitation to and an example of creative knowing in practice, serving as an example of how creative knowing helps us feel our feelings and remake the world. Creative knowing is the tool we are learning to use here, and this tool will help us learn about mindfulness and practice it in our lives. We could choose to use creative knowing to help us in our relationships, to learn about the land we live on, or even to examine ethics, values, or other avenues of professionalism in a traditional classroom. But here, we have chosen to employ this knowing to help touch the vast world of mindfulness. Together we will harness the power of it to help us pay attention: to our feelings, to how we intend to shape our world, and to all the ways we can open ourselves up to the experience of living more abundantly and connectedly. As the Indigenous author and scientist Robin Wall Kimmerer, a member of the Citizen Potawatomi Nation, says in her book *Braiding Sweetgrass*, "Paying attention acknowledges that we have something to learn from intelligences other than our own."[11] It is with this spirit and recognition of the many manifestations of knowledge that we begin as we learn about the practice of creative knowing and how it can teach us mindfulness.

3

CREATIVE
MINDFULNESS

I WALKED INTO a dark meeting room, flicked the fluorescent lights on, and listened to their distinctive hum as I took stock of the meager space before me. I exhaled in frustration as the sterile droning of the lights in the background reached a steady pitch. This isn't quite the welcome song I had planned. In a few minutes, six young men would join me for a creative session here, and I wanted it to feel welcoming, not like an airport terminal. Cheap blue carpet, uncomfortable chairs, a kitchen down the hall with non-stop banging—we were meeting in one of the least inspiring places I could conjure up, but in the end it didn't matter. This group of men was willing to gather here because they knew it would help them on their road to healing from addiction.

I massaged the room a bit by shuffling the chairs into a circle. I put some interesting rhythmic music on and placed a series of small trinkets on the floor in the center of the room. I was hoping the whole package would offer at least a bit of intrigue. Once the men arrived and settled in, we warmed ourselves up with some simple conversation, a brief body-focused meditation, and an activity in which we traced the rhythm of our breath with pencil. I then invited the group to choose a question that they wanted to explore to help anchor the rest of our creative process for the day. After some brief consideration, each person wrote down a question in their journals. The questions varied, some wanting to explore forgiveness, others looking for hope in their treatment.

Jeff, though, had anger on his mind. He had been coming to my group for a while now, but I really hadn't made much of a personal connection with him. It was his choice to attend, which told me that he was at least curious about what we were doing here each week. I could tell by his uncontrollable bouncing knee during meditations and his reserved demeanor that his suffering was all-encompassing, making it hard for him to participate fully. He was trying to be present and open to this process even if his outward appearance seemed distracted.

His question about anger, unrefined and vague, was scrawled messily into his journal. Jeff had written something about it, making him feel insane and full of shame. I invited the group to take the toys, shells, rocks, wire, and other trinkets I had placed out earlier and create an installation where they would lay objects out in an artful way in response to their question. I encouraged the group to pay thoughtful attention to what objects they selected along with how and where they placed them. I asked them to notice color, texture, and perspective in their creations. I wanted them to play with things until it felt complete, all the while listening and trusting the internal voices guiding their hands. Above all, I asked that their installations feel right, and not necessarily look good.

Jeff took his time, waiting until everyone else had selected their items and then slowly moving over, tentatively grabbing a few. He was unsure, but I could tell, since he resisted looking in my direction, that he didn't want my help, so I gave him space to move into his process. He turned his back on the room, sat down on the floor, and began tinkering. Eventually, I looked back in Jeff's direction. He moved away as if to reveal his creation to me, saying "ta-da" with his body.

On the floor there was a scene of destruction, a toy Godzilla at the center of it, with wire, torn paper, and little green army soldiers strewn about and a tiny red gem heart buried underneath the rubble. Jeff was ready to share. He gave me a quick inviting nod with his chin, and I responded with a soft smile back. When I came closer, he instantly began narrating the scene for me.

"I am Godzilla, or at least that's what it feels like when I am angry. I turn into a different person and all I want to do is fight and destroy, but I don't mean to. It's like I am just a big lumbering giant busting through town, leaving piles of destruction behind me. I think Godzilla gets a bad rap; he isn't evil. He doesn't

even really mean to wreck things; he just can't control himself. He is too big for this world. He is more like a tornado. He just does his thing; it isn't personal. Then the problem is, I step out of Godzilla and back into myself and it's like I see all the hurt and destruction. That's the worst part of it. It makes me feel so insane."

Just like that, our weeks of tentative quiet were gone. Jeff and I suddenly had something to talk about. His closed, guarded demeanor was now open to me, and we had something that we could work on exploring together. Jeff talked more about his feelings of shame and guilt and his inability to control himself or to make amends. We talked about the tiny buried gem heart, a symbol for all the relationships lost to anger in his life. I listened, and when I thought the moment was right, I asked him to take a breath and see if he could go back into himself and feel where Godzilla lived inside of him. He did this, took a few deep breaths, and instantly reported that it was in his stomach. In a short period of time, he had now come up with a name for his anger and a place where it lived in his body. Then I asked him if he could distinguish between the part of him that felt Godzilla in his stomach, and the part of him that was Godzilla. I could see him take a few more breaths and noticed his body relax just a bit more. He reported, "Yes, it's there. It's like I am almost looking down and watching that part of myself." We took some time and breathed into this space together, imagining in our minds' eye a growing space between the two parts of himself. When we finished, Jeff offered me a deep nod and a smile saying, "I didn't know that space existed. I thought it was all just one blob of me inside." As a close to our creative process, I asked him to write a short poem about his creation. Jeff's poem spoke about how "insane" he felt when he lost himself to anger, and the pain of watching his family fall apart in the wake of his outbursts. He told me his poem was a cry for help from his "real personality" trying to break through.

Jeff's experience of creating and finding a new internal perspective is a small example of what creative mindfulness looks like in practice. I knew that Jeff was receiving treatment from a therapist, so my role was to help Jeff use the creative process to express things he was having a hard time naming and teach him skills in mindfulness so that he had more resources on his road to recovery. It's likely that Jeff had experienced trauma at some point in his life and has probably worked very hard to escape that pain by distancing himself from his

body. In this creative process Jeff identified (for maybe a rare moment in his life) a space between himself and his actions by turning his attention inward to his body. He found space between his Godzilla anger and destruction and the unintended harm he has caused the people he loves. Most importantly, he found space in between the parts of himself, realizing some nuance to his inner experience rather than feeling everything all blobbed together. The awareness of these spaces will help Jeff to choose which parts of himself he wants to act from rather than feeling he has no choice. After all, it's very difficult to access parts of yourself you don't even know are there.

Developing this language for our internal landscape is essential if we want to live with intention. For Jeff, Godzilla was part of a growing vocabulary for his inner world. As he uncovers each part of himself that he can feel and name, he will better understand himself as a whole. He isn't Godzilla, that's not the full picture of Jeff; he is so much more than that. Jeff is Godzilla's observer. He is the guy watching the movie of Godzilla, a spectator who can locate the exit sign and leave the theater anytime he wants. It's this Jeff who we want to find, name, and nurture.

Two Paths toward Creative Mindfulness

This story shows us how creative mindfulness can unfold in two ways: it helps us to enter the present moment and to cultivate awareness and perspective of our cumulative experiences. As an example of the first, Jeff was encouraged to enter the present moment when I had the group sketch the rhythms of their breath. In this warm-up activity they were paying attention to a tiny part of themselves (in this case, their breath) as it happened moment to moment, all while they were documenting it with a pencil.

As we will learn through the exercises in this book, we can build a repertoire of practices, like drawing our breath, listening to music with presence, or observing our bodies as they move, that encourage us to pay attention to the present moment more freely. For Jeff, having a bank of creative practices that support his capacity to enter the present moment was an important resource in helping him to find moments of stillness as he journeyed through his recovery.

The second way creative mindfulness unfolded for Jeff was through the question he explored in the creative construction of his Godzilla installation. When he brought his question into his installation, he was able to emerge on the other side of the process with a new perspective and awareness of his struggle with anger. In this way we can embody the principles of mindfulness in our lives, practicing finding our own unique patterns and experience of living. In the follow-up discussion and work we did together, we deepened this awareness by helping Jeff to breathe into the newfound space. Investigating where he feels anger in his body will help him create a more nuanced awareness of his internal experience and outward actions rather than the generic blob he was stuck in before. Surprisingly, Jeff was able to build his internal vocabulary through the unlikely vehicle of a toy Godzilla. As you progress through this book, be prepared that your own awareness may show up through unlikely sources as well; it's all part of the magic of the creative process.

Jeff will need to continue to practice each of these creative mindfulness elements with intention (entering the present moment, and cultivating awareness and new perspectives of himself), welcoming more and more of himself into his creative practice in order to become a keen observer. Jeff was in a place of suffering and transition, but the same process can support anyone at any time in their lives. One thing that mindfulness teaches us is that the present moment is always available to us no matter who we are or what we have encountered on our life's journey.

What Is Creative Mindfulness?

Creative mindfulness supports us to live with greater awareness, helping us to live with peace and matching our motivations to our intentions in our lives. As we learned through Jeff's story, and as I will share with you in a myriad of ways through client stories and my own experiences and insights in this book, the practice of creative mindfulness is something that can transform how we live, understand, and experience our lives. Creative mindfulness isn't something that just takes place in our creative lives. We don't practice it in a vacuum; instead, we embrace a dance between our life and creativity and watch the way they support, inform, and court transformation in all areas of our lives. This

practice breaks down walls and encourages us to make sense of things in a more integrated and whole way. It's not a prescription to follow; it's deeply personal and ever expanding. Creative mindfulness has us seek connections rather than divisions and find new ways to live and express ourselves. The interconnection between our life and the practice of creative mindfulness is so abundant and rich that it can be hard to distill in simplistic terms. Nonetheless, I will try by breaking down some basic principles and practices that can help to illustrate what it is in theory and practice.

As a start, it's important to know that creative mindfulness isn't a fixed term or discipline, but rather an umbrella phrase often utilized by people who seek to fuse the wisdom of mindfulness into various art forms. Visual arts, music, dance, theater, writing, and many other art forms all have various contributors to the field. The diverse voices shaping this emerging field share a common approach using the creative process to practice embodying the principles and attitudes of mindfulness while emphasizing the significance of finding awareness through the process.

Creative mindfulness facilitators care deeply about the creative process and pay attention to the moment-by-moment unfolding of it. The process is paramount; it's a container in which we can enact and pay attention to our thoughts, emotions, and bodies. It's irrelevant if the products are beautiful, skilled, or innovative. The products of the creative process hold their greatest meaning when they are shared and understood within the context of the broader process they were born within. This doesn't mean that the creations made through it aren't inherently beautiful or interesting; it just means that the intention and awareness found in the creative process is where most support and attention goes.

My own unique interpretation of this work draws heavily on two traditions of wisdom: the Expressive Arts and mindfulness. The Expressive Arts as a field of practice began in the 1970s at Lesley University in Cambridge, Massachusetts. This new approach drew from the disciplines of the creative art therapies, philosophy, and Indigenous healing systems, recognizing the value of bridging various arts disciplines and supporting people to express using a variety of modalities. Human beings have always expressed in holistic ways that seek connection; the Expressive Arts recognizes and draws on this to promote healing

and learning.[1] It is important to recognize that although the Expressive Arts is a newer academic discipline, it is built on what Indigenous peoples and other ancient cultures have known and have been practicing for thousands of years: creative expression is the thread that holds individuals in the cradle of community and aliveness.

My training as an Expressive Arts educator means that I work with multiple forms of creative expression for self-reflection. I don't restrict myself to one, which is why I use the word *creativity* rather than *art,* which typically denotes visual forms, professionalism, and aesthetics. You will see in the exercises, invitations, and stories that I think of creativity in the broadest sense and always include at least two mediums of expression. Something may begin in a visual form, but we will always take a part of it into another creative medium like poetry, movement, or music. The Expressive Arts honors the unfolding nature of creative expression, recognizing the shifts and changes that can happen from one moment to the next, and in particular as an expression moves between mediums. As we will see, attuning to the shifts and movements of the present moment lends itself well to the principles of mindfulness, which is why the Expressive Arts is so useful in this practice.

The second discipline that informs my work is mindfulness, which is also a diverse field with many contributors. In my own life it made perfect sense to begin integrating the two, as the experiences I was having with mindfulness practices were informing my Expressive Arts' practice and vice versa. I couldn't keep the two separate, and once I welcomed each discipline in, I began to see what a natural relationship the two had. Despite the prevalence of mindfulness in modern society, much is still confusing about what it actually is or looks like in practice. When we think about mindfulness, it is important to recognize that it isn't about religion or spirituality, which is a common misconception. It doesn't need to compete with your current practices or beliefs.

Mindfulness practices can be found in some form or other in virtually all faiths across the world along with many spiritual practices. This suggests that the versatility of the practice connects us to something fundamentally human. It is this universal experience that my own practice supports and aims to cultivate in others. In Part 2 of the book, you will be introduced to various principles of mindfulness such as non-striving, non-attachment, and trust,

among others. The principles outlined do not represent a complete or definitive list but draw from and expand upon Jon Kabat-Zinn's teachings in the mindfulness-based stress reduction (MBSR) program that has become a seminal approach to breaking down mindfulness for western folks.[2] By engaging with these principles this way, we enact the wisdom of the moment, applying it to our understanding of ourselves and the world as we create and live more mindfully each day.

A Particular Way to Pay Attention

As we build this foundation of a creative mindfulness practice, it is helpful to spend some time better understanding what mindfulness is, as well as what its fundamental characteristics are, so that we can be clear about what this practice is. Jon Kabat-Zinn is a renowned figure who is credited with bringing secular mindfulness into healthcare from the 1970s to present day. His work is seminal and has been instrumental in bringing mindfulness to a broad appeal in the west. His definition of mindfulness is a helpful anchor for us as we attempt to understand and distill how creativity and the practice of mindfulness intersect. He defines mindfulness as "the awareness that arises through paying attention in a particular way: on purpose, in the present moment, non-judgmentally."[3] Let's take some time to unpack that definition a bit more as we consider how this can be applied to creative realms.

This definition suggests first that mindfulness is awareness, and the way in which we cultivate that awareness can be varied but must be intentional, not by chance. We could choose to pay attention to the present moment through movement like we do in practices such as yoga, tai chi, or mindful walking, or we could choose to pay attention to our breath like we do in traditional meditation. Creative mindfulness is simply another pathway to awareness, another way for us to observe the present moment with intention and without judgment. This may sound easy, but the practice of actually checking in with and paying attention to our inner worlds at any given moment is something many of us have become quite good at not doing for most of our lives. We have been taught to supress and ignore our feelings, bodies, and the world we live in. Sometimes

it feels like modern society would prefer if we were just floating brains without the burden of a body or connection to our surroundings.

I want to give you a practical example right now of what it means to intentionally pay attention to the present moment. Just take a moment and cast your awareness to your hands. Notice the difference between your two hands and see if one seems to be asking for more attention than the other. Now, close your eyes and see if you can spend just a few moments with one hand, feeling it from the inside out. Resolve to give yourself a few minutes to feel it; for some, this will come easier than others. What does the inner world of your hand feel like? Are there any sensations? A temperature, a tingling, a way in which it expresses itself? Does your hand want to move? You might not be able to articulate it, but just see if you can feel it and notice it. Can you imagine the shape, color, or texture of this inner world? Imagine the internal feeling of your hand in your mind's eye. Stay with it for a little while and follow its inner experience as long as you can.

When was the last time you noticed the private world taking place inside of your hands? For many of us it may be never, or not recently, unless we are meditators or have experienced some physical injury to our hands that has required us to pay attention. Most of us roll through our days not paying attention to our hands in any way. We let them type, touch, steer, make, gesture, and care in virtually every moment of the day with little attention. In this experience, we not only paid attention to our hands in the present moment on purpose, but we also encouraged ourselves to express this inner feeling through creative means. We brought color, shape, and line into our imaginations as a way of making sense of it.

Every time I do this little activity it is amazing to me how many people aren't able to report verbally the feelings and sensations taking place inside of their hands. I often will hear people say things like "it's hard to describe" or "I can't really find the words." But when I ask them to notice it in terms of color, texture, and shape, they are immediately able to, and in many cases are able to translate this to a page using pastels or markers. This internal world taking place inside of our hands is happening at any given moment, and we can pay attention to it on purpose and express it through our creative knowing. If this little world

in your hand is happening all the time without you noticing, what other tiny realms do you have hidden away waiting to be noticed?

Creative Mindfulness Is Purposeful

Mindfulness is purposeful, and in creative mindfulness, we are keenly aware of why we are creating and what the purpose of our expressions is all about. This means that before we create anything, we must first be clear about what our intention is. When we sit down, are we working toward an end product, do we have a goal in mind, or are we simply creating with presence? Is this about making something for others to appreciate, to advance our skills, or is it about honoring our deepest desire to create and express ourselves? It's this distinction that can help us cultivate mindfulness in our creative pursuits.

Before we go any further, let me say that it is perfectly fine to have an idea in mind and work toward bringing it into this world; that's simply different from what we are seeking in a creative mindfulness practice. Many of us are always going to have a part of our creative practice that is about making something beautiful that showcases our own unique ingenuity as creators. There is no problem with this; in fact, we will explore this in more depth later when we learn about the idea of having two arms in our creative practice. We don't need to give this up. The practice of creative mindfulness is something else entirely that we use for a completely different purpose. Think of it like this: sometimes we go for a walk with no particular destination or plan in mind, and other times we have a specific place to go or a specific plan. The experience is different despite the fact that we are still walking in both of these scenarios. There is a time and a place for both. This type of creativity is about being clear about what your intention is from the start, just like you are when you go for a walk.

When we practice creative mindfulness, it means we make space for creativity that is different. We create to enter the present moment, or we create seeking new perspectives and awareness. We watch our paint move, noticing textures, shapes, lines, colors, and tensions at play. We pay attention to our creative impulses. We offer attention to our sensory experience as we touch and explore the various strings, paints, chalks, pens, and other mediums. How do they smell, sound, or move? We notice our thoughts, our emotions, and the stories

that come to mind. In short, we work to be present with what is in the unfolding moment in our creative practice. When we bring this attuned presence to our pursuits, we can choose to have it end here, or we can look at the products we create and see if they can offer us greater perspective and awareness.

This shift around purpose has been the greatest transformation in my life, and I have seen it impact so many others in the same way; it frees them from the tension they feel between wanting to create and always feeling like what they make isn't good enough. When I look back on my own life, I can see how my struggle to create with purpose caused me so much unhappiness. In my younger years, I was always engaged in something creative, whether it was theater, sketching, writing poems, or painting. From the outside, I looked like a creator; the truth is, I was scared that the things I made weren't good enough, weren't pretty enough—that I didn't have talent. I would jump from pursuit to pursuit, but nothing stuck. Deep down I was sabotaging myself. I was seeking perfection and praise, and when I didn't get it, I moved on to the next pursuit, never quite fulfilling the need to create that was deep within me. I was never able to find satisfaction because I was coming at creativity from a great deficit. My purpose, to fill my ego with something beautiful, something that qualified as "artistic" in society's eyes, was misguided.

It wasn't until I realized that creativity transcends the ego, that it's just as important as our breath and essential to being human, that I finally felt creative. I came to my pursuits with a new purpose. I began creating in a way in which what I produced didn't matter. I completely let go of the idea of perfection, art, and beauty. This required me to completely surrender everything the world has taught me about creativity. I began to do what I call holding space for myself, honoring, first and foremost, that my creativity is something sacred and connected so deeply to who I am that it transcends applause and judgment from others. As we work toward the pursuit of creative mindfulness, we must keep our purpose in mind and find our own reasons for why we create.

Creative Mindfulness Happens in the Present Moment

When we think of the present moment it can seem so obvious and simple that we overlook the significance of it in our everyday lives. We recognize that things

can shift or change in a moment, but we don't often think about our role in how that shift takes place. Mindfulness helps us to observe ourselves in the present moment, and the more we observe ourselves and watch the moment unfold like a movie on a screen, the more we realize that we can begin to choose how each scene plays out. Let me share an example from my own life that illustrates the significance of the present moment to this drama of everyday life.

My son was in a winter sledding accident that required an emergency trip to the hospital. As we drove, I was calm and collected, helping my son each step of the way, but this was not my first reaction. My initial response when I saw my son injured was fear and panic. It was bad. I can remember the moment when he looked up at me and saw my concern. It instantly fueled his fear, and for a few moments, things escalated. Thankfully, I noticed my role in this and realized that I needed to be calm so that he could feel safe. In the end, I managed my initial terrified reaction and, through a lot of breathing and intention, I stayed calm.

Cut to two weeks later: my family and I were headed to the airport. I was a panicked mess. We were leaving the house 15 minutes later than I had planned, and I was angry and anxious and couldn't resist the urge to bring everyone around me into the same state. This was not a fun drive to the airport for anyone despite the fact that, in reality, we had ample time before our flight. Afterward, my husband gently brought my attention to the stark contrast in my reactions to both situations. One situation was much more serious than the other, yet somehow, I was able to manage my reaction in the serious situation and not in the insignificant one. So, what was happening?

Our reactions to life vary from moment to moment. Our world is constantly changing, and as we experience each moment, we are often responding to whatever happens. Some days are predictable and manageable for us, other days throw us all kinds of challenges, and others offer nothing new or challenging yet, somehow, we just can't cope. Moment to moment our experience of living is constantly changing. Mindfulness helps us see that we have influence over how we respond to each moment; we can react, or we can bring purposeful attention to the moment and choose how to respond.

In the situation with my son, I noticed my reaction and made a choice to be calm. On the trip to the airport, I was lost in the trance of my reactions, totally unaware that I could choose a different approach to being late. The only

difference between these two situations was my purposeful awareness in the present moment. Being aware of the present moment in our creative practice strengthens this muscle of awareness, allowing us to take this awareness into other parts of our lives.

A moment in time may feel fleeting and minuscule but it is actually where everything happens. There is no other place where life is lived. Our lives are, in effect, a series of unfolding moments, a string of beads, one after another, threaded together. How many of these beads do we actually slow down for and touch? In other words, how many of the moments in our day do we bring our purposeful attention to? For many of us it's not many. We are often lost in our thoughts and reactions, preoccupied and unable to notice or bring purposeful attention to our lives. For many of us our moments are spent worrying about something in the future or ruminating on something long past.

In creative mindfulness we are intentionally observing the present moment and noticing our reactions and thoughts, observing them almost like a movie we are watching of our lives unfolding. The creative products we make are little remnants of these moments that hold symbolism of what took place and allow us to push pause and reflect back to see what was happening. In this way the final product does matter, but only in the context of the story of how it was born. When we create this way, we aren't just making things; we are unearthing little parts of ourselves from deep within and bringing them out into the light where we can touch, hold, and inspect them with open curiosity.

Often, when I am working with a client, I will envision that they are using the ritual of art-making to unlock a hidden doorway inside of them, going in for a moment, grabbing a small treasure, and then bringing it back for us to explore together. In Jeff's case, it took the form of Godzilla. For me, it's the photos you see at the beginning of each chapter in Part 2 of this book. You, too, will create things on this journey that are echoes from moments passed. Consider these as artifacts from a present moment long gone, ready to guide you on the next steps of your journey.

Creative Mindfulness Is Non-Judgmental

The final part to Kabat-Zinn's definition of mindfulness is that we do not judge the purposeful attention we place on the present moment. This condition of

mindfulness is often easy to understand but hard to change for many of us. Being non-judgmental means that we are resisting the urge to label, make sense of, and make up a story about whatever we are experiencing. Think about the last thing that you created. Chances are that while you created, you offered yourself constant narration, talking about what was good, bad, working or not working, where it was going, and on and on. We are often a judgmental narrator to the story of our lives, and in our creative practice, we can be especially judgmental.

Making judgments and conclusions about our experience is a way that we make sense of and learn from our lives. For example, when we are young, we learn that fire is "hot" and "dangerous"; we are told "don't touch." If we don't listen to our caregivers' words and test this ourselves, we learn firsthand that fire is "painful." Having names for our understanding of things is what orients us to the complexity of our world. Imagine, though, if we only understood fire as a bad thing, if we cut ourselves off from experiencing its warmth, glow, beauty, and usefulness. We would be cutting ourselves off to so much—in fact, more than we could comprehend.

We have all experienced the world this way. We were taught that things were good and bad, right and wrong, and as we got older, our brains began to do what they are primed to do—help us learn from experience. Thank goodness for this because our mammalian capacity to remember and learn is what keeps us from danger and allows us to influence our world. We are primed to learn from our experiences. It's part of what makes us uniquely human. However, this accumulation of experience has a double edge. On one hand, it helps us learn from our past experiences, and on the other, it can close us off to the world. We can be tricked into assuming that we already know and understand things, never giving them a second thought. Our brain makes shortcuts and snap judgments about things and, over time, this can make us closed and rigid, unable to perceive the nuance of things. This ultimately kills our curiosity. Nothing is ever completely understood when it is named. The practice of being non-judgmental to whatever is happening in the present moment is a way of softening and opening ourselves up to nuance and subtly inherent to everything and everyone.

I had a profound moment of softening my judgments in a very ordinary moment a few years ago. It helped me understand why I need to intentionally

cultivate this practice in my life. It was late fall when I headed out for a walk with my then three-month-old baby. I popped her into the carrier on my chest, and almost immediately after I stepped out the door, it began to snow. It was the first snow of the year, and my daughter's first experience with snow, ever. She immediately noticed it and was looking up into the sky at this new thing. I don't really know how she was experiencing it; I can only imagine how a three-month-old experiences anything in the world. But as I watched her, I thought to myself that she didn't have fear, sadness, joy, or even confusion. She wasn't dreaming of skiing or dreading shoveling snow. She seemed to be absorbed in the complete sensory experience of it. She didn't even have a name for it. It just was.

She would blink as the flakes stuck to her eyelashes. She sometimes would bounce her head around if the wind threw a few snowflakes on her warm cheek. Mostly she just looked around and watched it fall. She was in a place of complete open awareness and I couldn't help but be touched, and inspired, to think that I could choose to experience this with her in a similar way. I felt empowered in that moment, knowing that I could choose to put away my thoughts, history, stories, and ideas of snow and just be in the sensory experience alongside her. It was an amazing walk we shared together; there was so much peace and stillness as we watched the snow fall. It could have easily gone a different way. I could have rushed through it and been annoyed. I came home and later that evening I wrote a little poem that helped me mark this experience and make sense of the lesson that unfolded in that moment for me. Once again, my creativity was a faithful companion to living a mindful life.

My daughter will eventually need to learn that the snow is cold, and she will need to dress appropriately or risk being chilled. But the layers of other stories and judgments about snow will be of her own making. She will need to decide which judgments are helpful and which ones aren't. She will need to decide if her conclusions are genuinely hers or if they are simply reproductions of things other people and society have told her. In essence, she will create her own story about snow, and I hope that when she does, she will know deep down that she can continue to re-create that story again and again—it isn't fixed.

Non-judgment is noticing the stories we tell ourselves in the present moment and choosing instead to let things be as they are. It is acceptance of

whatever is happening—pain, sadness, fear, happiness, comfort, and so on. We then must be with it in a non-attached way, just as my daughter was with the snowflakes. If we are experiencing pain, we purposefully tune into it by paying attention to what it feels like in the present moment. When we do this, often we find that even chronic pain is still shifting and changing; rarely is our experience of it fixed. What prevents us from noticing this is the story we tell ourselves about the pain; the story acts like a blanket obscuring our vision, showing us only one thing.

Creative mindfulness practices are a container for us, a little petri dish to help us look close-up at our lives and see what grows. We can use it to enter the present moment and see what is, and then notice the layers of judgments and stories that we are tempted to conclude about ourselves. We then can choose to be with what truly is in the present moment and let it tell us a new story. What if snow and cold were joyful? What if my pain was a gift? What if I focus on what is actually happening in the present moment and attend to what is, rather than make up stories about what might or could happen? Nothing is fixed in the present moment. Everything is fluid. Every story is a series of judgments that can be replaced with something else. This is where the magic of creativity is especially relevant. We can literally create a new world. We can harness our imagination and creative impulses to open ourselves up to new ways, new conclusions, and continuously shed our past judgments.

A Vulnerable Act

As we are learning, the creative process integrates so much of ourselves; creating is one of the most integrated things we can do as human beings. What other activity can hold our senses, emotions, body, spirit, relationships, thoughts, purpose, past, present, and future all at once? Maybe not every creation you make will include everything listed here, but likely it will include more of yourself than not. We need to recognize and honor that creating is an extremely vulnerable act. It is all at once a leap and a flag in the ground. We play in the unknown and then claim it as our own discovery. Our hearts are on full display when we create, allowing us to see (sometimes for the first time) ourselves as we truly are, and that can be terrifying.

Creative mindfulness encourages us to tune into this vulnerability and get to know it and befriend it so we can take it to new places. It is a process that helps us to intimately know ourselves, and as we are slowly learning, one of the most natural things we can do with a new discovery is express it. Every great novel you have read, film you have watched, or painting you have seen all touch a human vulnerability in some way. They cast a light on something human, holding it up like a mirror, showing us parts of ourselves and what it means to be human in some way. Our art might not ever be considered a masterpiece, but to us, and those that matter most to us, it will hold this same significance. It will be raw and real and act as a way for us to know and understand ourselves and the world with greater clarity.

If we step into the present moment and touch a vulnerability within us that makes us feel scared and want to pull away, we can think of Jeff. Like him, our knees may bounce, and our eyes may want to look away, but what I have found is that if we can trust the creative process and channel our uncertainty and fear into it, letting it move and flow here, that our fear finds a safe container. Our creative actions can attune us to the unfolding moment and neutralize our fear; they can absorb us, guide us, and show us a new, safe pathway forward.

Trust in the creative process and use it to enter the present moment, use it to bring back artifacts from deep within yourself that offer you new perspectives, awareness, and knowing. It's these actions, creating with this new purpose, that will support you to find stillness and insight in ways that you were never open to before. All you need to do is close your eyes, find your breath, and trust that you will find your way.

4

CREATIVE LIVING

I ONCE HEARD a Zen koan that beautifully exemplifies the journey toward knowing through creative mindfulness. A master poses a question to his student: "When you meet a person who is truly awake, you shouldn't greet them with words or silence, how will you greet them then?" The master's question leaves the student stumped. What can one do except speak or be quiet? In time, and after careful reflection, the student realizes that a greeting can happen in infinite ways through an action like a bow or a smile, through an offering like flowers or a cup of tea, or by demonstrating an open and grateful heart. The master's question is designed to challenge the student to let go of thinking of things in extremes and instead embrace the notion that there is always a middle way, a space that is infinite in possibility if we are willing to let go of what we think we know. What I love about this story is that it reminds us that there are other ways to be, that when we let go of the mind that wants to constrict and differentiate, we find that actions, movements, and spirit can be embodied beyond the realm of thinking.

Our journey toward knowing through creative mindfulness requires us to walk in unfamiliar terrain and take new perspectives, always seeking to embrace complexity and paradox. Creativity isn't something separate from us but rather integrated into every part of our lives, or as I like to call it, creative living. The phrase *creative living* often conjures up alluring and sexy images of a wild-and-free artist holed up in their studio, producing amazing, provocative

things. But this is just an old story about creativity that the world tells us, that true creativity is out there, on the fringes of madness, with twinges of obsession and unrivaled talent, cut off from the rest of the world. Living a creative life is more than this extreme portrait of an artist; it's a perspective. It's a way of seeing the world that asks us to embrace the mundane in the everyday rather than cutting ourselves off from the world and waiting for a bolt of inspiration to come. It means we are fully integrating our whole selves—mind, body, emotions, and spirit—in our creations, welcoming them all to be expressed freely. Creative living means we embrace imagination, playfulness, and curiosity. It means that our creativity is an ally, a resource, a tool to be utilized in all aspects of life.

The business community has caught on to the benefits of creativity. Take a moment, and just google "creativity books" and you will be inundated with books on how creativity can give you an edge in business and corporate ventures. These books get it partly right: yes, when we embrace creativity in our work and problem-solving it has tremendous benefit. But they are missing the full story. What about our spirit and bodies? What about our relationships with other people and the planet? Creativity isn't a resource to be extracted from us, or simply a tool of productivity; rather, it's an innate part of what it means to be human and thus lives in an integrated way within us. Creative living means we pay attention to our world in both the micro and macro sense. When we welcome this insight into our full selves, we can transcend productivity and even thought itself.

The western world has conditioned many of us to think of the world in binaries, asking us to conceptualize things in two separate boxes—you are either this or that, one thing or the other. You like the Beatles or The Rolling Stones, you are a Republican or a Democrat, you are male or female; we find examples in every part of life forcing us to enter a dichotomy. This reductionist type of thinking flattens the nuance of life, robbing us of the broader spectrum where most of life occurs. We may be awakening to how destructive this type of thinking is in many parts of our lives, but many people still approach creativity and art making with this flattened either/or type of approach. We start by declaring ourselves as either a creative person or not, applying a label that defines everything we do afterward. Then we conflate creativity with art and reserve the word *artist* for professionals who have "made it," leaving everyone else to the title of *hobbyist* or *crafter*. Popular influencer culture has taught us

that the purpose of creativity is to make something good enough to sell; if it's not, it should likely be trashed or hidden away. You either take classes to cultivate your skills or go to paint night because "anyone can do that." We have been taught to compartmentalize our creative impulses into tidy boxes that do little to serve us and mostly work to define and limit us.

In the real world, life plays out in varied directions, if we pay attention to it. A few years ago, I was teaching a class in creative mindfulness. What I saw unfold in this class was students finding varied pathways, each of which led them toward greater creative living. Jordan was a formally trained artist who came to me in a bit of a funk. He found himself out of practice after becoming a parent and couldn't find his way back to creating. Whereas Sharon was someone who routinely found herself creating for reflection and insight, having worked with an art therapist many times, and often creating in her art journal to support her mental health. At the end of the class Jordan found himself completely in awe of the transformative power of creating without needing it to be beautiful, while Sharon left my class with a newly stamped application to art school and a goal to formally build her creative skills in visual art. Both students were in the same class, but each found completely different outcomes. Each student entered a process of finding stillness through art allowing each to emerge on the other side more committed to living a creative life, but in different ways. I was thrilled that both found the relevance of doing what I call *creating with the two branches of practice*, an important concept to understand if we are to live a creative life that walks the middle way in all its abundance.

Growing Two Branches in Practice

Think about being a strong, rooted tree with two branches in your creative practice. One branch grows toward creative knowing offering insight, healing, and awareness, whereas the other grows toward exploring beauty and skill in your chosen mediums. Each of these branches ultimately serves to nourish and support the tree; each is a part of your overall ecology that helps to keep you nourished and growing. There is little doubt that the world is dominated by, and prizes, the branch that helps you to cultivate skills and learn new techniques. This branch seeks accomplishment, artistry, and competence. Your

other branch is purely about expression—helping you to connect to a creative place where you go to explore feelings, emotions, your body, your needs, and desires. This branch is all about having a sacred place where you can express yourself through your art and make sense of the world. It is tempting to let this conceptualization fall into the binary trap, but the branches come from the same source—you. The branches influence one another, sometimes sharing and informing each other, always growing from the same source. When you recognize the way both branches feed and nourish you, that they are extensions of your core self, you see that creativity isn't an either/or type of activity but a practice that inhabits the middle way, integrating a wide expanse of being.

The intention behind each of these branches is completely different but many people will conflate the two and get frustrated. They want to express, but they get caught up when their skills fall short of their expectations. Or they want to learn new skills but feel flattened and uninspired in their creations. Each branch serves a purpose and can work together to feed us, reaching and growing toward new heights, but we need to hold space for each. Think of a child learning how to speak first, then later to read and write. These are skills they learn to help them express their inner experience, but to think that you must have words to express yourself is silly. Expression happens with or without words as the Zen koan at the start of this chapter so beautifully demonstrates. Your creative expression can unfold like this as well. You can take a class refining your skills and find that it helps sharpen your capacity to express a difficult emotion. Or you can take a difficult emotion into that same class and use that as a point of entry for testing your skills.

As we approach each day with our intention toward living a creative life, we need to allow both branches to grow and hold space for the broad spectrum of creativity, not let one dominate the other. We must seek to integrate our whole selves—body, mind, and spirit—and greet the creative process with actions of love and tenderness as we listen patiently for the lessons to take shape.

Essential Practices Before You Begin

In the past you may have tried to embark on a journey like this and found yourself tripping on your skills, wanting to make something beautiful, or even

overwhelmed with feelings and uncertainty. The creative process rarely follows a predictable path (that's what is so exciting about it), but before you jump in, you can do some things to support the proper conditions for it to flourish. I would like to offer you a series of practices that you can use to anchor or ground your creative process and, and in doing so, I hope to touch off a domino effect that helps you to stay on the path of creative mindfulness. Each of these practices support one another, helping to cultivate habits and establish a framework that primes us to feel safe and secure as we create in this new way. They will serve as a guide for how to approach each of the creative invitations in the second part of the book, but you can also build them into your own creative practice generally. These are all suggestions; I recommend taking each one and playing around to make it your own. Think of each one as a helper, or a nudge in the direction of creating toward knowing, but the ways in which you choose to enact each is completely up to you. As you begin each creative invitation in Part 2, you may want to come back and revisit the following points to help you make sense of how to best approach the process.

Practice #1: Create a Ritual

If we begin our creative process with a ritual, we are signalling to ourselves that we are moving into a different space, that we have left normal life and are now stepping into something special and sacred. Marking space and transitioning from one world to the next through a ritual is something that human beings have been doing for as long as we have existed. Rituals surround birth, marriage, and death across the world and many cultures mark the transition from one thing to the next. We note a transition in a similar way, from a mundane moment to an intentional one, but a creative ritual doesn't have to be so complex or spiritual. It can be simple and personal, just a series of actions that you do each time you create, signaling that you intend to step into this creative space differently than you would regular life. For some people, it might be that they drink a cup of tea, or begin by taking a few grounding breaths; others write a quick poem, or even start with a journal entry to help express what's going on for them in the moment. Your ritual might be a special pair of slippers or going to a special space in your home, lighting a candle, or setting out a beloved object. My own personal ritual includes beginning with a short breathing meditation

and movement to rhythmic music. It doesn't matter what you do; it just matters that you mark the space as sacred and special the same way each time. Your ritual draws a line in your life in a way that helps you delineate that you are now holding space for yourself. Doing this routinely will help you notice your thoughts, soften your attachment to creating something that needs to be skilled or beautiful, and keep you grounded as to why you are creating.

Practice #2: Arrive

Begin each creative process with a simple activity to attune to the present moment. Throughout the creative invitations in this book, I provide suggestions for simple creative meditation practices that can help you transition to a state of deeper awareness and savor the sensory experience of the moment. Simple actions like mark-making, moving to music, focusing on something in your environment, and so on all help you to tune into the present moment and connect to a spacious feeling of awareness. As you become more versed in your own practice you will discover your own unique ways to arrive; feel free to experiment and play with what works for you. Think of arriving as a way to prime yourself for the creative process helping you to tune into a broader awareness, if even for just a few moments.

Practice #3: Set an Intention

Our broad intention is to create toward knowing and insight, but each time we sit down to create, we can make a smaller, more-specific intention that speaks to what we want to explore in the moment. It's helpful to examine what it means to set an intention as it can become confused with having a plan or a checklist of what you would like to achieve. The Latin origin for intention is *intentionem*, which means "to stretch out" or "lean toward." In Middle English intention went on to mean "heart, mind, and feelings," so when we set an intention, we are stretching and leaning our hearts, minds, and feelings in new directions.[1] Think of an intention not as a goal to achieve but as a place to move toward. You may want to ask yourself, "What do I intend to lean or stretch toward today?" You can't check an intention off your list. You can only feel the movement toward it. Maybe you intend to notice your body as you create or pay attention to the lines in your work. Perhaps you intend to notice your thoughts as you create or want

to explore a specific feeling or emotion you have been experiencing. Begin with setting an intention knowing that it will point you in the direction you want to grow. Your intention can take the form of a silent thought, you can write it out in a journal, or you can even share it verbally with someone. At the end of your process revisit this intention and see if you can feel any movement or growth toward it.

Practice #4: Ask a Question

As we are seeking to know ourselves and the world with more clarity, our creative practice should feel like a place we can go for answers. If we begin our creative process by asking a question, it helps us to focus and bring our reflective energy into it. Sometimes our questions feel charged and desperate: "What should I do with this anxiety?" Other times they may feel more steadfast and patient: "How can I be more compassionate?" Before we create, if we write out a simple question that we want to explore in our creative practice, we will find that we have primed ourselves into a process of inquiry and insight. This is different from our intention to lean and grow in new directions; our question is born from our needs in the moment. It allows us to bring our tensions and uncertainties formally into our creative practice and find answers. Simply ask yourself, "What do I want to know right now?" Write out the question and then, at the end of your process, loop back to the question and see if you have any new insight or clarity.

Practice #5: Notice Your Impulses

When we create mindfully, we are creating in an embodied way, integrating our senses, minds, emotions, and bodies. Our inner world becomes something we can see in our actions, made visible as we express it. For example, our inner feeling of fear becomes something we can see on a page or that tightness in our chest turns into a poem. In each of these transformations we notice what is happening in our inner worlds and then wait for an impulse that embodies it to move the process forward. Many of us have been taught to supress or hide our impulses, that they are bad and need to be overcome. However, our impulses hold a well of information for us; they are the tiny seeds that help nudge us toward embodying or bringing our inner selves out. Our impulses may show

up as a desire to pick a specific color, a quick movement of our hands, the desire to tear, scribble, or perhaps grab something soft or hard for our creation. Our impulses often don't make sense; they come to us as strange whispers or actions. We don't need to interpret them in any way, just follow them. As you create in this way, pay attention to your impulses and welcome them into your process; remind yourself that this is how the hidden parts of yourself become seen.

Practice #6: Trust the Process

The phrase *trust the process* has become a sort of cultural mantra over the last decade, and with good reason. The wisdom behind the phrase has broad application to many areas of life, including creativity. In the creative realm, trusting the process is a way of surrendering control, of reminding ourselves of the unknowns and subjectivity inherent to the process. It's a way of recognizing that there are so many variables at play that we can't possibly know or manage, so we employ faith in the process above all else. In the seminal book *Trust the Process: An Artist's Guide to Letting Go*, Shaun McNiff wisely reminds us that, "Creativity is a force moving through us, and only through practice do we learn how to cooperate with it. The 'process' is like a muscle. It needs to be exercised in order to function effortlessly."[2] In this way, we remind ourselves to trust the process, that we are practicing cooperating with the unknown, building our muscles of being with uncertainty, and in turn, we are allowing so much more to emerge than we could ever do through thought alone.

Practice #7 Multiple Mediums

As you progress through this book you will notice that we are exploring creativity in the broadest sense, always utilizing multiple mediums in our creations. For example, we will be moving in between drawing and words, movement and color, and using objects and symbols. As we work toward opening ourselves up beyond the binaries of life and move into the juiciness of everything that lies in the in-between, we find that our capacity for expression expands enormously when we offer ourselves more tools. Each artistic medium unlocks different parts of ourselves giving us access to more tools of expression, and when our pallet for expression is bigger, we can say and understand more. Each medium speaks a different language, and what you will discover is that the mediums

speak to one another. The language of color says things differently than the language of movement, shape, textures, or words, and when shape speaks to color, well that's when we find ourselves in the realm of creative knowing! It may be uncomfortable for you to write a poem if you are typically a visual artist, and it may feel weird to find objects or move your hands as a way of expressing an emotion, but as we trust the process and anchor ourselves to our intention, we realize that these other mediums help us on our path to knowing. We don't need to be accomplished in them; we are giving ourselves permission to be curious and explore how they can support us on our journey toward knowing as they give us more tools to express and expand our language.

Practice #8: Write

In each creative invitation I will ask you to write in some form. It is important to remember that your writing doesn't have to follow any conventions, from school or work or elsewhere. Correct spelling, grammar, proper punctuation and the like are not necessary. The purpose of writing is to help you further distill and discover the essence of what you are uncovering. At times you will be asked to give your creation a voice or engage it in a dialogue through the written word. Other times you will give your creations a title or name, and often I will ask you to write a poem or journal about your experience. Please leave your own personal history with writing, good or bad, at the door, and remember the writing here is about expression, not perfection. Your writing may be silly, make very little sense, be messy, and come together in bizarre ways. Welcome this. The writing you do is a chance for you to begin to give voice to the process and all that it has uncovered for you. As you write, let the words flow without judgment or criticism. Resolve to fill a page in prose and see what emerges or to write a poem that doesn't rhyme or follow any convention.

If writing feels uncomfortable or scary, set a special intention to remember that it is an action helping you to discover your voice, a chance to let your creations speak to you and through you and to help you find insight. Trust your hand to begin writing even if you don't know what to say. You may even find yourself writing about how you don't know or even writing "I don't know" again and again until something comes. In each writing prompt I have included a small poem, or a sample of my own creative writing, to help you see how simple

and abundant this can be. Those examples are very different from the edited "book" writing that you're reading now!

You may discover or know already that writing is something you value; in this case you may choose to expand your writings into stories or pieces of creative nonfiction. I have done this throughout this book, as well, in my personal reflections. Let your writing take you where it needs to. I promise, as scary as it may seem at the start, the insight you find through it will be immeasurable!

Practice #9: Share Your Experience

Sharing our work with others can be complex; after all, creativity is an incredibly vulnerable act. The purpose of this type of creating isn't to share it for admiration, scrutiny, or feedback; rather it's a way to have our insights known and witnessed by others. Sharing our creations helps to make the insights they hold real, allowing us a chance to integrate and synthesize all the richness we uncovered in the process. When we show our creations to a safe person and tell them about what we discovered, or what happened to us in the process, we are, in a sense, engaging a witness who can acknowledge the significance of this creation in the context of our whole selves. In a way, it's a final act of recognizing and respecting this part of ourselves that knows through art, which in turn encourages it to continue growing. Having a goal to create a body of work to formally share is great if this is something important to you, just as sharing on Instagram or Facebook can also be great if it feels safe, but nothing will replace sharing our creations in the flesh with someone we trust. We need a safe witness, a trusted person we can tell about our creative experience and share our completed products with. You will know this person is safe because they have agreed to not offer criticism, value judgments, or advice, but rather just to listen with curiosity and care. It might be a therapist, your partner, a close friend, or perhaps someone who is progressing through this book with you. Support and community will be key for you, so plan to identify your safe person or persons in advance. At the end of each of our creation invitations, I will encourage you to find a safe witness to share it with. Don't underestimate this part of the process; for many, this functions as an incredibly powerful act in solidifying their knowing.

This isn't an exhaustive list of practices but rather a start, a place for you to begin delving into creative mindfulness and moving toward knowing through your art practice with safety and purpose. As you become more comfortable creating this way, you will start to recognize which practices are most important to you and which ones you can tweak or change to better meet your needs. With each of these practices in place, as well as an understanding of creative knowing and creative mindfulness, you are ready to begin your own creative process toward knowing and insight. My hope is that the lessons, stories, and creative invitations you are about to embark on will help you bring warmth and compassion to your own holes and bring you a deeper connection to and stillness with a world so in need of your presence.

PART 2

Meditations and Creative Invitations

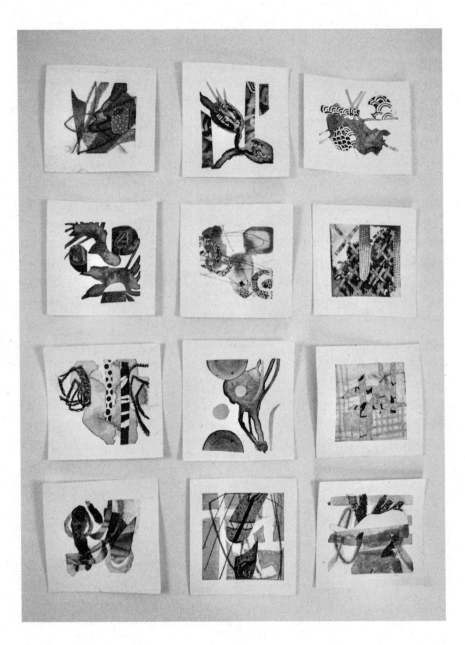

Pandemic Play (mixed media)

5

SURRENDER AND
THE BEGINNER'S MIND

AFTER SIX YEARS together, Daryl and Ellie decided to do something bold and move across the country for Ellie's job. They had hoped that they would find new energy and renewed connection to one another through this change. Instead, they found loneliness, uncertainty, and increasing resentment toward one another. Our work together was initiated by Ellie. She was an artist and risk taker and had heard about me through a work acquaintance. She hoped that I might be able to support her and her partner to "turn toward one another again," as she said. Daryl was amenable to this work but not without hesitation. He immediately told me he wasn't creative but loved Ellie and agreed that they were on a negative path, so he was willing to give it a try for her.

In our first session together, I asked them to take some time to name and share what feelings and thoughts had been prevalent for each of them that week. I asked them both to show me these using shape, line, color, objects, or imagery. Ellie was quick to sketch a messy scene of a flock of birds with black and white scratches, a representation of what it felt like for her to be "pecked at" in the many directions of work, home, and internally. Daryl opted to grab a few art cards full of imagery depicting dark tones and strange figures in isolation. In the last minute he grabbed a toy lion figure and placed it on top of the images. He had been feeling lonely as he worked from home and missed the strength and energy he used to have; the cards represented him now and the lion was

the old version of himself. We spent some time talking about their creations, sharing how they each chose to depict their experiences. As I held this space for honest intimate sharing, I noticed each of them physically turning toward one another, softening, and Ellie offering a gentle touch to Daryl as the reality of their feelings came to light.

Our work together continued to progress in this way, Daryl and Ellie expressing their deepest inner experiences to one another through creative means, and then I helped to hold space for them to share it authentically with one another. It was their willingness to be present, to listen, learn, and be genuinely curious about each other's inner worlds that was the most nourishing thing for them. Instead of being defensive, the couple started to find softness with one another, and I could sense that each of them was able to communicate their inner worlds with more ease and clarity. In time Daryl began to feel more comfortable expressing himself creatively, even admitting that maybe he did have a "creative bone" buried deep down.

In one of our last sessions together I asked them if they would be comfortable with me creating something for them, a creative response about how I had been witnessing them progress through our time together. With open curiosity they agreed and sat back while I worked on creating an installation on their living room floor from the bag of supplies I had brought. On the carpet I constructed a large circle using gold wire, on the outside I laid art cards showing images of pain and loneliness (some of which were the same cards Daryl used on our first meeting). I then added detritus like old leaves, torn paper, broken glass, and as many figures of people as I could find. Inside of the circle I placed two sets of eyes I cut from a magazine. Once I was complete, I told them the title of the creation was "Beginner's Love." I shared with them that this scene represented the shift I had seen in them—a willingness to keep the world at bay and forget all the details and stories, instead meeting one another with genuine curiosity rather than assuming they knew what the other was experiencing. The eyes were symbolic of the new, fresh perspective they had found for one another. Despite their shared history and interconnected lives, they were able to meet one another in the moment, almost as if it was the first time. Daryl and Ellie agreed, and the concept of fresh eyes seemed to especially resonate with their experiences. It was a lovely moment of shared understanding between the

three of us in front of this creation. What they were doing was bringing beginner's mind to their love, letting go of all their history and attachments and truly being with one another in the moment as they were. After about six sessions together our ways parted, but it was clear to me that Daryl and Ellie had found a new skill six years into their relationship, a willingness to listen to one another with open curiosity and find love as beginners do.

Beginner's Mind

At Columbia University a leading neuroscientist offers an undergraduate course called "Ignorance: How It Drives Science." Stuart Firestein's course isn't about admonishing or shaming ignorance; rather it's about celebrating what we don't know and reveling in the questions that propel our knowledge further. Firestein argues that the fuel for good science is embracing a paradigm that acknowledges that the more we learn, the more we realize how little we know. He suggests that it's a fallacy to think we might ever have all the facts laid out before us. Knowledge, as he says, is "an ever-expanding ripple on a pond . . . knowledge generates ignorance."[1] Consider, for a moment, what it would mean for us to embrace this paradigm in the western world where knowledge is king. It would be a truly radical act for us to pride ourselves on what we don't know instead of what we do.

Why is it so rare to see ignorance and our lack of certainty celebrated? Part of the answer may be found in the work of David Dunning and Justin Kruger who, in 1999, published a compelling piece of research that questioned how accurate a person is at assessing their competence.[2] What they found is that, as human beings, we tend to overestimate our knowledge and capabilities, assuming that we perform better at things than we actually do. This phenomenon has come to be known as the *Dunning-Kruger effect*, and it's why most of us think we are above-average drivers and why everyone in your workplace perceives themselves as top performers. In various circumstances, across many fields of study, the effect holds, suggesting that, as human beings, we are deeply uncomfortable with being perceived as beginners, preferring instead to be perceived as experts, even in things we don't really understand or aren't very good at.[3] Perhaps most fascinating is how this research has been portrayed in popular

culture; it seemed to touch on a shared experience that many of us have had in our lives characterizing other people so perfectly—our ignorant colleague, that "know it all" at the party, or our arrogant teacher. But as author David Dunning said, "The first rule of the Dunning-Kruger club is you don't know you're a member of the Dunning-Kruger club. People miss that."[4] We like to think this effect is about other people, but it's actually about us and our ability to recognize what we don't know and be okay with that.

Perhaps it's no surprise that in western culture where expertise, authority, and knowledge are perceived as being the pinnacle of humanity, we feel shame and humiliation in admitting what we don't know. We want to feel competent and confident, to feel status in this world, so we avoid things that are hard and instead overembellish our capacities. Yet, the illusion of arriving, making it, mastery, or knowing all is simply an act of the ego. If we look beyond western culture, we see that this connection between knowing and worth is cultural by design. For example, in most Indigenous cultures the status of an elder is paramount and the community understands that there is no fast track to becoming one. Instead, it takes time, humility, and a lifetime of experience to be considered for this level of stature. This means that most of the community sits in a place of not knowing, learning, and seeking the wisdom and guidance of elders to help them navigate the world—a vastly different arrangement than what currently happens in western culture.

We live in an age where expertise has become flattened and confused. The internet, increasing education levels, and our interconnected world have democratized knowledge, making it readily available to all. At the same time, the role of experts has become increasingly more important as we seek solutions to the climate crisis, pandemics, and political unrest. We need the wisdom and guidance of experts more than ever, yet as David Dunning reminds us, if we don't see ourselves as part of the group with much to learn, and instead see ourselves as experts who know it all, than we are, in fact, living in a false reality. Perhaps the real sign of expertise is humility, for as we find, the deeper we go into any area of the world, the more we realize how little we know about it. Artist and author Austin Kleon offers a Dunning-Kruger Prayer that perhaps best summarizes how we can relate to our ignorance, "Let me be smart enough to know how dumb I am and give me the courage to carry on anyway."[5]

The mindfulness principle of beginner's mind helps us to find comfort in experiencing the world fresh and anew, recognizing that there is no end destination at which to arrive. It allows us to befriend the infinite, recognizing how little we know and how vast and flexible the world is. Famed Zen Monk and Teacher Shunryū Suzuki, who is credited with bringing Zen to the western world in the 1960s, famously said, "If your mind is empty, it is always ready for anything, it is open to everything. In the beginner's mind there are many possibilities, but in the expert's mind there are few."[6] Many of us have had the experience of marveling as we watch a child puzzle through a moment, freshly learning how their body moves as they first climb a tree or how they explore the laws of physics as they balance blocks. Children live moment by moment without the burden of expertise, and in doing so, also find unparalleled creativity and innovation. They live in the realm of curiosity, trying new things out and constantly welcoming new people, ideas, and activities. Over time we begin to accumulate experience and knowledge and we begin to feel like we know how things will unfold and how the world works, leaving this open, fresh approach to the world in the past. Beginner's mind is an invitation to reclaim this perspective and see things once again with an open mind and fresh eyes, just like a beginner would.

There is a poignant story that the founder of Judo, Kanō Jigornō, a master in this field of martial arts, asked on his death bed to be buried in his white belt. His request was symbolic of leaving his mastery and status behind, instead opting for the emblem of a beginner to carry him into the next realm. As George Leonard suggests in his retelling of the story "Kanō's request . . . was less humility than realism. At the moment of death, the ultimate transformation, we are all white belts. And if death makes beginners of us, so does life—again and again."[7]

Holding the perspective of the beginner's mind doesn't negate what we know; instead it recognizes all that we do not know, allowing us to be students of life as we seek to release ourselves from the bondage of our insecure egos and instead be with what is. The reality is that this is our first time being in this exact moment, no one has ever been here before, and so we must approach it with curiosity so that we don't miss a thing. In the example of Daryl and Ellie, when they looked at each other with fresh eyes, willing to set aside all that they thought they knew about each other, they each felt seen and met with love. If

we approach life, each other, and the task at hand humbly as new students, we may find ourselves again like a child—open, receiving, and uncovering new things in the moment we would have otherwise overlooked.

Original Seeing and Creative Expression

It may feel like a daunting and abstract concept to approach life with beginner's mind, but as with any intention, we can begin small and cultivate our practice bit by bit. Beginner's mind is just this—a practice, a way of reorienting our attention and surrendering our attachments as we relish being in the unknown. If we treat the creative realm as a place to practice, bringing fresh eyes and an unattached approach to the moment, we will begin to find greater ease in this approach as well as more inspiration. In fact, many of the obstacles or challenges that folks struggle with in their creative pursuits can be remediated through beginner's mind. A lack of inspiration or ideas, struggles with confidence and perfectionism, and a need to build skills can all benefit from surrendering our attachments to how we think things should be, allowing us to call forth fresh eyes to guide us instead.

In the classic and abundantly wise book *Zen and the Art of Motorcycle Maintenance*, author Robert Pirsig tells the story of trying to help one of his university students who felt they had nothing to say in an essay. She wanted to write five hundred words about the United States. At first Pirsig advised her to narrow it down and just choose the city of Bozeman instead (the town where they lived). She went away and returned, still stumped, overwhelmed at how vast the task felt. He then counselled her to just write about main street, but again she returned, still at a loss. Finally, he suggested "Narrow it down to the *front* of *one* building on the main street of Bozeman. The Opera House. Start with the upper left-hand brick."[8] The next day she came back and handed him a five-thousand-word essay. She said she went to the opera house and began looking at it brick by brick and ended up spending all day in front of it writing; once she started, she couldn't stop. Marveling at this dramatic shift Pirsig later decided that his student was practicing what he knew as "original seeing." He believed that she was stumped before because she couldn't think of anything worth repeating about the topic. But when she went with her own eyes and

experienced the building for herself, she didn't need to repeat anything, she was experiencing something on her own, and as Pirsig says "the more you look the more you see."[9]

This story of original seeing is beginner's mind in action; instead of approaching the task with a plan or assumptions about how we think it will come together, we can let the moment lead our process. In this same way any creative endeavor can be broken down "brick by brick," a painter or photographer may choose to work only in one color or explore only the shape of an object, leaving all other details to the side. A potter may let the clay dictate the vessel rather than vice versa, or a musician may focus only on one tone, playing within its bounds to find a new song. In each creative instance we begin by recognizing the infinite directions that can be taken, and instead of letting that weigh down the process, we create a process that is free from the burden and pressures of becoming something, instead taking our direction from the moment.

One of the best ways to do this is by intentionally asking ourselves questions about what we know and don't know in our creative process. We can focus on finding a question or a "what if" to drive our process. A good way to start this practice is to begin each creative process with a question, clearly naming something we don't know or understand and allowing that to shape the process. This may be something as simple as "I wonder what happens when I mix these two mediums?" or something more integrated like "I wonder what would happen if I took this joyful experience of watching the rain fall and welcomed it into my creative expression?" We can formalize our position of beginner's mind by taking a few moments to write out what we don't know as a way to anchor ourselves in wonder and curiosity rather than the pressure to perform.

Another way we can practice beginner's mind is by intentionally stepping away from our expertise. You may be an expert weaver but what happens when you dance? What can a painter discover from writing about their creation? Instead of staying in our comfort zone, we can step just to the side and find another mode of expression that we don't know about to integrate into our creative process. Pushing the limits of our creative expression into new territory may be scary as we leave our competence and experience at the door and remember what it feels like to be a beginner once again. It may be a deeply uncomfortable prospect to let go of the skills, mastery, and the expertise we

have grown accustomed to having, but in the spirit of living an abundant life, we must intentionally cultivate spaces in which we let go of what we think we know and dance and play in the unknown, loosening the veil of knowledge on ourselves. In doing so we may find a new energy, fresh eyes, or a more joy-filled approach to everyday life as we remind ourselves of the illusion of knowing, recalling that each breath is a new one to behold, one after another, until we finally reach the last frontier of death.

A Boulder without a Name

In the gradual warming of the spring sun, I sat in my backyard underneath a twisted apple tree, reading. I was content in my recently purchased home and new marriage, feeling that I had finally arrived in a life I had chosen for myself. The apple blossoms were just starting to burst, and the tree offered the perfect canopy. It was idyllic, the perfect backdrop for a life-changing event to unfold. Hollywood doesn't like to show this sort of drama; it's much too mundane. There wasn't going to be birth or death, no melodramatic lover's quarrel, no tornado barreling past. Rather, it was a simple moment when a story came into my consciousness, shaping my language, my experience, and the trajectory of my life forever. One story, from one book, read in one regular day under an apple tree, and I was forever changed.

I was newly learning about Zen through a book called *Nothing Special* by Charlotte Joko Beck and it had been a pleasant read so far. Then I read the chapter titled "Sisyphus and the Burden of Life." In it, Beck tells the ancient Greek story of Sisyphus, a man who had managed to cheat death twice, angering the gods. As a result, he was sentenced for eternity to push a giant boulder up a steep mountain, and each time he reached the top, it would tumble back down to the bottom and his journey would begin all over again. Sisyphus was to be locked forever in an endless struggle of pushing the boulder up the hill and then watching with heartbreak as it rolled back down. Often, in retellings of this story, we are made to think of him as a victim, being done to, a man without agency or a hope of changing his circumstances.

Many of us can likely see ourselves in some version of this cosmic struggle, trying to hold on to the good stuff and feeling defeat when we find ourselves not

where we want to be. For me, at that moment under the tree, it seemed that for my whole life my eyes had been trained to the top of some mountain, believing that if only I could reach one more milestone or achievement, I would have finally made it. There I was, at the top of a mountain, as I sat under that apple tree feeling like I had arrived, but it was only a matter of time before I found out that the house, marriage, safety, and security of feeling that I had arrived with were fleeting and all about to disappear. I was at the precipice, right before the first of many dramatic tumbles I would take down the hill in my life.

I recall the philosopher Camus's essay about Sisyphus in which he suggests he is teaching us about the absurdity of living and that "one must imagine Sisyphus happy" as he surrenders himself to the chaos of life.[10] Yes, perhaps when the hurt and resentment pile too high and our lives collapse under the weight, we can just choose happiness. There is power in this message to be sure, that one can simply choose to be happy in the face of whatever comes our way. But Beck's interpretation of the story was something different, a message I had never heard before. She was suggesting that it's not simply a matter of choosing to be happy in the face of suffering, but rather resetting the whole game the gods have set up for us. Instead, she suggests that we can use our free will to not get caught up in the hope of reaching the top or reeling in the disappointment of the boulder falling back. Rather, we can consider that, "Like Sisyphus, we are all just doing what we're doing moment by moment. But to that activity we add judgments, ideas. Hell lies not in pushing the rock, but in thinking about it, in creating ideas of hope and disappointment, in wondering if we will finally get the rock to stay at the top."[11]

And with those words, the story took hold of me, becoming a constant companion in my life—a support asking me to stay with the moment, to avoid projecting too far in advance about how I thought things might be or should go. And instead, I could see the inevitable ups and downs of life as just that—life. No slight to my husband, sons, or father, but in that moment, Sisyphus became the main man in my life. A voice on my shoulder, a wedge in my thoughts, and the fuel that helped me make it through another day. On the days when it feels hard, like the boulder will never reach the top, I catch myself calling the burden "heavy" and instead remember that this is merely a judgment, a clever attempt at trying to escape my life by thinking that it could be anything other than what

it is. I tell myself, "This is it," and I remember this is my life right here and now, everything else is supposition.

Sometimes I imagine Sisyphus in my ear as I prepare Christmas dinner or plan a special night out with my husband. I hear him say, "Be careful, this will never go as you planned, enjoy the preparation as much as you enjoy the thing." And then sometimes my anxiety tells me to be steady and careful as I push the boulder up the hill, but then Sisyphus gives me that look, and I remember that I am not in control of the boulder; I merely have this moment to revel in what is—will I choose suffering or joy? Sometimes I look at my husband or my children and feel a certain arrogance that I know them so well, that I have arrived at some knowing about them, and then Sisyphus pulls me aside and begins his intervention, reminding me that, "the boulder is about to fall, you can never fully know them. Will you get curious or sad this time?" Sisyphus allowed me to let go of the idea that things are good or bad, or that they should be one way or another. Through this story I have found a freedom unparalleled to anything I have ever known.

Here I am speaking about this all as though I have figured it out, a great irony to be sure. Sisyphus has been a great companion to me for nearly fifteen years now; we have grown comfortable with one another, cajoling and nudging each other along through life. But, perhaps the gods saw my arrogance, because one day the boulder fell further down than it ever had before, and when I went to go push it up in my usual way, its weight had doubled. The global pandemic came knocking at my door and everything I thought I knew about living was upended. The weight of caring for my three young children, of being isolated from my ill father and mother, both in need of care and support, of shuffling the complexities of daily work, feeling burdened with decisions way beyond my expertise, and of losing all my social support, left me feeling crushed. Silly Rachel I thought, Sisyphus has been telling you there is no comfort to be found in the illusion of knowing, and now here you are, reeling in the shock that once again you are a beginner in life.

As the world spiraled off into waves of chaos and confusion, I sat at home and realized that I could either wallow in sadness at the bottom of the hill, or I could try to embrace the uncertainty. Sisyphus was asking me to stay with the not knowing, to resist judging, and to get curious about the uncertainty

unfolding in the world and in my life. My art was a place that the pandemic couldn't touch, a private world where I could practice being in the unknown, feeling like a beginner again, and surrendering comfort. As the days of lockdown and uncertainty droned on, I began to intentionally design a creative process that would have me invoking beginner's mind and relying on Sisyphus to be my coach, reminding me to stay in the moment and let go of judgment.

To do this, I needed to ask my brain to take a back seat. This was not a time for my art to be cerebral or planned out; I needed to let go of thinking and just be. I began playing around with trying to paint my emotions and respond to what was happening around me through poetry, but it all felt too comfortable. I needed to replicate the disorientation that was happening outside my walls inside my art. One day, I turned on some music, started to move, and began to make marks on paper. I used ink, pastel, watercolor, pencil, or whatever I felt compelled to use in the moment. I tried to let each mark be an extension of the movement that my body was doing in response to the music. This sometimes resulted in messy scribbles or scratches, and other times soft colors melting into one another. I then cut up collage papers, attaching bits and scraps of pictures and words to it. It all felt new and somewhat uncertain. I didn't know where it was going, but I knew that was the point.

I kept with this process, just moving, making marks, attaching remnants, and in time, I could see a sort of translation taking place. The music was evoking something in me—movements, color choices, and attractions to textures. I had no idea what the movements were about, which nerve the song was touching inside of me, or where any of it was going. Sisyphus looked at me and gave me a wink—staying with all this uncertainty was right where I wanted to be. I decided to see if I could create thirty mini abstract pieces using this process. But I also wanted to acknowledge the raw emotions that they were born from, the context of chaos and uncertainty I was sitting in. And so, once each image felt complete, I would offer it a response through a poem. Together each abstract piece and poem was my attempt at staying curious with the emotions I was feeling as I leaned into the unknown.

Today, I have seventeen images hanging on my wall, each with a corresponding poem. I haven't reached my goal of thirty and, as I write this, I am still in the midst of the pandemic. I didn't think it would go on for this long,

and I thought my project would be finished by now. "Ha-ha," says Sisyphus, "here you go again, don't forget, this is it, this is your life, be careful, you might miss out on it will all that thinking." Sisyphus and my creative practice came together during a disorienting time of my life, helping me to stay with the now, to become aware of what I was feeling, and to let go of the desire to name, judge, or cling to any illusion of control I had. Amid the uncertainty, mark by mark, I stayed with it. What more could I do with a moment?

CREATIVE INVITATION: MOVEMENT AND ABSTRACT ART

This creative invitation will have you invoking beginner's mind as you explore music and rhythm to make a series of abstract pieces. During this exercise you will be working on a series of three to five pieces, creating multiple images at the same time as a way to deemphasize the end product. Each abstract mark will be an invitation to be curious and resist to urge to judge, arrive, or feel accomplished in any way. Throughout this process you will be noticing your inner thoughts and meeting them with open interest, helping you to cultivate a practice of being comfortable with not knowing.

ARRIVE

To begin this process, take a few moments to connect to music through your body. I recommend that you choose music that is rhythmic in style and that you feel connected to. Drumming, chants, electronic dance, or recommended playlists that feature rhythm are all good places to look for songs. Find a safe space where you are able to move freely. Straighten your back as much as is comfortable and take a few deep in and out breathes, noticing how your breath moves throughout your body.

When you feel ready, turn on the music. Start by just listening with intention and curiosity to the rhythms and flow of the song. If the impulse comes, move your body. You may feel the urge to sway, raise your arms, lift your feet, or twist your torso. This may feel strange or uncomfortable; either way, remind yourself that this is a chance to offer beginner's mind to the moment. Stay with the music and gently allow your body to connect with it in whatever way feels right for the moment. When the song ends or you feel the urge

to move subside, take a few moments to be in stillness, not moving and without sound. Notice the sensations or feelings that this brings up for you.

SET AN INTENTION

Now that you have embodied curiosity, it is time to examine your relationship with beginner's mind more formally. Ask yourself in what ways you can welcome this practice of beginner's mind, curiosity, and non-judgment into this creative practice and formally set an intention. For example:

I intend to stay with curiosity and notice my urge to judge.

I intend to surrender any attachment about how I think this process should go . . .

I intend to cultivate an open and accepting heart, moment by moment, throughout this process.

ASK A QUESTION

It is now time to ask a question related to beginner's mind, curiosity, and/or letting go of judgments specific to your life. There may be an area of your life that you have become complacent in or feel that you have expertise in that you want to explore. Or you may want to let go of comforts and intentionally seek something new as a way of remembering how to be a beginner. Write a question that gets at what you most want to learn from this process. For example:

How can I bring beginner's mind to . . . ?

How do I resist the feelings of not knowing in my life?

Where in my life am I ready to let go of the illusion of knowing?

PREPARE

To begin this process, we want to evoke a mindset in which we see ourselves as a student in life. Start by gathering one or two old magazines, scissors, a piece of paper or your art journal, and a pencil. Ask yourself, "What does a student of life need?" As you flip through the pages and see imagery, ask yourself how this image might be a resource or support for someone seeking to be a student of life. Cut out five to seven images and then paste them on your page; write next to each what the image symbolizes. For example, you may

find an image of a hand petting an animal and write, "Students of life need to slow down and connect with life in all of its forms." Or you may see an image of something strange that you can't identify and next to it, you write, "To be a student of life, I need to stop and notice the strange." Your images and words will be your own visual record of what it means to be a student in your own life.

ABSTRACT MARKS

Now that you have felt a sense of beginner's mind and have prepared yourself with a supportive mindset, you are now ready to begin making abstract marks. Gather a few mediums such as paint, ink, watercolor, pastels markers, and so on, as well as various tools such as paint brushes, sticks, wire, or anything that may make an interesting mark. I suggest that you cut three to five pieces of watercolor or mixed media paper to the same size and tape them down to your work surface. Create a square border around each paper using painters' tape, washi tape, or masking tape. Test your paper and tape combination first to see if removing the tape will rip the paper. Creating the border will allow you to make expressive marks without the page moving as well as offer a frame to hold the momentary marks within once the tape is removed.

Once your paper is prepared, find some music to fuel you throughout this process. You may want to revisit the rhythmic music from earlier or find something new. You will want about 1 hour's worth of music. During the first song just move to it, noticing your breath, movements, and what it feels like to be in the moment with the music.

When you are ready, begin making marks on your paper. Choose one wet medium and one color that you feel drawn to in the moment for this part of the process. Allow the music to spur your body, if you are moving quickly let your marks be quick and fast, if you are slow and melodic let this show up on the page. When your marks are complete you will want to let them dry as you stay moving to the music, or if you like, you can take a hairdryer to the marks to speed up the process. If you choose to do this, be sure to still stay connected to the music and your movement.

Once your pages are dry, use a second dry medium such as pastel, markers, or pencil. Again, let the music dictate how these abstract marks come to the page.

ADD PAPER

With your abstract marks on the page, you are now ready to add small amounts of collage paper. Look at the colors, shapes, and lines and see if you can find a small snippet of a

picture, book, flyer, card, or similar to add into the image. Take your time with this process; notice how your mind may want to insert judgments or thoughts that take you away from curiosity and playfulness. If at any time you feel overwhelmed or disconnected, go back to your question, step away from your papers, and go back to moving to the music.

Once you feel that each of your papers is complete, you are ready to gently lift the tape from the corner. As you do this, notice how the image you have come to know shifts and changes with the white space being revealed. Take a few moments to revel in this newfound sense of wonder at how your image has changed, yet again.

DISTILL

As a final part to this process, choose one of your images that you feel most connected to and write a poem about it. What is this image telling you about beginner's mind, being a student of life, letting go of judgments, or your original question? Let the image dictate the words to you as you stay with curiosity and openness. Begin by writing three to five words that you feel are connected to the pieces; for example, you might write the words *fragmented*, *bright*, *fearless*, *hard*, and *emotion*. Then use those words to begin writing a poem. You may want to take each word and work it into a poetic sentence or simply jump in and see what emerges as you bring the words together. Here is an example poem written in response to an abstract piece created through the same process.

> *Wild, free chaos. A rare moment in time. The boldness of my marks tempts my inner rebel. Perhaps I can let a little of my untamed heart come out to play today? See what grows and try again another day.*

WITNESS

Find a way to share this process with someone you trust. What stands out for you about the experience of trying to evoke beginner's mind or the findings you uncovered in the imagery or poetry? Allow your experience here to be an opening to thoughtfully share and examine the implications of beginner's mind to you in your life. As you share with this other person, see if you can give and receive with an open, receptive mind and heart, continuing the practice of discovery in relationship to one another.

Wasp Paper Wonder (found natural objects)

6

FROM STRIVING
TO STILLNESS

JENNIFER WAS A YOUNG, bustling creative complete with a lovely home and partner, but she also carried a tremendous amount of stress. As a survivor of childhood trauma, she has spent her adult years fiercely trying to heal and overcome her past. She was working so hard at healing; I got the impression it was a full-time job; her pursuit was relentless. After a few interactions with her, it was clear to me that not only was her past trauma causing her suffering, but she was also carrying the added burden of chronic stress as she tried so fiercely to heal. I was always awed at her steadfast dedication but also saddened because it looked so hard for her to just be. It was as though her initial wound was also being tightly bound by the added stress and pressure of working through each new healing venture she took on, from talk therapy to body-based trauma interventions, to medication, to the next new course she found. It seemed that she had a desperate feeling that this must work, it had to. She had spent a lifetime trying to heal, and yet she never felt like she had quite arrived. It wasn't my role to help her heal her trauma (that was the job of her therapist), so I decided to help her find some joy amid her stressful life.

During a class of mine Jennifer attended, I asked the students to decide what they would focus their creative process on. I suggested that it could be a struggle or simply a feeling they wanted to spend time in, such as joy, gratitude, or hope. Jennifer's eyes lit up with the welcome revelation that she didn't have

to go into the deep shadow parts of herself that day; in fact, she didn't need to accomplish anything in our time together; it was enough for her to offer presence to the process and to create as an act of celebrating what is. Her need for healing was still important, but that day all she had to do was be.

At the end of the process Jennifer had a levity about her as she reported how incredible it was to just put her pain down for a moment and let it be. She chose to explore joy by focusing her attention on nature. She sketched the light and trees she saw out her window and wrote poetry about the beauty that the natural world was offering her during the hour she created. For just one hour, nature offered her sanctuary, a place to turn her gaze toward, a place where she could just be with the joy it had to offer. Her process brought her newfound energy and fulfillment and a much-needed reprieve from her stress. All of this was significant for someone carrying such a heavy load. In a world obsessed with doing, what a relief to know that sometimes the greatest antidote to our stress is to simply be, to do nothing but offer presence to wherever we are and feel that with intention.

Below the Surface

Life is inherently stressful, each of us is trying to grow and prosper with a unique set of burdens pressing down upon us. The stressors we face in a lifetime are varied and many, each with sharp teeth hungrily pecking away at us. For some people, stress is the dominant feature of their lives as they navigate trauma, poverty, and similar. For others stress is tempered or lessened depending on the resources and privilege they hold. We may lack resources or support, feel drained from toxic interactions, or find that too much is expected of us at work, home, or by society at large. Our bodies grow and age under the command of stress, leaving us forever marked by it as many of our illnesses can often be traced back to chronic stress that leads our bodies to unravel. Stress taints every part of our lives; it seeps into everything we do, many of the decisions we make, and much of our internal experience.

The felt impacts of stress are real and abundant, but there is also an illusion to stress. We think that we can control stress, that when we have little of it in our lives, it's because we have done something well, and when we have lots, we feel

it's our fault. Of course, those illusions make us forget the roles of privilege in creating ease, or the structural roots of dis-ease. Many of us have been looking in the wrong direction, focusing on trying to control our stresses rather than how we relate to them. Our true agency and influence lie in how we respond and react to stress, not whether it exists or not. The conditions of our lives may be stressful, and they are sometimes beyond our ability to change, but many of us intensify this stress when we try to both hold it and navigate it on our own.

A conversation has been playing out in popular culture over the past few decades, a wrestling match over whether we should be letting things go or letting things be in the face of stress in our lives. In one ear we have Idina Menzel singing "Let It Go" from the Disney movie *Frozen*, shaping young minds and old, encouraging us to forget the past and actively step into something new. The advice of this song puts the responsibility on us to do something and act in the face of our suffering—sound advice in many instances—but what happens when there is nothing to do or when we have done everything and find ourselves more ragged than before? In the other ear we have the song "Let It Be" by The Beatles. Paul McCartney wrote this song after having a dream in which his mother, who had passed away, came to him and told him to just "let it be."[1] McCartney found such hope and positivity in the message that he didn't have to do anything, that insight would come without action. With some suffering, like the grief that comes from a loss we cannot undo, that we can't let go of, there is no action to take; rather, we must let things be and choose how we relate to it. Both of our ears have found wisdom through the music of popular culture (perhaps that's why both of these have persisted as such iconic songs); the challenge for us is to discern when we must take action and let things go or do nothing and let things be.

In Jennifer's case, she had already let go in so many ways as she actively tried to do and made something new for herself; it was now time for her to let things be, to release herself from the need to do something, from the overburden of personal responsibility she felt. She is not unique in her relentless pursuit toward doing and then feeling the shame that she has never quite arrived. Many of us routinely layer on a special type of stress in our lives known as *striving*. As though our pain and suffering aren't enough, we then add on a feeling of failure for not being how we think we should be. We think we haven't come

far enough, worked hard enough, succeeded enough; that we aren't wealthy enough, healthy enough, good enough. We persistently feel like we need to do something in the face of suffering, that it's our job to release ourselves from it or fix it. It's not enough to be traumatized or harmed by the world, now it's our burden to heal and overcome the pain too. In a world where so many are under resourced, trying to attain the unachievable day to day, we have become very skilled at using the tools of oppression on ourselves. From an early age, we've memorized the messages that if we are in pain, it's our fault, so we must be the ones to fix it. And so, pain begets pain, trauma springs forward through the generations, and our persistent feelings of lack run deep.

As though the weight of everyday living weren't enough, many of us carry within us a pernicious lie. Though we trick ourselves into thinking that the stress we face is normal and our fault, most stressors are structural in origin, they aren't inherent to us but rather toxic by-products of living in the modern world. Western society habitually harms Black people, people of color, Indigenous people, and Lesbian, Gay, Bisexual, Transgender, Queer or Questioning, and Two-Spirit people; it neglects disabled people, chronically ill people, and other people who don't fit into an ideal body category; it unfairly distributes resources; and it has normalized greed. Yet when we experience stress, it feels so intimate and personal that we often forget the external causes. Our unique, individual webs of stress are created when we lack needed supports and resources, yet we believe we are solely responsible. We believe that we need to let it go, to disengage from the source of our pain. We believe that our stress is of our own making and undoing. We shoulder the enormous burden that we should be doing more, that we need to try harder, and that it's our own personal failures that are at the root of all our issues after all. It's no wonder we are exhausted at the end of the day; we are literally shouldering the weight of the world as though it's ours alone to manage.

We need to transform our relationship to the stress in our lives and resist the trap of frantically always doing something in response to our circumstances. The mindfulness principle of non-striving allows us to be in the moment and feel whole and complete without the expectation that we should be anything more. What if instead of starting from a feeling of deficit, we recognize that we are good enough, right now, exactly as we are, blemishes, bruises, mistakes,

holes, and all? That instead of staying caught in the wheel of trying to make things different or better, we simply feel whatever we are feeling in the moment without needing to change or augment it in any way? What if we observe the world around us, let our senses take over, and just be? What if we softened our grip, rest our clenched white knuckles, and instead let things be as they are for a moment and drink in what is? What we notice as we rest in awareness is that a call toward right action springs forth with greater purpose and clarity than our habitual doing.

This may sound counterintuitive, as though this is a passive state in which you just let the world do harm to you and take no action, but the practice of non-striving is just the opposite: it's a powerful place of agency from which to act. Non-striving is an intentional choice of what to do with our energy; it's the act of being still and seeing clearly through the fog as we wait for the call to take fruitful, purposeful action. The pains we are subjected to in the world are not our fault. Jennifer's childhood trauma is a tragic reality not of her own making; she cannot undo what has already happened, but she can choose how to react and respond with her emotions and her body. Our energy and resources are so precious that we must be wise and patient with how we use them, feeling into if the circumstance is something for us to let go of or if it is time to just let things be.

Creativity and Non-Striving

For many people creating something new is an exercise of trying. Often, we sit down with the goal of immediately making something that meets our high standards of what "art" should be. We want it to be beautiful, interesting, valued, praiseworthy, or otherwise admirable so the world can enshrine our creation. Of course, skill advancement and making something of cultural significance is a worthwhile venture in and of itself, but when seeking worth is our default, or if we haven't even considered any other way to approach our creative work, then we are likely stuck in the trap of striving. All of this has become exacerbated in the age of Instagram where even novice creators are subjected to a public evaluation of tallying hearts. Despite a recent movement toward sharing "process shots" of creative work, even these images are curated as beautiful half-done creations, a promise of the magnificence to come.

Paradoxically, it is precisely because so many of us have become accustomed to creating with such effort toward the end that art making is so well suited for practicing and training our minds to practice non-striving. Creating without attachment to the outcome requires resolved intention to go against the current of what we normally do and be okay with making something that may never be deemed as valuable or worthy by the world. Non-striving in our creative practice begins with an intention to disconnect the process from the outcome. It lets us value being in the present moment with our materials, senses, the movements of our body, and our internal thoughts and emotions. We soften our approach and use this time of creation to practice being aware of everything available to us in the present moment. We are patient and tender with our creations as we listen deeply for the clear impulse to act. This is vastly different than creating with a strict plan in mind and holding ourselves (often harshly) to an imagined standard that we feel we must achieve. Non-striving is an invitation to the present, a chance to let go of the stress and turmoil of day-to-day life and our churning minds, and instead be intentional with our energy and focus as we attune to what is in the moment.

Sometimes getting away from our routines—metaphorically and literally— can offer just the right opening to practice something different. Creating in, and with, nature offers us the opportunity to realign with our surroundings and observe ourselves and the world more peacefully. Here we find the dual benefit of nature—it helps us to manage stress while also allowing us to observe our relationship to it more clearly. Over the last decade, a host of new research has emerged affirming what we likely already know—being in nature is a powerful buffer, helping us to manage stressful events as well as helping us calm our anxiety and sleep better.[2] As our daily lives increasingly move indoors, research is finding that we are losing many of the restorative benefits of being outside. One study has found that spending as little as 120 minutes a week outside positively impacts health and overall wellbeing—of note here is that any experience in nature provided these benefits, not just active experiences.[3] When we are immersed in nature, especially without the distraction of our phones or technology, we can't help but be in the present moment as our brains attune to the movement of trees, the sounds of wind

and birds, the smells of the air, and the feel of the ground below our feet. This immersive experience has a powerful tempering effect on our mental state, yielding tremendous benefits to us.

The Woodpecker

Crouched down in a cold clump of leaves in the woods, I watch a woodpecker—persistent, unbothered, moving up and down a tree next to me. It is methodically tapping its beak, bit by bit, looking for something to eat. I watch and wonder . . . Aren't you tired of this relentless pursuit, tired of smashing your face again and again with the odds stacked against you?

It's early morning and my body is already buzzing with stress. My baby is crying, my other children are fighting, and it's all hitting me after another sleepless night. I am six months postpartum with baby number three, and I have been struggling to adjust to my new life. I am supposed to have it together at this point in my life; I should have made some progress by now. I wasn't supposed to have to try this hard. But today I can't step out of my own fog. I can't prescribe myself time to create and breathe, I am just too tired.

By contrast, the woodpecker keeps on tapping. Tap, tap, tap—look for food. Tap, tap, tap—try again. Tap, tap, tap—no time for disappointments. Tap, tap, tap—that would be silly, counterproductive to living. How fleeting disappointment must be for you, I think.

Not me. I take one hit in life and the disappointment reels through me. I desperately seek ease, my eyes always halfway gazing elsewhere looking for relief, wondering when I can stop trying so hard. My mother used to talk about her own struggles, referring to them as "smashing your head into a brick wall." But you, woodpecker, don't seem to be struggling or frustrated. You simply move on, moment by moment, unbothered, not worried about what happens next, what the outcome of each tap against the tree is. This is your life, the enduring pursuit of nourishment moment by moment.

My husband and I joke that we are constantly tweaking things, searching for a better flow in our lives. We are always informing each other that we have made a new change in our home: we move a pot from its old drawer to a new

one, or we try to make new systems for managing the chaos of laundry, children, and our lives. We just keep trying. We each hold a sincere belief that with each new tweak, we will improve things. It's easily one of our best attributes as a couple; we are both persistently interested in bettering ourselves, our lives, and our community. We know that we have agency and influence in our world, so we try to use it for good.

But sometimes coffee isn't enough. Sometimes more sleep can't help. Sometimes it feels like all my trying, rearranging, tweaking is only making it worse. Like there is no influence, no mark I can make in this world, or in my life. Sometimes all my therapy, my self-help books, and my good advice are just beyond my reach. Sometimes I am locked in a moment where showing gratitude feels like a boulder I just can't lift. It's so hard to pick yourself back up when all you want to do is close your eyes and find some quiet. Sometimes I am tired of all the trying. And this is how I feel the morning I find the woodpecker, the morning I flee my house in exhaustion, tired of feeling like I can't catch up.

On this day I am tired of enduring the grind and seek refuge at the bluff behind my house. I close the door and walk away from my family and the stress, setting the intention to find a place where I can just be still in the woods. This is the morning where things shift for me, when the woodpecker comes to me, showing me how to be in between each tap of its beak. You, my woodpecker friend, have come at just the right moment . . .

Tap, tap, tap; the woodpecker calls to me. I watch and I listen. It's showing me how it's done. To keep showing up in each moment. Tap, tap, tap, a genuine presence. Tap, tap, tap, each moment born anew.

What if I never get it right, never quite arrive, never work it out? But what if it's actually just about showing up, again and again, finding little treasures in the moment and continuing on? No past resentments, no future longings. Just a willingness to show up each day, again and again and again. I watch and listen to you, woodpecker. I watch and see that you don't stop and wallow in disappointment when you work so hard without reward. You move on because you must, because that's what living is. Tap, tap, tap. It feels like you are here to show me how to be. Reminding me that with each moment I feel amiss, all I need to

do is show up again to the next one. I can choose to let go of all the trying, let go of wishing things were different, and just be; that is enough.

I take a breath and feel the call to create, to do what I know helps me be present and whole. I walk for a while and then hop off the path . . . and that's when all the magic begins, just where it always happens, in that moment when we hop off the regular route and move to the land of curiosity. I find something I have been longing to find all summer—wasp paper. A bird has found an old wasp nest and torn it apart. Tattered little bits of the former hive are strewn about. It feels like a gold mine. I hold a piece of magic right in my hands. I breathe. I tinker. I make a few installations with all of the wonders around me. I lay berries on the wasp paper in a line, a circle, random configurations. I introduce colored leaves, grasses, paying attention to shape, line, color, and space. I feel my internal feeling's saying yes and no to me as I play with each placement, but mostly, I let go. I show up in this little pocket in the woods. I let my thoughts and stress fall to the background, and I find my breath.

I let go of the desire to brood, to wallow, to hold onto the fretting that occupied my morning. I find my breath and I just am in the woods with these treasures. I spend time with them, slow down, and play with their arrangements, taking a few photos. As I begin to create with presence, I can feel a shift happening inside me. I am shaping the world around me, and as I do, I can feel my inner landscape being shaped too. I feel relief. I feel my fog lifting. I begin to feel calm, but my gaze is already tempted to move to what is to come next. The temptation to be anywhere but now is a constant lure. I pull my phone out of my pocket and write a quick poem in response to my little wasp paper creation.

Then I remind myself that today I showed up, in this moment, here and now, I actually did it. I remind myself that it's the act of showing up, not the outcome, that's most important, that I don't have to try so hard sometimes, I can just be and that is enough. I release myself from future progress. Today I showed up in this pocket in the woods and made something, I stepped outside of myself and felt a connection to others, to life, to the great cosmic order of how connected we are. Tap, tap, tap, because that's what living is.

CREATIVE INVITATION: CREATING WITH NATURE

As we examine our stress, we may feel the need to act, to do, or to make things be different or better. Instead, as we employ the principle of non-striving, we bring our awareness to the present moment in nature, allowing ourselves to be just as we are. In this creative invitation, we will use natural materials and poetry in an actionable way to make sense of stress and exhaustion in our lives. Nature will serve as both the backdrop and the medium for our creation, helping us to see just how distinctly human our stress is. This process will reveal more clearly to you how stress manifests in your own life, while also offering you a chance to practice non-striving as part of the natural orders of nature.

ARRIVE

Ideally this activity will take place completely outdoors. Plan to visit a natural space, such as a park, forest, beach, or even your own backyard/balcony to create. If leaving your home isn't possible, collect natural materials or natural-made materials and plan to create near a window, a plant, or anywhere you feel most connected to nature. You should choose a location that feels safe and has natural materials available such as old plants, sticks, rocks, and so on. When outdoors, you may want to bring along a chair or a blanket to help you feel comfortable.

Once you have found your safe natural space, begin by taking a few slow, deep breaths, inhaling through your nose to the count of seven (or as long as your body can), then holding it for just a second, and then exhaling slowly through your nose to the count of seven. Try this breathing rhythm for a few moments or see if you can find your own rhythm that feels right for you. Pay attention to the experience of your lungs filling up and releasing. When it feels right, begin casting your gaze toward the sky. Continue breathing and paying attention to the sky, imagining yourself connected to its vastness. You may choose to be in this open, observing state for as long as you need, noticing your surroundings and the abundance of nature. You may also choose to take a slow walk or just notice the creatures and plants that you are sharing space with.

SET AN INTENTION

Set an intention that explores what you want from this process. In what direction are you hoping to grow or lean toward in this creative process? For example:

I intend to let go of my need for control and influence in this process.

I intend to put my worries down and be with joy.

I intend to be with myself rather than fix myself.

If you find yourself getting pulled in other directions or distracted in any way, remember to go back to your intention; it will serve as an anchor for you.

ASK A QUESTION

What insight or knowing are you hoping to gain from this process? Take a moment and ask a question about your stress or striving. For example:

How am I striving in life?

What story about my stress or suffering can I let go of?

What is my stress trying to show me?

How can my art and/or nature help me manage my stress?

What do I need to let go of and what do I need to let be?

PREPARE

Find a natural object you would like to work with as a start. Look around for something that seems to have a story to tell or may have endured much in its life. Begin by touching your object and exploring it with your senses. What do you notice about it? Can you see any signs of the stress it carries? Imagine the history of this object; how was it born, what has happened to it throughout time, where may it have travelled to and from, what stress has it endured? Sketch out a life story for this object using shape, line, color, or words. This may be in an art journal spread, doodles, words, or poems; express this imagined history in any way that feels right to you as you trust your impulses.

Once you feel you have captured its story, as a close to this activity, offer this object some recognition through movement and words. Begin by saying "I see you" to the object and tell it what you have witnessed about it (speak in your mind or out loud). Now offer it a movement or gesture of recognition using your hands or body. This might be placing your hand on your heart, making an offering with you hand, or stretching your arms in a motion of gratitude.

CREATE YOUR INSTALLATION

When you feel that you have sufficiently arrived, it is time to begin making art. You will be creating an installation (this is just a fancy term for placing objects together in an artful way) using found natural materials to help you explore your question. As you step into this creative process, you will need to pay attention to your impulses, listening closely to them as well as to each natural item that you find. Your inner voice and the materials will both communicate to you and help you to create something in response to your question. Remember, if you are unable to access a safe outdoor space and are creating from your home, see what objects nearby remind you most of nature.

Recall your question and then begin to gather five to seven natural materials that you feel can support you in exploring it. This may be rocks, sticks, leaves, grasses, shells—anything you feel drawn to; you don't need to understand why you have selected it. When you have collected your items, begin assembling them in an artful way. Place them with intention as you hold your question in your mind. Pay attention to shape, line, color, texture, space, and so on. You may choose to answer your question, or you may choose to depict your question; either works. The goal of this activity is to begin taking the question outside of you and into the natural materials. Whatever bridge you find between the two is sufficient.

WRITE

When your installation feels complete, grab your journal and begin writing. Begin by giving your creation a title or name. If a photo of this creation were to hang on a wall in a gallery, what would be its title?

Now write a poem in response to your creation. If your installation had a voice, what would it say to you? You may want to use the prompt "I am here to tell you . . ." and let the words flow from there. Begin writing in its voice rather than yours and trust the words to come; this voice will be your poem. Write for as long as you need to capture the voice of this creation. Here is an example of a poem written in response to a natural installation.

You can trust that something beautiful is unfolding in just being with what is. Let your heart soften. Let some beauty in, let trust flood you. Just be, in the grandest sense of the word.

DISTILL

As we bring this part of the process to a close, begin to harvest the insight from your installation and poem by identifying what is most meaningful and essential for you and your process. Look back at what you have written and underline two to three key words or phrases. What insight do the words have for you in response to your question? You may want to take these key words and write a new poem, or if it feels easier, journal about the significance of the words. Return to your breath and connect back with your natural surroundings. What does this all mean? What have you learned about your stress? How does it make you feel? How does this connect you to others or the world at large?

As you hold your question and these threads in your heart, find a way to begin closing this activity. You may want to take a photo of your creation to preserve it, or you may want to dismantle it or even leave it to come apart in its own time through the elements. Trust yourself and find a way to honor this process as you bring it to a close.

WITNESS

As always, it's important that you find someone to share your insights and learnings with. As you explore how your stress and exhaustion is connected to others and the world at large, it's important that you find a way to strengthen this connection with others. Who can you share your creative journey with? Are there words from your poem or perhaps even the photo that you took that can help you share what this process has meant for you?

Bubble Gum Ghosts (mixed media and thread on paper)

7

CUTTING THROUGH
THE FOG OF ANXIETY

TARA SITS AT A TABLE, cutting images from a stack of papers. We are a few weeks into a group class exploring self-care through the arts, and this morning we are exploring our inner experience of our feelings through collage. Each time I look back at Tara, I see the stack of papers in front of her growing. I go over to check in with her and see how her process is unfolding. She buoyantly tells me that everything is "good, just finding papers . . . not really sure what I am doing!" I can see just by looking at her that she is feeling stress; her posture is tight, her gaze restricted, she looks almost robotic as she touches each paper. I ask her if she feels that she has found an image or texture that captures the meditation experience we have just done. Her demeanor crumbles and she says, "You told us to listen to our inner voice, but I can't hear anything. I think I am doing it wrong."

Tara, of course, wasn't doing anything wrong. Through our work together, we would come to find out later that she had never connected to an inner voice that she could trust was her own. Every voice inside her was second-guessing, uncertain, worried, or just a replication of something she thought she should be saying. Tara was living with anxiety, and it bore down on her like a thick fog; she didn't trust herself, and her view of the world never felt certain. Her anxiety had been mostly manageable for her until she had recently moved into a new home. Now she was experiencing panic attacks and often went to bed with a racing heart and mind. Tara could no longer find stable footing anywhere in her life.

Instead of focusing on her anxiety, we used art making to notice all the ways that Tara lacked trust in herself, which included second-guessing herself during the creative process, feeling unsure about what marks to make, and always wanting to "do it right." Tara had never realized how much self-trust she lacked. I asked her to make a piece of art that portrayed what trust looked like for her in this moment. She made a dark black cloud with the words "unworthy, helpless, and fear" in the center—a painful image that clearly portrayed the perilous uncertainty that was at the core of her relationship to herself.

Our work together continued, and we focused on building an inner resource of trust that she could tap into. To do this, we needed to help Tara listen for inner wisdom instead of always tuning into the alarm of her anxiety. As a start, Tara and I began to notice all of the ways she could trust herself in the moment. We noticed her breath working sufficiently without help, we tuned into her heart pumping, her digestive system working, and we noticed that she could move her body in any way she chose.

In time, we discovered that music was a powerful tool to help Tara listen to her inner wisdom. Together we would listen to music and would notice her impulse to move, sway, or lift her legs to the rhythm. Tara began to hear an inner voice, which she described as a quiet impulse or intuition to move to music. In one particularly memorable instance, Tara was intentionally listening to music and I asked her to create a picture using shape, line, and color in respond to it. She quickly made blue and green marks, paused, and then reported that an inner voice was instructing her to tear it up. Tara didn't question it; she knew she could trust it. Tara calmly and intentionally began tearing up her artwork feeling awe and surprise at the new shapes and the transformation that unfolded so assuredly. She met the voice with curiosity and could feel that this voice was the real her that had been buried underneath her anxiety. It was a simple moment, but this intentional listening, this inner experience of being curious, was what started her crossing through the fog of anxiety and into a place of trust.

Which Voice Do I Trust?

For some of us, years and decades are swept away under the strain of anxiety like Tara's. The details of our days are lost to a fog. We look backward and then

forward and realize that our lives are constantly under threat as anxiety occupies all of our time, energy, and existence. We spend our days and nights living in this fog, pretending we are present, when really our minds are swirling in a million different directions.

The particulars of your own anxious narrative may be about work deadlines or conflict with others, they may be about your health or security, or about the pressing issues of climate change or transforming society to be more just—or maybe they're made up of a little of each. Anxiety is so much more than the future; it's also trapped in the body of now and the fabric of daily life. Justifying the cause of your anxiety will only cause more, but examining your relationship to it and to yourself may just offer a new path forward full of trust and stillness.

Anxiety has become a prominent condition many people struggle with daily. Instead of viewing this condition as a deficiency emanating from within, we can understand it as a messenger, an alarm bell ringing inside of us warning us that something in our outer world isn't right. Instead of pointing the finger of blame inward at ourselves, what if we looked outward to an ill society as the culprit? Lack of support and true intimacy in our lives, overwork, chronic stress, overstimulation, and living with the perilous impacts of poverty, colonization, ableism, and systemic racism—our bodies and minds have been put into a state of alarm that we can't seem to escape. Anxiety is a signal, an adaptation our bodies have been forced to undergo as our needs chronically go unmet. Often anxiety manifests after a core vulnerability has been touched within us, such as an illness or a major life change like a move, a job change, pregnancy, divorce, or even being confronted with our own mortality in the face of a global pandemic. Long after our vulnerability has been exposed, the feelings of alarm persist; they become a new way of being, tuning us constantly into our mortality and how inherently sensitive we are as human beings.

But the real terror of anxiety is that it cuts us off from our internal wisdom. The longer we override the warning signs of anxiety and disregard their wisdom, the louder they get, until one day we may find that all we can hear are their reverberating bells. We wake up each day and rehearse this fear in our minds and bodies, again and again, until eventually our bank of memories and experiences that we once listened to and relied on, our internal voice of wisdom, seems to have vanished. We forget that we once trusted ourselves

and had impulses and intuitions that helped guide us. We have sown so much distrust and fear in our lives that we have cut ourselves off completely from our internal selves and can't see the abundance and wonders of the world waiting for us. To break this cycle, we must first begin to trust that our anxiety is trying to tell us something, that intuitively, deep down, our inner voice is speaking to us, telling us what this pain is all about. Only then can we begin to trust our impulses and the whispers in the back of our mind again, following their lead, bit by bit, as they work to guide us toward nourishment.

The famous turn-of-the-twentieth-century artist Henri Matisse provides an example of how listening to one's inner voice can allow you to step away from anxiety and instead find reverence and awe in its place. A contemporary to Picasso and an established artist in his own right, Matisse lived a life full of anxiety, depression, panic, and pain. His suffering was well known; he often spoke about how painting (and his use of color in particular) was a way for him to manage his emotions. In the latter part of his life, from his 60s to his 80s, he was plagued with severe illness. First, he was diagnosed with cancer, then he suffered a botched surgery that left him in a wheelchair, and in addition, he found himself with failing eyesight. All of this was a tremendous blow to a man so devoted to, and in need of, creative expression. Matisse knew he was in decline; he was being tested and needed to find a new way to reconnect to his inner strength if he was to continue making art.

While he lay in bed unwell, Matisse had an impulse to reconnect to a symbol from his childhood. He heard an inner voice telling him to begin exploring scissors. Because he had come from a home of weavers, he decided to pick up the same large cutting shears familiar to him as a child, and he began cutting paper without knowing why or where doing so would lead. This little voice of curiosity in the face of adversity and anxiety led to him creating paper cutouts or, as he later would describe them, "painting with scissors." Matisse described this period as his second life in which he birthed a new art form. He felt this technique was a way to go back to the basics of art, and it resulted in some of the most confident and autobiographical works of his career. Matisse trusted his inner voice and the strange call to play with scissors, and in turn, he found it to be a powerful resource that brought a new world to him in the

face of anxiety and pain. Even from his bed he found he was more alive as an artist than ever before.[1]

This story is an example of what it means to listen closely to one's inner voice and to trust its guidance in the face of great adversity. This inner voice isn't specific to the great masters of art; each one of us has tiny whispers of curiosity and wisdom within us. Each of us has whispers that say no or yes or that direct us this or that way, impulses and intuitions that attempt to coach us from within, moment by moment. To begin trusting ourselves, we must locate that inner voice, find an entry point from which we can hear it, and then meet it with trust. As we listen to it more and more, we begin to find confidence and assurance that emanates from within us, neutralizing our anxiety. We find agency in realizing that we can choose which thoughts to pay attention to, which ones to pick up and follow, and which ones we can put down. Listening to our inner voice becomes a resource, a support, helping us to trust the unfolding nature of life and trust ourselves to navigate whatever comes our way. When we listen to those little curious directives from within, they help us navigate our lives and remind us to tune into the beauty and grace available to us in any moment. Slowly, we detach from anxious thoughts and find that we can trust ourselves and the world. As we embark on this practice, it's important to remember that building inner trust in the face of anxiety doesn't happen overnight; rather it is a relationship we are reestablishing with ourselves, one that takes time and practice to build.

Trust in Creativity

A body of evidence around the efficacy of engaging in creativity to manage anxiety supports the lived experiences of Tara and Matisse.[2] The links between art making and anxiety in the literature are ever expanding with conclusions ranging from discovering that making art increases blood flow, influences the reward centers of the brain, lowers cortisol levels (the marker for stress), and induces a meditative state.[3] Art making has also been shown to promote relaxation, help people to investigate thoughts, and promote emotional regulation.[4] The evidence is slowly breaking down and verifying, bit by bit, the personal

phenomenon that many people can attest to: creating something makes them feel less anxious.[5]

Engaging in something creative is, in its essence, about being with ourselves. Whether it's visual art, music, movement, or handmaking something, in these spaces, we find ourselves alone with our impulses, intuitions, ideas, and thoughts. It is a place we go to be with ourselves and (if we choose) listen to what we have to say. We follow the impulses of our hand's movement, find internal wonderings that surface in the moment, or listen to an internal dialogue playing out, suggesting, "What if I tried this?," or "This needs more," or "I think this means something." We sit down with ourselves and encounter strange whispers from within. They don't always make sense or seem to be relevant at the time. With each instance that we listen, surrender our need to know, and trust ourselves, we are encouraging our inner voice to speak with more confidence. It's almost as if the internal wisdom we hear in our creative practice is offering us breadcrumbs to follow on the path toward restoring our sense of wholeness.

Creativity is an incredibly vulnerable act, yet safe, because we aren't actually under any real threat. If we make a mess on a canvas or bungle up our sculpture, who cares? In the grand scheme of life, the consequences are miniscule, but the potential rewards are enormous. Creative expression is a safe space for us to be with vulnerability, a playground where we can practice being with our raw insecurities with low stakes. Here we learn to be alone with ourselves, listen deeply, and touch our deepest vulnerabilities, getting to know them, making space for them, and getting comfortable with them. Sometimes the content of our creations reveals to us a hidden pain or darkness, but other times it's simply being in the unknown that can help us to expand our tolerance for uncertainly rather than to recoil in fear. When we step into the creative realm with ourselves, we never know what will emerge.

The time we spend making something is also a time of refuge, a time when we can put down our anxious thoughts and revel in grace and beauty as we allow ourselves to be intentionally absorbed in color, sound, and movement. We can focus on the texture, light, tone, or quality of our surroundings as we translate them into a creative medium. We can intentionally be with the unfolding magic of the process, letting ourselves be swept away as we transform raw

materials into something new. Our creative practice is a sacred place where we tune into the present moment and restore a relationship with ourselves as we revel in the magic and awe of the unfolding nature of life.

Whispering Ghosts

I have a name for my anxiety. I call it "the thud." It starts deep in my chest, a small trembling in my core. At first, it's just a minor interruption, a noticing that momentarily pulls me away from writing emails or washing my face. And then the thud gets stronger and amplifies each of my heartbeats, the reverberations cascading through my body, into my neck, my stomach, my movements, and my thoughts. The thud is always lurking in my shadow, but in recent years I have found its grip slowly unravelling as my ability to listen to and trust my often-strange internal whispers has grown. In fact, it was the appearance of two ghosts in my life that helped me to finally begin to manage it.

The first ghost appears one summer morning at 5 a.m. as I sit in the passenger seat of a rental car as my family and I drive down a northern British Columbia highway. We are travelling in the Northwest Coastal mountains region where the only thing greater than the trees is the mighty Skeena River that dictates everything about the landscape. An unnerving fog reaches across the highway making for precarious and uncertain driving. My children sleep in the backseat and my brain starts taking a long gaze—what if we get in an accident, what if an animal crosses the road, what if we break down . . . I feel worry starting to blanket me in every direction. So I place my hand against the window and focus on the contrast between the cool glass and the fan warming up the car. But an alarm keeps going off, a sensor on the side mirrors thinks another car is approaching. After flipping through the owner's manual for a while I conclude that the fog is so thick that the car thinks it's under attack. It's not the only one.

Then, all the sudden, I am jolted out of my internal drama as my husband hits the brakes. A black bear canters out of the thick trees and onto the highway in front of us. We both remark, something vaguely impressed, under our breaths to one another. I feel us begin to accelerate again only to immediately slow down. We are both lost in a moment of confusion as another

animal follows the bear—something white following closely behind. For a moment, we think perhaps the bear is under attack, and then we realize it's a white bear, the famed Spirit Bear or Kermode bear, rarely seen, and only in this part of the world. We might as well have seen a ghost; the bear and its shaggy white fur occupy a space in song, dance, and storytelling for Indigenous peoples of the area, but survey locals, and you will find very few have ever actually seen one.

As quick as the white bear appears it is swallowed back up by the fog, the moment is gone as quickly as it came. And with its retreat, I find my anxiety has shifted on a dime. I am now filled with awe and wonder, fondly recalling the white shaggy fur and suddenly able to see the beauty and mystique of the dripping fog covering the forest around us. It feels like the world has revealed itself to me, and in a single moment, I have found something—mythical, wonderous, and fleeting. This ghostly bear marches into my life for just a moment, interrupts my stream of imaginary what ifs, and invites me to slow down and pay attention. I marvel at the thud's sudden retreat, close my eyes, take a few breaths, and hear an inner whisper telling me to "remember the fog." I almost don't hear it, this little intuition that bubbles up—perhaps it is the magic of the moment that tunes me in deeper—but I resolve to explore this internal whisper, not knowing at the time that it holds the beginning of deep insight and relief for me. The ghost bear has left me the first breadcrumb of fog, and it is my job now to follow it, not knowing where it will lead me.

This is the way most of my knowing unfolds. A niggling something creeps into me and won't go away. It's a clue waiting to be dusted off and explored from different angles. Like a word on the tip of my tongue, the more I try to think about it, the further it retreats. But if I let it rest within me, if I play with it, let it wash over my body and move with me, then eventually the insight comes. I have learned that in times like these, I must first narrow my gaze, not zoom in on the issues or the goals like my brain wants to, but home in on the details of the micro dust lying in front of me. It's often the minutia that shows me the way when I listen to it, and so I sit down at my desk one day with the intention of exploring fog as the Spirit Bear had instructed.

I fill a white textured paper with scribbles of pencil, blobs of steely blue paint, and shining metallics. I use my fingers and a stick and whatever tools I have lying around; I completely surrender to showing the paper the weight it can hold. When you let impulse be the driver, everything changes. Time and space disappear, and the only thing that matters is the next subtle movement, the next instinct for color, the desire to do more, or less. Everything else swoops away into the background for another day. The process is a dump in every sense, and when I finish the first page, I make more, each one thick with layers and each a complete disaster. Then I lay each page in front of me, survey the mess, and simply walk away. This is what trusting the process looks like: you step out from under the weight of your life and make something, anything, with abandon, and then you wait to see what comes next.

I return to the scene of the mess a few days later—bubble gum colors, shiny glints, chaotic brush strokes. One reminds me of something, and another whisper inside me says, "Dog Man," a ghost from my past, and like the Kool-Aid man, it busts down my door, a surprising shock from long ago, coming all at once, both complete and sweet. Yet, another breadcrumb is laid out before me, parading me onward in wonder. I don't know what it means or why it is here, but I stay with my curiosity. Dog Man is a relic from my teenage years, a symbol of a period in my life that was all about time and space, a white rubber mask cartoonish with blue spots and a silly red tongue. It was something my friends and I would take turns wearing as we drove through town, went into Block-buster, or just generally sought out mischief. You simply placed the mask on, and voila, you were fearless and could do anything. This was a time when I was cautious, but not anxious, playful, but not reckless, when I trusted myself, a time before the thud ever touched me. Perhaps this memory is here to invite me to remember what life was like before the thud?

Then I hear another whisper, a memory of a night on the road in the fog with Dog Man, a fading memory of driving through the wetlands near my home in the suburbs of Houston, Texas. No one should have been driving that night, but we were kids governed by different sensibilities; we didn't know that fog this thick was dangerous. We barely made it to the freeway. We played with the lights; bright, park, on, off; but it was no use. We were in a cloud, and when

we came near the wetlands, it became two clouds. I stop the car dead on the road. My friend got out and walked around the car and then stood in front of it. One step backward, and he vanished. Then my friend came back into the car; we giggled and marveled at the spectacle of it all and slowly crept our way home, one inch at a time.

I realize that the fog with Dog Man felt completely different from the fog with the Spirit Bear. I begin to place all the pieces together and an insight begins to take hold inside of me. The fog didn't feel scary back then because that's how I lived my life at the time, in tiny segments. I worried about the inches around me, not the miles. I felt the weight, but none of it mattered yet; that was all down the road from that day. But today my life has a long gaze. I have a punishment of vision that never affords me the opportunity to stop my car and play in the middle of the road. I am in paralysis because my gaze is so far afoot. I see so many paths in front of me opening, but I can't possibly walk in six directions all at once. Which choice should I make? What if I order the wrong thing off the menu? I list all the things that could go wrong, everything I am missing out on, and let the what ifs pile high. I try to look in all the directions at once. Each time my gaze tries to go too far ahead, each time I carry the infinite of the world alone, the thud comes and sweeps me away. But the last time the Spirit Bear came to show me that I could place my long gaze down, that I could choose to find wonder and stillness in the moment.

I can see it all now: the breadcrumbs laid out before me, the lessons of the Spirit Bear and Dog Man, two ghosts reminding me that I don't need to hold the whole universe at one time, that the thud is an alarm bell telling me to slow down, soften my gaze, and be with the immediate. All along I thought the thud was the enemy, but really it can be a messenger, a warning in my life telling me to slow my pace, to bask in the fog and look for wonder there, and to let my gaze soften to one inch at a time.

I go back to my scrambled bubble gum Dog Man painting and brush my fingers across the peaks and valleys of dried color. The weight of the painting holds all of it. I know in an instant what I must do. I grab my scissors and begin cutting this mess into slivers. My scissors move slowly and methodically, and I watch the whole thing transform into a story. I lay the pieces out in front of me and breathe with ease. Copper hues and messy scribbles. I take the pieces

and continue to work with them, stitching them to paper, strengthening the hold of each slice, each memory, each moment. The piece becomes a salute to the thud and its invitation. The next time I feel it reaching for my chest or my throat, I will welcome it rather than resist it. Now I know it only wants me to slow down, to soften my gaze and take life bit by bit, to revel in the minutia and bring curiosity to the moment so I don't miss out on seeing the next ghost.

CREATIVE INVITATION:
FINDING TRUST IN PAPER CUTS

The invitation for this chapter will have you play in a low-stakes creative process exploring abstract paper cuts as a way of listening with curious intention for wisdom that can help you to break the cycle of anxiety. Through this process you will pay homage to Matisse's paper cuts while listening for your internal voice to guide you to curiosity and awe. If you are in a particular anxious place and find any of this activity overwhelming, you can adapt it by skipping any step or substituting collage paper for the painting.

ARRIVE

If you are someone who struggles deeply with anxiety, it is important to spend time properly preparing yourself for this creative invitation. You may want to alter or play around with the suggestions for arrival in a way that best suits you. The goal is to arrive with as much presence and curiosity for the process as is possible for you.

To begin, listen to a song with intention and curiosity and/or engage in some expressive movement. I recommend sitting in a comfortable position and listening with headphones. Explore following your impulses, moving your hands or body to the rhythm of the music in a way that feels comfortable to you. Think of this as a chance to try something new in a safe environment with no stakes. What happens when you offer deep focus and interest to music and rhythm? Can you hear an inner impulse? You may choose one of the following suggested songs, but music is a personal experience, so find a song that connects with you.

Suggested songs:

Olivia Belli: "Upland"

C.B. Rework Clark: "Amor"

Sarah Neufeld: "Stories"

John Coltrane: "Olé" (this is my personal favorite!)

SET AN INTENTION

As always, begin by setting an intention about what direction you would like to move or grow toward in this process. For example,

I intend to listen to myself.

I intend to listen for whispering directions from my wise self as I create.

I intend to meet my anxiety with curiosity as I create.

ASK A QUESTION

What insight or wisdom are you hoping to gain from this process? Take a moment to ask a question about listening, trust, or finding curiosity that will anchor your process. For example,

What wisdom do I most need to hear right now?

How can I begin to trust myself?

What is my anxiety trying to show me?

PREPARE

As a preparation for this exercise, begin reflecting on what your anxiety may be trying to warn or signal you about. Imagine that your anxiety is speaking to you, calling for help. Close your eyes and ask your anxiety, What do you need right now to feel cared for and loved? Listen to it, and notice any imagery, impulses, ideas, or memories that surface. When you feel ready, you will create a care package for it working on a clean page in your art journal or perhaps finding a special box to hold the items in. You may want to include imagery, symbols, words, or colors in this care package; follow your creative impulses. For

example, maybe you cut out an image of a hugging embrace, draw a picture of a symbolic flower, or write words of care that you then place in your box. Your items will be unique to you, and the words will be those your anxiety shares with you. When you feel complete, you may want to write a few words in your journal or offer a gesture of gratitude thanking your anxiety for speaking to you.

COLOR DUMP

You will begin your creative process by making a color dump. Begin by listening to your inner voice, impulses, and intuition through color and mark-making. You may want to continue to listen to music throughout this process to have something to focus on or to calm you if you find yourself feeling distracted. Begin by selecting two to three colors, each in a different medium (i.e., pastels, markers, acrylic paint, watercolor paint, etc.), that you feel drawn to and place them on the page in whatever way you feel called to in the moment. As you select mediums and colors, listen for an inner voice that is saying yes, no, or what if? Notice how you may feel tempted to ignore or override the voice. Let your movements be natural and fluid; don't worry about making a mess. Simply follow your impulse and listen for internal direction. If your anxiety feels like too much in this step, you can use collage papers instead of painting, cutting colors and textures from old books or magazines that you feel drawn to.

WRITE

For this step you may choose to write either on your painted page or in your journal. Look at your image and write out a few words or phrases that come to mind. This may be adjectives, feelings, phrases that detail connected imagery from your mind, impressions, and so on that feel somehow connected to your image. For example, you may write "energy," "vacationing at the beach," "peace," or "hopeful." The words can be anything that feels relevant to you expressed in any way. If you are writing on the page, you may choose to add these into the image in spots that feel as though they need it. Again, trust your inner voice: What words? Where? On or off the page? Do you need to write more? Let your inner voice tell you how this process should unfold.

CUT

Once your paper has dried, you are ready to begin cutting. Resist the desire to plan or envision a specific outcome. With your scissors, begin cutting the paper into various

shapes. Follow your inner voice, listen for directions, quiet suggestions, or simply things or areas that intrigue you. You may end up replicating the same shape again and again or making a few different shapes of differing sizes. Remind yourself that there is no right or wrong in this process, just an opportunity to listen to your inner voice guiding you through the process.

ARRANGE

Now that your pieces have been cut, it is time to begin arranging them. You may want to use another larger piece of paper, canvas, scrap of fabric, or something similar to act as a frame for arranging your cut pieces. Begin by laying out all the pieces on the table in front of you; spend some time observing each one. Is there one that you feel especially drawn to? Begin to lay out the pieces you feel most interested in onto your chosen frame. You may choose to use all the pieces or just a few. Play with arranging them in a satisfying way on the page. Notice your inner voice guiding you to place each shape as well as the space between each shape. Permit yourself to play and explore with a series of arrangements until your inner voice instructs you that you are done. You may even want to add in some collage paper or words; trust yourself to complete this project as you see fit.

DISTILL

Once your visual piece is complete, it's time to take stock of the process and what you learned throughout it. In your journal, explore what the experience was like as you listened to your inner voice and what the piece has to do with your question. Use the following prompts:

I hear my inner voice saying to me_____.

Throughout this creation, my relationship with my inner voice_____.

When I think about my question, I can see that this process and the piece I created have shown me_____.

WITNESS

Remember to find someone to share your insights and learnings with. Consider sharing with a trusted person the experience of listening to your inner voice as you created and what insights you think this process has for you about the anxiety that you experience.

A Collection of Holes (found objects)

8

EXPLORING THE IN-BETWEEN

A PEACE LILY sits on my desk, a few white blossoms just beginning to emerge. Allison walks in and immediately takes to the plant. This is her plant, she exclaims; well, not *her* plant, but a plant that signifies so much to her. Her own peace lily has become an emblem of hope since she had to leave her job because she became ill. Allison writes poems about her lily and discovers solace alongside the cycles of growth and rest in the natural world now playing out in her own life. For Carol, that beacon is an old gift from her son, a sky-blue glass vase stored high in a cupboard that she brings down occasionally and dusts off. It becomes a connection to her past, a symbol of enduring love that helps her cope with life after the loss of her adult son. Carol sketches this vase in moments of grief as a way of connecting to her son, her hand and heart working together to show reverence for his enduring influence on her. Anna sits aghast as the decorative gold leaf tree branch she has had for years (and not thought much of) suddenly takes on new meaning; it has become an emblem of bravery as she steps into a new life leaving unhealthy habits behind. She paints a picture of the branch, and through creative writing, gives it a voice, letting it tell her a story about patience and intention.

Each of these humble, everyday objects was reborn as a powerful signifier for each woman as she moved through change. Here we see that expression isn't just an action; it can become a perspective, a tool for finding a new way of looking at the world and allowing the world to speak to you through the everyday.

When life inevitably falls off its predictable track we may find ourselves lost. The passage to death becomes final, the divorce papers are stamped, or our job disappears, uprooting everything that was once normal for us. The resulting pain of the unpredictable leaves us scrambling to try to find sure footing again, looking for something to hold tight to while the world around us spins out of control. This is the in-between, a time and place when we are neither here nor there, a place where a part of ourselves is transforming into something new. While we float through the in-between, through whatever transition, change, or unexpected thing has unmoored us, we may find that our anchor comes from the most surprising places. For Allison, Carol, and Anna, it was through their mindful observation of the everyday objects in their lives that they found solid footing. Each of them reached out and touched an object in a new way, finding agency and influence in creating what was waiting for them on the other side of their transition. In this way our creative expression becomes our voice, a way for us to tell what comes next in our story.

We often think the way through madness and the unexpected needs to come from some great epiphany or expert. We think something out there will come to us and help us make sense of it all. As the stories of these three women show us, sometimes the grandest discoveries and the most supportive tools we find come from the simplest and most humble places. There may even be something sitting next to you, right now in this moment, that can help you. The cup of coffee in your hand, the blanket on your lap, that old pen sitting next to you, who knows? These mundane objects become tools for expression, encapsulating new ideas and ways of viewing our life. They are tools imbued with meaning and significance, communicating to us, and through us, about what we most need in order to move forward and let go of the past.

The In-Between

In 1879 French Impressionist painter Edgar Degas painted Miss La La, a trapeze performer at the Cirque Fernando. Degas was reportedly captivated by Miss La La, watching her perform many times, sketching her repeatedly as he attempted to capture the essence of her act until he finally created the acclaimed painting "Miss La La at the Cirque Fernando" and in doing so

forever entwining their lives.[1] Despite his fascination with her, he offers only a partial perspective of Miss La La, her head thrown backward, face obscured, skin color lightened, and teeth clenching a rope as she is suspended midair. She is unrecognizable to most, appearing more as a prop than person, but Miss La La was real, a true circus star for her time. She was known for using only her teeth to climb a rope to the roof of the big top, and her final act was shooting a cannon strapped to her knees as she dangled midair. As some scholars have suggested, Degas portrayal of Miss La La is incomplete, showing a flattened interpretation of her, subjecting her to his white male gaze when her darker skin tone was lightened by him. But if we look deeper than this surface image of Miss La La, we see we can learn much from her life, as history tells us she was a woman proudly living in the in-between, constantly engaging with the unknown with grace and vigor.

Consider for a moment the magnitude of her life. Born to a Black father and a white mother, she was a mixed-race woman living in Europe in the 1800s. With physical prowess and agility, she rose to great fame, performing in the circus while mothering her three children alongside her husband, a fellow circus performer. Miss La La was someone who made a life out of uncertainty, a life built on the fringes of the circus, who spent her days literally dangling in the air. Sadly, we know very little about how she would have defined herself, her complex life reduced to only what was seen in the spotlight of the circus and Degas's portrayal of her.[2] Degas tried to reduce her existence to a singular thing, but Miss La La defied definition; she made her home in the nuance and complexity of the in-between, and it is because of her fierce command of this vast space that her story is so marvelous and enduring. Miss La La provides us with a compelling metaphor for how to live with confidence when parts of us are neither here nor there. The painting seems to be the most enduring representation of Miss La La, but perhaps a different object would be a better symbol to recall her by. Instead, we could imagine a trapeze rope—a complex and nuanced symbol that celebrates her life spent dangling midair, rejecting the comforts of definition, as she made a life in the in-between.

Imagine going back in time to see Miss La La high up in the circus tent, swinging gracefully through the air. She's floating back and forth, holding onto the rope with her hands, and then a moment comes when she must let go. Her

grace is interrupted by our fear as we hold our breath and watch her suspended midair for just a brief moment—unbound, hurtling through time and space toward the next rope. She must float like this for a moment and trust she will land safely on the other side. The show would turn tragic if there was nothing there for her to hold onto, and it wouldn't be worth watching if she didn't let go at some point. It's the thrill of this shifting movement through the in-between, moving from one thing to the next and finding grace in the middle, that keeps us engaged. We can imagine that Miss La La didn't resist the in-between; rather, she made her life there. Her story reminds us that there is grace to be found when we have the courage to surrender, that we can relish our time spent there and celebrate the aspects of ourselves that defy definition.

Imagine if she was afraid to let go, unwilling to bridge the space in between; forever stuck, swinging aimlessly between here and there, wishing she was one place or another. This would be neither a show, nor dazzling, and the audience would just be a sad witness, knowing that fear had taken center stage and no great leap would be made. But perhaps this would be a more relatable performance. Many of us are dangling on our own trapeze rope, too afraid to fully let go, clinging to the safety and comfort of clean definitions, scared to step into a space that is neither here nor there. The in-between is a scary place, to be sure; after all, it leaves us undefined, unmoored, and uncertain.

It may be that the world has thrown you in an unexpected direction, and instead of following it, you are stuck holding onto old ways of being—a job that once served you, a relationship long over—wishing to go back to normal and never admitting that normal can never be again. Alternatively, you may have seen a transition coming for a very long time—finally landing that promotion, watching disease unfold slowly, facing an empty nest or retirement. These changes may not be unexpected, but you may still find yourself lost and disoriented in their aftermath. Most of us don't live in the unknown but rather step in and out of it throughout our lives, periodically feeling ourselves temporarily untethered. Stepping into the unknown requires a moment of liminality—a moment in which we approach the threshold, let go of the old, and step into uncharted lands (if even for a moment) to embrace something new. We find a new perspective of our lives, and somewhere along the way, in this in-between space, a transformation occurs. The old version of ourselves falls apart, making

space for a new one to emerge and sometimes revealing to us that parts of ourselves may forever reside neither here nor there.

At every juncture in our lives, all our power and influence lie in how we choose to view the world and the choices we make as a result. If we let go of our resistance and embrace change, stepping into the dizzying uncertainty and fear of the unknown, we may discover that what we once thought was stable and permanent actually never was. After all, all we have is the unfolding of moments, a constant return to change. One of the greatest teachers we have to help show us how to move through change is our breath. Each breath we take is like a trapeze act. During each inhalation, we hold on, and then our lungs reach full capacity, then, all at once, we simply let go and step into the liminal—a space neither here nor there on the threshold of becoming something, for just a moment; only to do it over again and again and again. This rhythm of holding on and letting go is what keeps us alive. Our DNA is programmed for change—we just have to listen to it.

We must make a choice, an intention to let go of what we once thought was or what defined us and grab hold of what actually is instead. If we can soften our gaze and let go of how we think things are or who we should be, we can find a new understanding, or a new story, fit for our life on the other side of change, instead. We often don't get to choose the thing that hurdles us into the unknown (although sometimes we do), but we can choose what to hold on to next and how we make sense of it all. Every moment is born anew, and we can choose in the next breath to embrace what is and let go of the old. We must ask ourselves, Will we view our life as Degas would have us do, diminishing the nuance and importance of the in-between spaces we hold, or will we see ourselves in motion, at times neither here nor there, reveling in the parts of us that defy definition, as Miss La La did?

Creativity and Change

At its core, the creative process is about stepping into unknown lands with intention and discovering what is there. Each time we approach a blank page, raw materials, or a bare studio, we are facing down the liminal with no idea where we will end up. For many of us, this is why it's so hard to start something

new; it requires us to let go of control and step into the abyss. When we make something new, we can think of this as an intentional act in which we are welcoming a process of disorientation into our world. We start with nothing, take a leap, and then slowly, bit by bit, we start shaping something new into being. Miles Davis (arguably one of the greatest teachers we have on improvisation and being in the unknown) says, in the biopic *Miles Davis: Birth of the Cool*, "It's not about standing still and becoming safe. If anybody wants to keep creating, they have to be about change."[3] Davis teaches us that an inherent part of creativity is embracing uncertainty. The unknown isn't the enemy; it's our teacher, nudging us forward into uncharted waters where great discoveries lie waiting for us. If change is the great constant in our lives, it's no wonder art is so well suited to support us in moving through it.

The fear and hope we inevitably feel at the beginning of a creative project present us with a chance to practice not running away or freezing, but rather bravely stepping forward to the edge of the unknown. We can use the creative process as a way to practice observing our relationship to these feelings and get comfortable with them so that when they inevitably bubble up again in other parts of our lives, we have some familiarity with them. We can choose to elicit creativity as our ally, helping us unfold change. Making something new is one of the simplest ways we can start practicing being with change and uncertainty. The risks are incredibly small, but the potential benefits are huge. We don't need to sell our home, quit our job, or initiate any other great change in our lives; all we need to do is find a blank piece of paper and start to fill it with ideas. One small creative act can be a monumental movement toward stepping into the unknown, and the more we practice this, the more familiar the experience of it becomes to us in all areas of our lives.

It would be tempting to think this was it, that once we take that great leap into the unknown and let our creative ideas find light, we instantly find relief and insight. But the creative process is messy and rarely follows a clean, linear, and predictable path. Instead, it sounds a little bit like life. You intend to start creating in one way and then inevitably (whether you like it or not) the creative process comes in, sweeps you away, and takes you somewhere else. We have no way to predict what will happen in the liminal space where our creations take shape, but we can remind ourselves that the chaos we are in is normal.

By practicing the creative process, we build our capacity to recognize and flow with everything that change, transition, and the unknown throw at us. We can't plan for how this process will unfold, but we can prepare by staying with our intentions, attuning to our inner world with keen observation, and reminding ourselves to trust whatever comes next.

As we turn toward our creative practice to help up become more comfortable with uncertainty, we will find that creativity isn't just a process; it's a perspective. Remember the tree branch, lily, and old blue vase from the beginning of this chapter? They didn't change; it was each person's perspective of them that did, and this transformation occurred because of a creative process. Each object acted as a mooring, a stable force to help make sense of life on the other side of a change that each person was experiencing. Each woman intentionally stepped into a liminal creative space, stayed with the discomfort, and emerged on the other side with a new perspective. The objects they found became symbols of their new perspectives, physically manifested for their new phases of life.

Sometimes all we need is a nudge into letting go and the right frame to help piece all the fragments of our lives together, and suddenly things click, and we can see things in a completely new way. This is what the creative process is: a place to lay everything on the table, untether ourselves from what we once knew, and see what emerges on the other side. The creative process is wise, and it wants us to find our way through change and write the next chapter in the story of our lives; it is standing at the ready to help us find a new perspective.

A Story from the Other Side

For years after my divorce, I would drop my son off with his father at the small-town Subway in between our homes. Over a brief hello and quick bite, we would exchange care, each off in our separate directions. Without fail, every time I began driving home, I would feel a sense of panic. I would start looking for my wallet, my phone, my purse; I would check that all the car doors were closed. It took me a long time to realize this consistent feeling of something amiss after dropping my son off was not a by-product of my haphazard frenetic existence, but rather a hole in the center of my heart that grew larger and larger with each

kilometer I drove away from him. I heard a quote one day that said, "Making the decision to have a child—it is momentous. It is to decide forever to have your heart go walking around outside your body," and it just clicked for me.[4] My heart was being forced to leave me on a predetermined biweekly schedule, and I was passing it off at a Subway restaurant. No wonder I was feeling panic.

During these years all I held onto was guilt. My marriage was over but my role as mother was now filled with pain. I couldn't seem to transition into this new configuration of family, and every time my son left me, the pain of my heart having to stretch so far would almost rip me apart. Some days I would tell myself he was fine, that he didn't even care that his parents lived in different cities, let alone houses. And on other days the stories took on a much darker tone. I'd think, all he really knows is brief, whole moments with both of his parents together shared over sandwiches and chocolate milk. How can that be enough for him? I would obsessively think about how I could make this life of separation some other way. I was using all of my creative energy to resist this change rather than accept it. There was so much futility in this for me. I read, mused, and meditated on this so many times in an attempt to find peace but never really moved in any direction other than toward shame and guilt.

As any parent missing their child knows, it's the silence that is the hardest. Coming home to the creaks and aches of your home magnifies what's missing. I can only imagine how deafening this silence must be to a parent who has lost a child. The constant bumping, bouncing, chattering murmurs of our children become syncopated to the rhythm of our hearts. When they are gone, our hearts beat a little quieter. It was in this quiet stillness that my creative process was set in motion.

I find myself moping around my silent house and notice all the beautiful holes I possess. My son and I collect sticks, rocks, and shells, and as a result, I have bowls and bowls of them all over. On this day it seems like each bowl I look in has a beautiful object in it with a natural hole. A hole that makes it special and unique. For the first time, I see this as a great cosmic reminder that I am not the only thing on Earth missing pieces.

A shell with a missing section punched out of it by the thunder of the sea, a stick with a knot tunneled out of it by weather and time, and even coral made up of tiny little holes and crevices, helping it to breathe and sustain life. Each

of these objects looks so perfect in its beautiful state of Swiss-cheese decay. As I study each object, I think to myself—does everyone collect things with holes? Maybe we are weird, or perhaps this is an attempt by my son and me to try to reconcile our hearts. Our souls are constantly seeking ways to make sense of this life, seeking some guide who will show us the way. I think deep down we know that we must search for the beauty in our situation. For me, in this moment, each treasured hole serves as a reminder that completeness is subjective. I instantly know I need to invite these holey objects into my own creative process.

I grab a few items that seem especially beautiful or important. I spend time studying them, being with them, noticing each of their holes. I wait for a creative impulse to arise. I play with them: stack them, lay them flat, move them in different directions, and try to imagine the origin story of each hole. I touch each object, place my fingers carefully in the holes. At first, I am resistant to this creative process, and a litany of aversion plays out in my mind when I think about how they relate to the hole in our family. I don't want to feel shame when it is revealed. I don't want to feel sadness or pain when its messy reality demands attention. I don't want to worry about it. I don't want to wish or hope it isn't there. I don't want to pretend it doesn't matter. I want to know it, even if it hurts.

I explore these objects for a long time. I keep wanting to add something more to them, fill their holes. I place flowers in their holes, I make each hole nestle into another, but nothing feels quite right. I take a number of photos and play with many different configurations. In the end, when I look at the series of images, the one that stands out is the one that is most effortless. I can feel my aversion begin to shift toward peace.

My holey objects are most beautiful simply laid bare, with nothing but the light touching them. My own desire to do, fix, and manufacture beauty is called out as a bluff. The beauty of these holes, and the beauty of my own family hole, can best be understood through the clean, uncomplicated presentation of each. I want this hole to be a part of me. I want it to be a signifier of courage, truth, and love. I want it to be something that all of us feel peace and beauty around. I want the rough edges of it to be something we each routinely run our fingers around lovingly. This image is more than just a photo—it's a document of my own transition to a new kind of mother who feels complete, even with a hole in her heart.

CREATIVE INVITATION:
LETTING GO THROUGH FOUND OBJECTS

The creative invitation for this chapter will have you finding and listening to found objects as a way of trying out new perspectives as you embark upon a change. When you bring them together in an artful way and then either photograph or sketch this new arrangement, these objects will help you tell your own story about transition, change, and the unexpected in your life. We can use found objects as simple tools to help us unlock our creative knowing. When we ask ourselves to express and communicate in the language of objects, we are deferring our sense-making to other more integrative ways of knowing that don't rely on words or cognitions; instead they rely on the language of symbols. Remember that your symbolic object may present itself in any form; it likely won't look like mine, those of my clients', or anyone else's.

ARRIVE

When you are ready to begin your creative process, start by taking a few moments to arrive in the present moment. Find a place to stand or sit comfortably where you can move your body with ease. Select a piece of instrumental music that makes you feel reflective. Begin to play the song and, with your eyes closed, imagine one part of your life on one side of you and where you aim to go next in life on the other side of you. For example, maybe one side is stuck, and the other is in motion; one side is lonely, the other side is connected; or one side is sad, and the other side is fulfilled. Use whatever imagery, ideas, words, feelings, or symbols best help you to conceptualize this shift or transition you are seeking. When you are ready, begin moving your arms in a way that's comfortable to you, back and forth between the two sides, following the rhythm of the music. You may choose to stay with this movement, or you may want to add in others; trust your impulse to explore both sides as needed. When the music ends, place both of your arms out to each side and stand, staying in stillness. What do you feel? What thoughts, sensations, images come to you? Honor this space and movement with a simple gesture to close the process, perhaps by placing your hand on your heart, reaching to the sky, or giving a nod of gratitude.

SET AN INTENTION

Begin your creative process by setting an intention for what you would like to gain from this journey. Remember to make your intention something you want to stretch or grow toward rather than something you can check off of a list. For example:

I intend to lean into a change or uncomfortable in-between area in my life . . .

I intend to be with the discomfort I am feeling about . . .

I intend to step into a liminal space through this process and notice how it feels . . .

ASK A QUESTION

The transition, change, or the unexpected shift you have experienced may be varied and vast, but let's use this process to focus and anchor your creative process. Begin by asking a question that you want to explore. This will help you to not feel overwhelmed or pulled in various directions. See if you can settle on one question that really gets at what you most want to explore and understand through the creative process. For example,

How can I best honor this change I am experiencing?

How can I better love the changes to my body and my health that have transpired recently?

In what ways does the loss of this relationship still impact me?

PREPARE

As a start to this process take 5 to 10 minutes to explore the transition you are going through that you want to welcome into this process. You may want to continue to develop the space that you explored through movement at the start or to focus on your question. Then, make two boxes or circles on a page, leaving a space between them. Fill one shape with ideas of where you are right now and the other with ideas of where you

want to be. Use shape, line, color, images, or words to fill each shape. Perhaps imagery, symbolism, or emotions need to be in each shape. Use whatever medium you like or feel called to in the moment to capture this. Look at the space in between the shapes. Is there anything you would like to add here, or should it stay blank? Once you have completed your image and have begun to reflect on change and transition in your own life, you are ready to begin finding objects.

FIND YOUR OBJECT(S)

Now begin the process of finding an object or objects to support you with the transition you are seeking. With your question as your guide, begin by walking through your space and looking at objects that are around you. Notice if a certain object seems to be calling for your attention more than others. Don't feel rushed in this process. As you move through your space, notice if an impulse arises in you, a call toward one object more than another. You may want to spend a set amount of time exploring this, or you may want to let it unfold over the course of a day or a week, noticing various objects as they draw your attention. If an object calls to you, consider doing the following:

Go to it and begin exploring it with your senses. Touch it, smell it, notice it in its physical sense.

Notice if any stories or ideas come to mind for you. Does this object have a history? Where did it come from? What is its purpose or meaning?

Allow yourself to be with each object that calls to you. Listen to it and let it speak to you. As it activates thoughts, ideas, and stories in you, listen to your impulses. Trust your intuition and begin to gather objects that feel right rather than those that make more logical sense. This is a chance for you to start building your muscle of creative knowing, so trust your impulses over your thinking senses. By the end of this process, you may have a series of objects, or you may just have one. You may end up eliminating objects from your final product or adding objects as you progress; stay flexible.

WRITE

Now that you have an object, or a selection of objects, deepen and define the meaning that they hold for you. To do this, you are going to engage your creative self and

offer a voice to each of the objects with the aid of your imagination. In your journal, write a few lines of reflective writing or poetry, giving each object a voice. What does it want to say? Trust the creative process and see if you can take a back seat while letting the objects take over and share their wisdom with you. Once each writing feels complete, look back at what you have written and underline two to three of the most significant words or parts. Here is a sample of writing where a teacup was given a voice.

You used to cradle me and find comfort, sharing abundance and love with your sister. Then you stopped one day choosing paper cups and to-go cups. I am dusty and forgotten, no time for tea with your sister, but it's not too late. I am ready in wait, craving your warm connection.

ARTFUL ARRANGEMENT

With your objects selected and their wisdom already speaking to you, it is time to begin exploring their aesthetics or physical meaning. Spend some time with your object (or objects) and see if you have an impulse or an idea for arranging them in an artful way. Consider how you could best place the objects to honor their voices. Do they need accompanying supports? Where do they want to be placed? Surrender to the creative process and have fun exploring how you can best honor the objects' meaning. Pay careful attention to how you feel as you work with how to place the objects. Listen to your body, feelings, and emotions, and don't forget to slow down and breathe.

CAPTURE AND DOCUMENT

Once you feel that you have made a satisfying arrangement or placement of your objects, it's time to document it. To do this you may want to take a photograph, make a sketch, paint, or do all of this to capture a rendering of what you have created. This is your chance to again play with color, light, and texture and explore the language of expression. How do these objects want to be captured? Does it make sense to accentuate a certain feature? How can you best capture or emphasize the meaning of this in your documentation of it? This part of the process can still unlock knowing and insight, so pay thoughtful attention to how you capture and document your objects, as this will be the way it stays with you as you move forward.

DISTILL

Throughout this creative process you have found objects, given them a voice, played with their artful arrangement, and captured their essence as you documented it. Along the way these objects have been helping you to make sense of, and deepen, your understanding of your experience. At this point you may have found the insight you were looking for, or you may want or need to keep refining it. If you have found it, capture this wisdom in your journal. Give your piece a title and write a few lines that distill the essence of what insight you have uncovered. If you feel the need to go deeper, you may want to continue exploring the objects by writing a short story featuring them, by including other objects into your arrangement, or even by sketching an object from different angles or perspectives to see how this influences its meaning.

WITNESS

When you have found and distilled the wisdom from your objects, as a final act, it is important to share what you have uncovered with a trusted person. Share how your creative process unfolded for you with a loved one, close friend, or even a therapist. When we share the meaning with someone else, it helps us to integrate our learning and make it real. Don't underestimate the power of sharing.

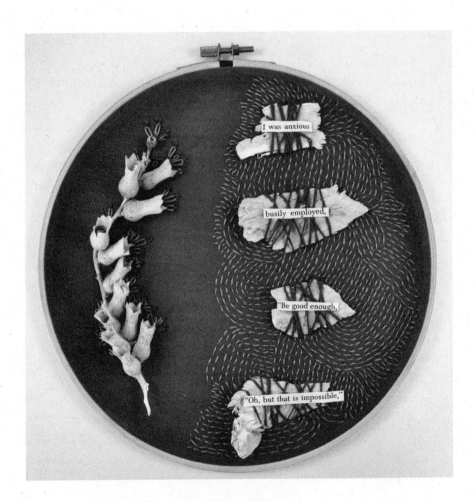

A Bifurcation (found natural objects and embroidery)

9

REWRITING THE SCRIPT
OF PRODUCTIVITY

NOT LONG AFTER I started working one on one with people, I began to see a common theme emerge. It felt like every conversation I had with a client began with them saying, "I know I should but"

A tension was hanging in the air—self-talk that fixated on deficiency was often followed by a wave of shame, and all of this was often wrapped up in the word *should*. This word seemed to signify not living up to one's potential, needing to do more or be better, a sort of cultural shorthand for making a value judgment that we have been slacking off and are teetering into failure. Once I noticed this, it seemed like the word *should* was all I could hear—"I know it's my fault; I shouldn't have let it get this bad," "I should be prioritizing my self-care more," "I shouldn't be so unhappy when I have food, a home, and my health," "I should just suck it up and make it work." And then I started hearing my friends say it, overheard it at the coffee shop, and even heard myself say it. Everywhere I looked an underlying script was being acted out; folks thought they were inherently bad, untrustworthy, or needed to be different. *Should* was just one word of many in this play, but the theme was clear; it was as though the default position of everyone I met was deficiency—no one was quite living up to the perceived standard. This insight was revelatory for me as a new practitioner. It touched on a tension that felt bigger than just a one-off situation; it felt endemic to the world. I could see the noxious harm of feeling deficient spewing

out everywhere, and I wondered who set this standard we are trying to achieve and whether we are all truly flawed.

Around this time, I had been working with a student named Laura for several weeks. She was part of a workshop series I was hosting. Laura was nearing retirement and I could tell she was deeply unhappy. She took each creative invitation seriously, with focus and intent, ready to take risks and learn about herself, but it was a hard process for her many times. I can remember one instance when she was cutting papers for a collage and she was stuck, tears welling up, a look of fear on her face. The room was busy, so we stepped outside in the sunshine. She held a paper with a shiny, gold, honeycombed pattern on it and we began to talk about it. This patterned paper had struck a chord. It was more than paper; it symbolized a life story. Orderly design, a rich, gold, predictable arrangement of hexagons, and the ghosts of hard-working bees not far off—this one pattern seemed to summarize the life of the good girl, good wife, hard worker, and devoted grandmother. Laura told me that she had spent her whole life doing what was expected of her, trying to be productive each day, and measuring herself with the yardstick of what she thought the world expected of her. She never questioned these expectations; it was so ingrained in her she assumed there was no other way to be. Each day she would judge herself (sometimes harshly) based on her ability to fulfill what was expected of her in the various roles she held. Every day she did what she should, and like the stack of hexagons, she felt all she had to show for it was a life of work and loneliness—a worker bee serving an unknown queen. As we stood in the sun, Laura found tears and relief in the catharsis of realizing the script of deficiency in her life. This, of course, was just a beginning for her, but she found new energy and freedom in finally seeing that she could choose something different.

I have gone on to hear so many similar stories from others, a cycle of bitter self-judgment that has us always questioning, Was I productive enough today? Did I do what I was supposed to? Am I trying hard enough? Did I get any closer? What else should be on my to-do list? Why can't I get through my to-do list? I began to see the threads of each malaise coming together, stemming from a single root—the pernicious script of *should* and a belief that we are only good when we are useful.

Internalizing the Script of Judgment

Photographer Patty Carroll stages the perfect home: matching curtains and drapes, a kitchen filled with impeccably decorated cakes and pies, and a room with immaculate, matching, pink décor. Buried in each scene is a faceless women suffocating in the trappings of domestic perfection, her face obscured, her body painfully contorted. Each photograph is a satirical commentary cleverly questioning the social roles that women play and showing how their identities becomes lost under the weight of their own quest for domestic perfection. In one scene named "Crisis DuCoture," a woman is buried under a pile of fuchsia clothes; the caption reads, "Deciding what to wear only led to giving up altogether!"[1] In another photo the legs of a women stick out from a stove, her pink high heels and the quaint hand-drawn photos for "mom" on the fridge showing the demise of a working mom buried under her domestic responsibilities. One can spend hours absorbed in the color, detail, and symbolism in each photo, each one commenting on the socially prescribed roles of women and their desperate attempts to find agency and identity in the claustrophobia of domesticity. In Carrol's words, "This work is about the quiet screaming that we do, when we are bending to the expectations others have of us."[2]

Carrol's work centers on the domestic sphere, but the experience of each of us trying to fulfill our own social roles is universal. The anonymous women Carroll portrays all find themselves caught under the weight of their own desire to be useful, perfect, successful, and accomplished. Her work has a distinctly vintage aesthetic to it, suggesting the tensions of identity and domesticity carry on through the decades. Over the course of the last century and a half, virtually every aspect of our daily lives has been rearranged around being useful. We organize our time around work schedules; we are required to have income to attain the security of home, food, and health; and much of our leisure has been commodified, meaning we need money to participate in it. While much of this has been taken for granted as the way things are, rarely do we have the means to question it. We judge ourselves based on the beliefs and stories that the world has been telling us; it has become the solid ground we stand upon, so it may feel scary to question it.

Most of us have been following the script our usefulness-obsessed culture has handed us, telling us that to be "good" we must be productive, independent, and constantly laboring for the betterment of ourselves and others. We see this script in action when we find ourselves believing that our achievements earn us merit, when we override our bodily needs for the sake of work, or when we engage in self-care or better our health so that we can continue to work and be of value to others rather than for our own wellbeing and enjoyment of life. Many of our internal thoughts center on the cycle of producing, measuring, and proving our usefulness to the world. We judge ourselves and override our inner needs when we say we are "feeling lazy" or that "we have to . . ." or "really should" Each voice is stifling our ability to be in the present moment and deepening our attachment to a future idealized and imagined version of ourselves we have yet to achieve.

We live in a time filled with life hacks, an obsession with optimization, and millions of products and services constantly telling us how to better ourselves. The default position is to presume that we are deficient to begin with, that we need to do something more to finally achieve worthiness. This results in us believing that we are not inherently good but that we need to be made so, that we must keep proving our value, and that our plight in life is of our own making. Everything has become our own personal responsibility. Feeling stressed out? Take better care of yourself. Unhappy? Transform yourself. Poor, homeless, ill? Prove your worthiness first and then the world may support you. We shoulder the burden of doing it all and face a constant barrage of internal dialogue that tells us that it's not enough. Perhaps the simplest way to test if you are subject to all this is to ask yourself, honestly, in this moment, Do I believe I am perfect just as I am, or do I need to change to be so?

In mindfulness we seek to attend to each moment without judgment, resisting the urge to label things as good, bad, right, wrong, and so on. But for most of us, judgment runs as a constant stream of internal chatter, sculpting our feelings, choices, and identity moment by moment. It's not until we begin to question where our voice of judgment comes from that we can see the intricate and sometimes crafty way it manifests in our lives. Often our judgments sound like echoes of our parents, family, bosses, teachers, other authority figures, or even popular culture and social media, each voice offering us a message that

we have internalized about how we should be. These voices collectively shape and sculpt the norms and expectations of our society, teaching us to stay within their confines and punishing those who stray too far.

In mindfulness, we let go of judgments about how we think things should be. Just like Laura and her honeycomb, we step away from the script of should and start to recognize how the expectations of the world impact us. We approach each moment feeling full and abundant, and we move toward intentional authentic action rather than doing things out of guilt, shame, and obligation. In doing so, we may find that we, too, have been lost under the distractions of our lives, like the anonymous women in Patty Carroll's work, and we are now ready to shake off the weight of our social roles and live more authentically. If we can notice the voices of judgment swirling in our minds, they begin to lose their power and we are left with a blank canvas that can be filled with whatever we choose. We no longer must play out the scripts of the past; we can choose to live in a way that truly meets our deepest needs as well as the needs of all who we love and cherish in this world.

Creativity as Resistance

Our creative practice has the potential to shine a light on our judgments, helping us to notice the ways that we perceive ourselves moment by moment. When we are in a creative act, we can quiet the world and just listen to ourselves. This can be a great source of pleasure or suffering depending on the day. My clients often report that when they create, the voice of a harsh inner critic may emerge telling them that they "aren't good enough," are "wasting time," or are "silly, pathetic, or entitled for being so indulgent." With just a single mark on a page, the stitch of a needle, or the click of a camera, a deluge of harsh self-judgments can be triggered. Instead of listening to and believing these voices, we can instead notice them, find space, and get curious about them. Our creative practice is the perfect place to do this noticing, to see what patterns show up in our internal dialogue and shine a light on the judgments we make about ourselves and our creations, moment by moment. Our creative practice is almost like a laboratory, a place to begin observing and studying these voices and their impact on us. I often recommend that people write down all the judgments and voices that pop up in their head during

the creative process with a nearby pen and paper. This helps us to both notice the judgments and take them out of ourselves where, afterward, we can view them objectively and see their impact. Once we begin to shine a light on these judgments, we begin to diffuse their power and recognize the ways they show up in other parts of our lives as well.

The creative process also has a tremendous capacity to be a place in life where we are more in our bodies and less in our heads. Although we can never fully turn off our cognitive selves (nor would we ever want to), we can intentionally create spaces where we cultivate a deeper relationship and connection with our bodies, senses, and the physical world we are in. Creativity is an embodied act; it integrates the movement of our bodies and engages our senses as we notice color, texture, tension, and sounds, allowing us to observe the world outside of ourselves with presence and curiosity. The more time we spend connecting with our bodies, senses, and the world, the stronger our relationship to them becomes. We begin to dwell in a space that is integrated with our minds rather than dominated by it, and in this embodied space, we are listening to the needs of our bodies and how our emotions impact the space rather than overriding this process or disconnecting from it.

In this way, creativity—specifically a creative process that we engage in for ourselves or creativity for its own sake—is an act of resistance, a place to dwell in that is holistic, connected, and integrated rather than the often-disembodied process of productivity. When we surrender to the creative process, we are letting go of the scripts of should and the need to be productive or useful. Instead we are dwelling in the immeasurable, engaging in an act that cannot be validated with the tools of society. Many creative spaces are filled with the echoes of productivity seeking to create value and worth, but the potential to leave these voices outside the door always exists. We can enter our creative practice, and it can be a space free of deadlines, utility, and output. Even professional creatives have the capacity to create this nonproductive space. It simply requires an intention to do so. We can play, explore, and just be; time can feel limitless, and then we can walk away and answer to no one, feeling more connected to ourselves and the world.

In a 2004 graduation lecture at Case Western Reserve University, author Kurt Vonnegut tells a meandering story of one slow morning of his life that

so perfectly sums up how presence, curiosity, and being in the moment can be overshadowed by our busy world.[3] Purposefully meandering and seemingly pointless at times, this tale of a morning where he sought to acquire an envelope and take it to the post office cleverly turns into sage wisdom from Vonnegut. With his signature tongue-in-cheek approach to the world, he shines a light on the subtleties and extraordinary power of simply puttering through the day without intent. As a close, he reminds the audience, "We are here on earth to fart around, don't let anyone tell you differently." Perhaps the audience was hoping for more practical actionable advice on how to find success in life (after all, the lecture was intended for new graduates about to launch into the world), but Vonnegut's wisdom requires the listener to detach from outcomes and see the beauty in the mundane. One of the great modern masters of literature with sharp wit and astute advice on resistance and the everyday, Vonnegut reminds us that we can judge ourselves with any stick we choose, so we should choose wisely.

Parallel Myths

The claw of toxic productivity in my life began with stories—the kind with wolves and bears, children in peril, and talking farm animals. As a child I would sit hidden away in a quiet corner flipping through the pages of nursery rhymes and fairy tales looking at the glowing radiance of the happily-ever-after page and feeling the terror of what was lurking in the unknown deep, dark woods. Each story started in a tiny corner of my psyche, and then it took up residence for good, shaping my little mind. Once the stories were there, they became a part of me becoming allegories for how to live, informing my language, and shaping how I understood the world. I wanted to avoid the bad stuff in life and get the good stuff, and it was these stories that seemed to hold the answers for how to do this.

Today, my daughter hands me a stack of books to read; she is three now, and all she wants to do is read books like her older brothers do. We sit down and read "Goldilocks" for maybe the dozenth time this week. She stares at Goldilocks' blonde hair and tiny stature; I think maybe she thinks that she could be Goldilocks too. My son yells from across the room, "What is the point of that

story anyway? She just runs away in the end; I don't get it." Then my oldest son chimes in, "You get to take whatever you want in this world just as long as you run away fast enough!" I want to dispute him, but I can't really think of another meaning for the story. He might be right; maybe that's why my daughter stares so intently. She is trying to decide if she can outrun the bears. Is that what I thought too when I was a child, that the world was mine for the taking as long as I thought I could get away with it? I wonder what the point of this story is; I can't shake the look of intent in my daughters' eyes, absorbing every detail, the story occupying a space in her mind that I don't quite understand.

I begin to wonder how the stories of my childhood shaped me. Back at my parents' house, I dig through the old bookshelf for books from my childhood. I find a scribbled-on copy of *Heidi*. My fingers run across the faded images of the Swiss mountains and forest flowers, perhaps they carved out an early belief in me about the power of nature. I find a faded copy of *The Swiss Family Robinson*, and I remember being in my bed, reading it, feeling enthralled with the self-reliance and endurance on display. With each book I pull off the shelf I can see a thread running backward through time—a message, belief, value, that still holds space in me today. I feel a mixture of gratitude and sadness, thankful for the stories of connection and hope and dismayed by the stories that taught me my most damaging beliefs.

I am forty now, and when I look back at the last decade of my life, I can count an exhaustive list of activity—I got divorced and then remarried, I gave birth to two more children (my first I had when I was twenty-eight), I finished my master's degree and my training in the Expressive Arts, and I changed jobs twice, started my own business, and moved four times. Behind each activity was often a veil of anxiety propelling me blindly and franticly to the next thing, a belief that I needed to prove myself to the world and be as self-reliant as possible. I also passed an endless stream of judgments on myself and experienced feelings that told me I was not enough, that what I did would never be enough, and that joy only came to me because of luck. Somewhere along the way an image of who I should be and how I should act came into focus, and ever since, I have been measuring, evaluating, and analyzing myself moment by moment against it, wondering if I will ever live up to it. I am Cinderella waiting for all my toiling and labor to be rewarded. I abstain from and police my indulgences just

like Hansel and Gretel taught me. And I know that little girls are supposed to be made of sugar and spice, so I have learned to suppress my untidy parts for fear of my puppy-dog tail showing. Each story is a mythic master, subtly shaping me to be something I can never quite live up to.

Today when I look around my home with its old drafty windows, the cold wind whips through them and I feel like I am living in the little pigs' stick house and the wolf is outside trying to get in. Maybe if I had worked a bit harder, if I hadn't taken so much time off after each of my children was born, I could have afforded a better house. I walk through my neighborhood and imagine which rich house I would buy if, somehow, I could. The Little Red Hen whispers into my ear, "the bounty and riches from hard work are only for those who actually do the work, not freeloaders like you." She is right, I remember this lesson. If I don't help cut the wheat, mill the flour, or bake the bread, then I am not entitled to the warm loaf when it comes out of the oven. People like me live in cold drafty houses; I have never worked hard enough to earn something so beautiful.

I catch my self-judgment spewing out onto my children, as I measure them against my beliefs. I have taught them that asking for help is wrong and self-reliance is good, to always choose activity (any activity at all) over laziness, or they will waste away. And that we must endlessly work to improve ourselves, never settling in life. I can see the origin of some of these stories, but others are elusive, and they don't feel much like fairy tales, but rather facts, truths that I can't quite let go of. But I have also noticed another story beginning to take up space in me, a magic beanstalk bursting through my mind that just keeps growing bigger and bigger inside of me, and it wants me to unravel every story that has come before it. This once small sprout of an idea has told me that I don't need to try so hard, that maybe I am complete already, that all my judging and measuring and shoulds and never feeling enough are just a distraction. I can teach my children they are whole to begin with, not broken creatures needing to be mended through so much work. I can shield them from this world of anxiety, shame, and never feeling enough. I feel a bifurcation begin to grow inside, the old belief inside me that I will never be enough remains, but a new belief that I am enough begins to occupy the same space.

I take my old copy of *The Swiss Family Robinson* and begin cutting words and phrases out. It feels like a tiny act of resistance to cut the pages up, a little

middle finger to the book that taught me the path toward loneliness and self-reliance. I cut out words and phrases, reading to make a found poem: "be good enough," "valuable prize," "we hurried," and "I was anxious," among others. I wonder what new lessons this story could teach me if I release the old ones from its binding. I take the phrases and explore how the meaning shifts and changes as I place them together in new ways, making new ideas and then dismantling them. It is an exercise in found poetry, reworking phrases like a DJ breathes new life into old music. I play around until I find the message I think I most needed to hear: "I was anxious, busily employed. Be good enough . . . 'Oh, but that is impossible.'" This is it; this is what I had been struggling with—the anxious pursuit of the impossible, an unachievable destination at which I had already arrived. I have been lost in anxiety and busyness, endlessly judging myself against an unmaintainable goal, and here it is, written in the words of this old book.

I place my words aside and go for a walk to meditate on them. I go to the river by my home and begin a walking mediation, breathing and feeling the connection between my foot and the ground. I want to feel a connection to something real and let go of the stories. The gravel and dried leaves crushing together under my feet feel real. I thought of Little Red Riding Hood; she was supposed to stay the path or else . . . Today I decide to try my luck with "or else." I step into the thick bush and notice a dried flower—each bell-shaped petal perfectly desiccate, timeless, and beautiful. Perhaps it was a vibrant color in the summer months, but today it looks perfect in its dull shades of earth. The phrase "be good enough" surfaces in my mind again and I think it is, right now, just as it is, good enough. I continue and see a fallen tree, beaver chips piled high all around. It doesn't make sense. The river is so far away; why would a beaver spend so much time cutting this tree down when he can't carry it away from here? I think of beavers being "busily employed" and wonder how many times they dedicate all their time and energy to a venture that offers them nothing in the end, how many trees lie dead, far from the river, where they can never be used? My energy shifts with the next steps, a little slower, a little more intention, a little less distraction in my mind.

I come home and place my perfect dried flower and my handful of beaver chips next to my found poem made from my old *The Swiss Family Robinson* text.

A plan to bring them all together begins to form, a visual representation of the division I have been living with—one side of me feeling complete just as I am, the other side anxious and busy. A new story begins to take shape. It's not complete; its two stories that don't feel so tidy: one story, in which I'm anxiously doing and judging, all in hopes that I meet my fairytale ending; the other story reveling in the grace of feeling whole and complete just as I am. I don't think I have ever read a fairy tale or nursery rhyme that made space for this expanse of being. I stitch this collage all together, sewing one side with the dried flowers, adding ornate details, and on the other side, I attach the beaver chips and my new poem, adding busy stitches to encase it all. A found poetry and embroidery collage, a marker of something, a new awareness taking hold inside of me. Maybe Humpty Dumpty had it right: maybe when you crack wide open you don't want all the kings' men to fix you, maybe the point is to stay splayed open, perfectly broken just as we are, messy and unruly outside the wall of conformity, celebrating the mess of ourselves and our broken bits laid bare.

CREATIVE INVITATION:
REDEFINING JUDGMENT WITH FOUND POETRY

Moment by moment we judge ourselves to be worthy, good, wrong, lazy, or any other host of beliefs we have about the way we should be. This creative invitation will have you create a found poem and a collage to reflect on the way judgment manifests in your life and the ways that impact you. Through this creative process, you will be noticing and then questioning the judgments and beliefs you have about how you should be and then identifying their origin. In many ways this is a process of questioning the solid ground on which you stand and the snap judgments you make about how things are and how things should be. Some of the judgments you hold may stem from family experiences, the workplace, messages from popular culture, and even society at large. I encourage you to listen to your judgments with an open mind. It may be an uncomfortable process to question what we have become so conditioned to accept in our lives, but liberating when we do so with curiosity.

ARRIVE

Begin this creative process by closing your eyes. Spend a few moments observing your environment, notice the sounds around you, notice any sensations in your body, and observe how you feel in this moment. Find a natural rhythm to your breath and begin to set the intention to inhale a feeling of wholeness or completeness, perhaps saying to yourself, "I inhale and feel complete." On your exhale, release any feelings of deficiency or lack, saying to yourself, "I exhale my feelings of deficiency." Do this for twenty breaths.

SET AN INTENTION

Set an intention that explores what you want to gain from this process or the direction you would like to lean or grow toward. This process is about beginning to see the judgments that you make about yourself and the world, moment by moment, so consider exploring the way judgment manifests in your creative process. For example,

> I intend to observe the judgments that come up as I create.
>
> I intend to stay with the questions that arise rather than being quick to jump to answers.

If you find yourself getting pulled in other directions or distracted in any way, remember to go back to your intention; it should serve as an anchor for you.

ASK A QUESTION

What are you hoping to gain from this process? Ask a question specific to your own needs in this moment about how judgment manifests in your life. For example:

> How do I think I should be?
>
> Where does my inner voice of judgment stem from?
>
> What am I believing about myself in the context of . . . ?
>
> How does judgment creep into my creative practice?
>
> What messages or stories have I internalized that are destructive?

PREPARE

To begin this process, it may be helpful to start identifying the inner tension around how you wish you were or how you feel you should be, compared to how you actually are. Uncovering this gap between our two selves will help us to begin identifying some of the judgments that may be trying to govern you moment by moment.

Using either words or through sketching, depict an ideal version of yourself. Close your eyes and in your mind's eye envision an ideal version of yourself. Who would you be in mind, body, spirit? What would be different? What would be missing or added? Capture this image of your ideal self on the page using words or imagery.

Take a moment to observe this version of yourself. What are some of the things that you would need to do to make this a reality? Why do you think that you aren't this person already or that you should work to be this person?

Look back at what you have captured now with a new perspective. What are some of the judgments, beliefs, or values that are driving this idea of how you should be different? Write out three to five of these tensions that are driving this. You will work more with these judgments in the creative process.

FIND YOUR POEM

Begin finding your poem by flipping through old books or magazines looking for phrases or words that hold intrigue for you. Trust that the words and phrases that you most need to hear will come to you in the process, that you don't need to go looking for them. You may want to cut from a book with special significance to you or seek other texts that may feel less familiar. Aim to cut around ten phrases or words.

Once your words and phrases are cut, begin forming them into a poem. Clear a surface and begin to place phrases next to each other, playing with order, placement, and so on. See how many different configurations you can explore and how the meaning shifts and changes. Choose a composition that you feel offers you the most wisdom. You may not want to use all of the phrases you cut, and you may also want to seek out specific linking words or other words with significance to help complete your poem.

CREATE YOUR COLLAGE

In the next part of the process, you will create a collage as an accompaniment to your found poem. You can make a collage of found images, papers, objects, fabrics, or anything else you feel inspired to include. Your poem may have imagery or symbolism in it, or you may choose to accompany it with found matter that imbues the feeling, emotion, or meaning of it. Aim to collect at least two to three objects or images to bring together. Like you did with the found poem, see how moving them around, playing with space, cutting, and adding marks, color, and so on enhances their meaning and significance. Think of the visual composition as an extension of, or accompaniment to, the poem that enhances its meaning.

WRITE

Once your collage and poem are complete, return to your journal to help you uncover and formalize the meaning and insight you found in the process. Imagine that this poem and collage came from a very wise part of yourself, a part of you that can see the big picture and has come to offer you wisdom to help you in this moment. Using the prompt "My wise self has come to me throughout this creative process to tell me. . .," begin to openly write in your journal. Allow the words to come with ease. You don't need to think too hard or try to solve anything; just trust the wise part of yourself to let the words flow. Once you feel complete, look back at what you wrote and underline the most important two to three key words or phrases.

DISTILL

Looking at your found poem, collage, and the key words or phrases you underlined in your journal, go back to your initial question and consider what you have learned or uncovered throughout this process. How will your moment-by-moment judgments, internal dialogue, and thinking change because of this? How do you want to evaluate yourself differently or embrace your wholeness with more intention? Consider what the bigger lessons and takeaways are for you. You may want to write them down formally.

WITNESS

As always, it's important that you find someone to share your insights and learnings with. As you explore your own self-judgment and how the world has shaped your belief about yourself, it's important to share this with others and build a culture of support for yourself to embrace this new insight. Who can you share your creative journey with? What insights do you most want to share?

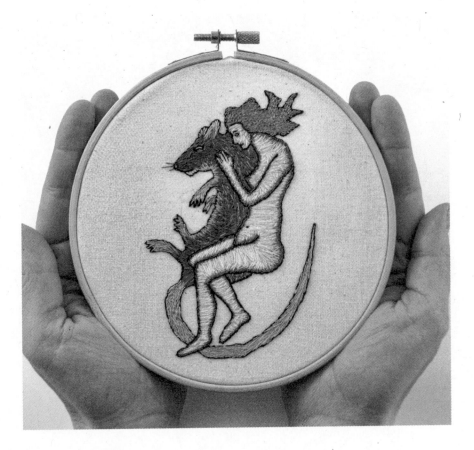

An Intimate Fear (embroidery)

10

WELCOMING
FEAR AND PAIN

I OFTEN BEGIN my classes by reciting a poem out loud. I find that poetry has the capacity to instantly collect a room and connect everyone in it at the most human level. Sometimes I choose poems that center on hope; other times I choose poems that cut to the heart of a shared pain. In one memorable creative mindfulness class, I read an empowering poem. I could see the gravity of it settling down on each person, a soft recognition of their suffering and pain through the alchemy of poetry. The room was uplifted and joyful, and then I asked everyone to recall a challenge they were facing and begin sketching it. In an instant, the hopeful prescription of the poem faded into the background. The reality of suffering was laid bare once again with nowhere to hide.

The same phenomenon plays out many times in my classes. We welcome life into the creative process and flip back and forth between hope and suffering, resistance and desire, curiosity and withdrawal, again and again. People show up with optimism about trying something new, but inevitably the messiness of life enters and the excitement fades. Pam was one of these students experiencing the push and pull of the dark and light in the creative process. Focusing on a difficult situation she was facing with her partner, she used red and black scribbles all over the page to depict the heavy anger she was noticing in her chest. Afterward, when we discussed the process, she said she felt like

she had just been baited and switched: that the poem had made her feel optimism at the start and then, within moments, she was back in the doldrums of her anger. She had been feeling resentment and distance growing in her love, but she was scared to face it. She didn't want to go there. She had a deep well of resistance to facing the anger she had toward her partner; she wanted to keep working with the optimism, not the pain. Pam wanted to find resolution, but her fear was telling her that maybe there was a backdoor into this problem, a way in that was softer and easier.

Pam and I continued to talk and work through her fear and anger. We discovered that she had been spending a tremendous amount of energy avoiding it, trying to downplay it, telling herself to get over it, and rationalizing why she shouldn't feel this way. Pam wanted solutions—she wanted to do something to fix the distance she had been living with. She loved her partner and didn't want to leave them, but she had unnamed hurt that was consuming her every day. The process I was offering her wasn't a big sexy fix to her problem; there was no pill or five-point plan, we weren't going to draw away her anger and fear. In fact, it was just the opposite. This approach was a way to strip away all the thinking and really be with the fear she had about facing this issue.

We sketched her anger again and again, each time getting to know it a bit more. Sometimes it was prickly and sharp, other times hidden behind something. Sometimes it moved fast like a swoosh on the page, and other times it weighed heavily. We tried to understand the shape and nuance of her anger just as an artist would observe the details of a bouquet of flowers they were sketching. Sometimes we would draw a safe container or place where her anger could rest as it was, such as in cardboard boxes, coffee cups, green meadows, and placid lakes. Each scene was an invitation to allow her anger to just be. In time and through practice and intention, Pam's fear and resistance to her anger began to recede. She could finally see her pain instead of running from it. After all our sketching, it finally felt familiar to her, and she was able to communicate it to her partner with calm decorum. Their problems didn't disappear, but something else grew: a willingness to be with each other fully. Pam stuck with it; she found courage in the face of her fear and a willingness to be with the uncomfortable, and in the end, she found a space in her life, a place for her fear, anger, and hope to come together.

Living Alongside Fear

Fear is a shapeshifter, constantly transforming and remaking itself. It can be hard to identify fear because it shows up in so many varied ways: it can make you feel numb, anxious, powerless, dominated, stuck, or even chaotic. When we peel back the layers of our suffering, it's often fear at the core. In the western world the cultural narrative is that we should act, be brave, and do something about our fears—take the upper hand. We are told to "face your fear," "overcome fear," or "act in the face of fear." Yet we needn't look far to see that fear is never fully conquered; rather, it is persistently changing forms and popping up in new ways. We may not fear spiders, ghosts, or the dark like we did as children, but if we look closely at our lives, we see that our fears have simply dressed themselves up differently and morphed into something new. Most of our fears now live in our unconscious, craftily wrapped up in a million different moments of our day. Instead of the spiders, we now fear rejection, loss, hurt, or getting into trouble. We have replaced ghosts with losing love, or not living up to our potential, and our fear of the dark has become a fear of wasting time or wasting away.

The illusion is that we can, one day, finally arrive at a place where our fears are gone. Mindfulness offers us an invitation to practice acceptance—to neither run from nor eradicate our fears but to make space for them. We spend a tremendous amount of time and energy trying to avoid and outrun our fears, but what if instead we saw fear as important and valuable? We would then flip the script on fear and accept that we will always be afraid of something, choosing instead to learn to live in this reality. In doing so, we may find a new type of freedom.

A fascinating story has been emerging over the last thirty years in scientific literature about Yellowstone National Park that provides a poignant analogy for the benefits of living alongside fear.[1] There are few greater symbols of fear from the animal world than wolves, and for seventy years Yellowstone National Park was without this apex predator, having lost them all through hunting. As a result, the elk populations began to surge. Because they no longer needed to fear the wolves, they began to move around less and graze more intensely on willow and aspen tree stands. This began to negatively impact the beaver

population who relied on these trees to survive the winter. The beavers suffered, and the impacts continued down the food chain. The lasting impacts of the absence of wolves wasn't fully understood until biologists reintroduced a pack of wolves into the park in 1995. Suddenly, the elk needed to be afraid again, and this changed their behavior. The elk began to move around more, which allowed the decimated natural areas to regrow. The beavers had an abundant food source once again and could build dams, which affected fish and bird populations. A positive cascading impact on virtually every animal in the ecosystem unfolded as a result—even the rivers were reshaped—all of which can be attributed to the reintroduction of wolves. It turned out that wolves and the fear they caused in elk were incredibly important shapers of ecology. When the elk lived with fear, it promoted a more balanced and sustainable outcome for the broader ecosystem.[2]

This research contributes significantly to how ecologists understand ecosystems, but it also serves as a compelling analogy: not all the impacts of fear are negative; fear belongs in this world, and the presence of it has far greater impacts than we can possibly understand. Perhaps the answer isn't to eradicate the proverbial wolves in our lives but rather to live alongside them, accept them, and seek to understand them better as they relate to the ecology of our own lives. When we seek to eradicate that which scares us, we are negating the broader function it serves in our lives. Fear keeps us safe, motivates us, and reminds us of what we value; it has the capacity to push us into new terrain (just as it did for the elk.) The lesson of the wolves and the elk isn't that the elk shouldn't act on their fear or that wolves can never cause harm but that the broader context that fear functions within is complex and important, and that we must accept fear rather than resist it or hide from it. In this story we are not the wolves or the elk; we are the ecosystem that relies on a delicate balance to sustain ourselves. When we eliminate the wolves in our lives, we may be causing a new harm, but when we begin to see the wolves, understand them, and live alongside them, then we can begin to live in balance with the world.

To do this we need to cultivate a new approach, find new wisdom to guide us in learning how to live alongside our fears as they shapeshift in and out of our lives. One approach, built on the notion of acceptance, comes from Buddhist psychotherapist Bruce Tift who asks a powerful question in his book *Already*

Free: "What if you had to keep living with your biggest problems until the end of your life?"[3] For many people, this is their greatest fear—that they will never escape living with pain, rejection, loneliness, or whatever form suffering takes in their lives. Tift asks us to reorient our thinking away from eliminating our fear of suffering to accepting that these things may always be with us. We can view this as a powerful thought experiment, but we can also see it as an invitation to take on a new paradigm, a chance to reorient our thinking and behaviors from resisting and avoiding our fears to embracing them.

Mindfulness teaches us to use the powerful medicine of acceptance in the face of the unpleasant realities of our suffering. Will we spend our lives running from the wolf, or will we be still, observant, and seek to understand the way the wolf functions? If we attune ourselves to the wolves in our lives and begin to understand their impact on us, the role they serve, and seek to cohabitate with them, then we can act with intention and wisdom rather than fleeing to whatever comes next. We may overcome our fear of rejection when we find safety in true love, but what will we do when fear comes back again, now telling us we will lose it all if we ask for too much in this relationship? Accepting our fears doesn't mean that we don't do anything and let harm come to us. It's just the opposite: we get to know fear and understand it so that we can take the right action. We see fear as a type of wisdom, and we seek to learn from it each time it appears in our lives, accepting and inviting the shapeshifter out into the light so we can recognize its power.

Expressing the Unconscious

To make sense of our complicated relationship to both our conscious and unconscious fears, we need to employ tools that function at both levels. Typically, we are asked to talk about our fears using discursive thinking—employing our cognitive analytic thoughts to express them. We may describe our fears in a straightforward manner, tuning into our conscious understanding of the emotion: "I am afraid to be alone, I hate being in my house, I always feel better having people around." In contrast, our unconscious mind functions in the background, making quick perceptions and associations and formulating ideas, often through symbolism. Right now, your brain is regulating your breathing and heart, connecting what you are

reading with your experience, maintaining your personality, processing sensory information, and so much more, without your conscious awareness. This part of you is quietly working in the background without note, like a silent, invisible companion.

Imagine trying to communicate your fears without words. You would likely resort to using bodily gestures, scribbling colors on a page, vocalizing, or finding images to act as symbolic representations of your fear. Spontaneous creative expression, the imagination, and symbolism each stem from the unconscious mind, allowing us to access and listen to it. Although we can never fully separate our conscious and unconscious minds from one another (nor would we ever want to), we can begin to bring our unconsciousness to the forefront and listen to its symbolic language. We can choose to rely more heavily on our embodied expressions that draw on culture, memory, dreams, and other symbolic signifiers. In a way, it's another language we speak, a subtext we use to communicate the intricate. Symbolism is born from the imagination; when someone is in an imaginative state, various parts of their brains are actively working together. In a sense, the process of imagining is that of integrating various parts of ourselves, from our bodies to emotions to our unconscious beliefs and perceptions, helping to make it all conscious. When we welcome our imaginations to speak to us in the symbolic, we are bridging the unconscious with the conscious, gaining a 360-degree perspective of ourselves.

When we present a question to ourselves, such as "What am I afraid of?," we can participate in a sort of call and response and allow our imaginations to create symbolic answers that sit outside of the cognitive plane.[4] If we can quiet the inner chatter of our minds and let our unconscious begin to reveal itself, we can begin to understand ourselves and our problems in new ways. You may have had the experience of trying very hard to solve a problem or find inspiration, but then you reach a point of mental fatigue and exhaustion and walk away. Then later, while you're walking, showering, driving, or doing a routine task, the solution suddenly presents itself to you—a eureka moment! This phenomenon is a result of a quieting of the conscious mind that allows your unconscious mind to begin working at the problem. Once your mind can work more holistically, suddenly the solution has the space to emerge.

History is filled with stories of countless discoveries and creations being born once the conscious mind rests and the unconscious mind has a chance to go to work, and the insights often emerge as symbolic representations. In 1865, German chemist August Kekulé visualized the ring structure of benzene after daydreaming of a snake eating its own tail; the insight changed our understanding of how molecules bond.[5] The Rolling Stones guitarist Keith Richards is reported to have created the opening riff for "(I Can't Get No) Satisfaction" after awakening from a dream and quickly recording the melody; the song later went on to become *Rolling Stone* magazine's #2 ranked best song of all time.[6] Both stories are examples of the phenomenon that many of us have experienced before: when we allow our subconscious to speak, it does so through symbolism and expressive languages, weaving together wisdom, insight, and knowledge from every realm of ourselves.

When we engage in spontaneous creative expression, improvise, or work with dreams and the imagination, we are actively inviting our subconscious to the table. We are asking it to speak and offer its insight that may or may not have been integrated into our conscious selves yet. As we seek to live alongside our fears and understand them fully and completely, we must learn to listen to the symbolic, to the echoes of our imaginations and dreams, and view these as worthy, important messages from another part of ourselves.

Welcome, Mouse

I wake up early each morning to be in the quiet. I meditate, perch myself on the corner of my couch, and drink black tea as I watch the light slowly fill the sky. I hear just the sounds of my breath moving in and out, my furnace whooshing, and my fridge motor humming; the three have a peaceful harmony together. In these moments, it feels easy. I don't have to worry about anyone else; I feel safe in my own cocoon in control. But inevitably, a few times a year, a mouse creeps in and joins me too—clawed feet scraping behind the bookcase, scurrying sounds from the stove to the fridge. An intruder is sauntering through my space, my morning, my peace. With the appearance of a mouse, my stomach lurches, my feet bounce like a cartoon character, and my blood pressure zooms

to a new high. My peaceful bubble cracks wide open, the outside world and all its chaos rushes in, and I am alone with my fear again.

From the moment I left home as a fresh eighteen-year-old, mice have been there ushering me into what life is like in the real world. Every place I have ever lived has had me in a showdown with mice, waging war with traps and poison, and spending sleepless nights listening for scurrying sounds. I've encountered a mouse in my closet clinging to a green sweater, one nesting in my son's clothing drawer behind his socks, and one scurrying across the counter while I cook dinner. When mice are present, I can't rest; they move through the most intimate parts of my home and it seems nothing is off limits. Their territory is ever-expanding as they reach into me, setting fear in motion in every part of my body. It feels as though the mice strongarm me into sharing my home, and without my consent, they erode my boundaries, becoming creatures of inevitability to whom I must forfeit my peaceful life on a routine schedule.

I like to think that I am the type of person who is in control and independent; I can take care of myself, find my way, advocate, and get shit done. I push through and away discomfort, overriding sickness, sadness, pain, hurt, and exhaustion (not the healthiest skill set, but handy). When mice show up, however, the whole illusion crumbles; they traipse through my home and through me and reveal all the terror and fear underneath that veil of independence. The fantasy that I am in control, that I have sealed all the cracks in my life, is revealed with the first squeaking sounds of an intruder. I hear the snap of a trap and the death rattles of a flipping mouse pinned between the metal bars, and all my vulnerability is laid bare. It may as well be me trapped and begging for my life. The mouse is the messenger, reminding me that I am finite, mortal, and that there are limits to my control. I can't do it all alone; in fact, I am really nothing without help. I must rely on the tender exchange of care with other people in my life, and that feels messy.

The truth is that behind the curtain of my life, I am a woman trying to love and care for three young children who test and tenderize me every day. As I sink deeper in my love for them, I watch them change and grow, which requires me to constantly adjust and adapt my love for them in response. At the same time, I am also faced with my own love for my father, who is dying a bit more day by day. To love him means to watch him suffer; his health is now far beyond the

realm of anyone's control. I can't govern either of these loves; there is nothing independent about them. I am done in by joy, pain, loss, and happiness. I offer a good morning hug to my children, who soon descend into a squabble over a toy dinosaur; I visit my father, eager to share with him the news about my new publication, but the morphine is strong today and he can't stay awake. Here I am, standing with arms full of love, not quite sure how to give it away. I wanted the depths of love and intimacy, but I never understood how chaotic it would feel. Part of me wants to pull back, way back, and forget the hug or sharing of exciting news; I want just to be a custodian of caring—making meals, saying happy birthday, existing on a biweekly schedule of connection. I want the goods of love, I want to jump in with both feet, but I know now that the water is always going to be a bit chillier than I want it to be, and that's what I hate. Every time I find peace and connection and breathe with peace, something unexpectedly scurries in, showing me the pain on the other side of love.

One afternoon I collapse on my couch, beyond exhausted, my quiet morning a million miles away. More bad news about dad today, a house full of loud children, and I am locked down, in the thick of the pandemic. My home and my heart are bursting at the seams with chaos; I can't remember the last time I felt in control. I decide I am not going to get up until I feel better (knowing that may never happen). I close my eyes and begin to doze. I am in that liminal place, in between awake and asleep, in a dream world of sorts, walking through my home, room by room, and then I see a mouse and begin to follow it with my eyes. It darts through my blanket, disappears inside my cupboards, scurries along the back of my couch. My body is flooded with vulnerability; I feel more and more out of control every move the mouse takes. My heartbeat is in my throat and fear takes over my body.

But things are a bit different in this not-quite dream state, and below all the fear, I know that I am dreaming, that it isn't real. With the sliver of agency I have left, I decide, for some reason, to follow the mouse. When I get close, I hold my hand out and invite it to come to me. I can now see it's also terrified; it's trepidatious and leery of me, but despite this, it climbs up into my hand. For a moment I am holding this creature with tenderness, and our shared fear dissipates into trust. Then, in a clear flash, an image of me intimately holding and cuddling this mouse as we sleep comes to me. In this scene, the mouse is large and gentle;

I don't feel an ounce of fear, just reverence and love. Then I wake abruptly and find myself sitting on the edge of the couch, the image still hanging in the air in between this world and that. I know this vision is symbolic, inviting me to welcome and accept the fear I had been carrying. At this moment, there is so much chaos in my life, so much constant change, and so much I can't control. Each of my children is so ardently and wildly taking their own path of becoming, inching further away from me and closer to independence day by day. And my dad... I know he will die one day soon. We all will, and then what will we do with our love? I feel my children moving into their own beings, my dad slipping away toward death, and I am left with a mountain of love and vulnerability, knowing that change is inevitable and I can't control any of it.

I know that I need to follow this imagery and the wisdom of my imagination, so I grab my sketch book and try to capture the image that has come to me. The tenderness, the welcoming arms, the tawny brown mouse fur I caressed in my hand. I sketch four or five drafts, each image subtly different, and then I look at the marks, at the completeness of the images, and still feel the need to linger, to spend more time with them. I don't want this experience to go away so quickly; I keep feeling a tug to prolong the experience, a chance to be with this knowing longer. I decide to translate the image into embroidery—the slowest, most intentional medium I know. As I move the sketch to fabric, select just the right mousy brown colors, and begin sewing each tiny stitch, I know there won't be a quick escape, that this image of fear and me nestled together will be in my mind and my hands for weeks.

As I stitch and meditate on this imagery, I realize that I am already living face to face with so much that I fear. To love my children, I need to let go of control. I must be with their ever-changing moods, interests, and evolution of becoming. I must walk alongside them, hand in hand, until the end. At the same time, I also find myself needing to move closer and closer to letting my beloved father go, nearing this threshold of having to say goodbye forever, and he, surely, won't be the only love in my life I loose. Yet here I am, living this truth, living alongside my fears, letting go of control, embracing the chaos and finitude of love, feeling starkly and unabashedly naked and vulnerable in my love. As I stitch, I realize that all my fears are already here. It isn't some future-state activity; I am already knee deep in it, caressing its tawny fur each day. With each stitch, I can

feel this realization, and somehow the grip fear has on me begins to loosen as I understand it more.

After forty-plus hours, my stitching is complete. It is time to let this piece hang on my wall alongside the others. My friends and family will walk through my home and notice it on the wall and wonder what this strange piece is all about. I suppose I will have to tell them it's me getting intimate with my fear. Yes, I am terrified of mice, but I am also terrified of surrendering to the chaos of what it means to truly love. Perhaps it will be difficult to explain how a mouse has come to symbolize this fundamental truth, but for me, the image speaks lifetimes of wisdom. This morning, I awake to the regular sounds of my breath, the furnace, the fridge, and my old friend mouse scratching away in the corner. A flash of fear floods me, and then I breathe again and remember that the mice are always there, that they will always be there no matter how many traps I set. It's an inescapable truth in my life that to be fully in this world, in the depth of love and life, I am undoubtedly and most certainly out of control, a passenger riding this life, reveling in the beauty of loving, until one day the ride ends.

CREATIVE INVITATION:
SKETCHING YOUR WAY TO ACCEPTANCE

Creativity has the capacity to help us tap into our unconscious minds and reveal our hidden fears, whereas mindfulness teaches us to find acceptance for the fears we unearth. When we welcome fear into the creative realm, we can begin to see it with new eyes and practice acceptance for the way it functions in our lives. For this creative invitation, through a series of sketches and creative writing exercises, we will utilize spontaneous art-making techniques to help us slowly welcome our fear into the world, and by doing so, practice acceptance.

Please note that because this process seeks to work alongside the unconscious, you may feel surprised by imagery, the level of emotion, or your response to the process. If you are someone who has experienced trauma, you may want to consult with your therapist or key support person to ensure you feel safe and cared for in this process.

ARRIVE

Begin by taking a few moments to explore the movement of sketching. Take a big piece of paper and two mark-making tools (pencil, charcoal, pastel, etc.) and set a timer for 5 minutes. Place a mark-making tool in each hand, close your eyes, and begin drawing on paper with both hands at the same time. Feel the sensations of the movements, the sounds of the marks on the page, and the rhythm of your hands, moving together. You may want to play and explore the sensation of moving your hands in synchronicity, separately, making a circular pattern or lines. Follow your impulse and continue to move both hands until your timer goes off.

Take note of your inner experience; see if you can list as many feelings, emotions, and sensations as possible that describe how you are feeling in this exact moment. Write them down on the marked-up paper or in your journal.

SET AN INTENTION

Set an intention that explores what you want to gain from this process or the direction you would like to lean or grown toward. This process is about connecting with the unconscious and cultivating an attitude of acceptance for your fears, so you may choose to create an intention that touches on either one of these. For example,

I intend to welcome my subconscious to take the lead.

I intend to notice and make space for any fears that I uncover in this process.

Go back to your intention during the process; use it as an anchor when you find yourself feeling overwhelmed, distracted, or uncertain.

ASK A QUESTION

What are you hoping to learn more about or explore in this process? Ask a question specific to your own needs in this moment, about how fear may be consciously or unconsciously manifesting in your life. For example:

How does fear show up in my life?

How does fear impact my relationships, work, choices, and so on?

Which fears am I conscious of, and which ones am I still unwilling to face?

What is my subconscious trying to communicate to me?

PREPARE

To begin, identify a symbol from your imagination. There are two ways to do this:

Explore a Dream

Close your eyes and see if you can recall any recent or reoccurring dreams you have. In your mind's eye, go back to some of the imagery, symbols, or feelings that were present for you in this dream. Spend a few moments reconnecting with the dream, inviting your senses to absorb the experience once again. When you are ready, follow the upcoming sketching and writing instructions.

Imagine a Symbol

If you cannot recall any dreams, simply close your eyes, take a few moments to ground yourself and connect to your breath, noticing the in-and-out rhythm of it. Once you feel settled, imagine yourself picking up a large book and flipping through the pages of it. On each page is an image of an object. Begin flipping through the pages noting the images that you see. Once you have seen six to eight images, ask yourself which image best represents you. Flip back to that page and view the image in new ways or using new perspectives imagining now that you are the object. How does the change in the object's presentation relate to you?

When you are ready, follow these sketching and writing instructions:

Begin to sketch and write about what your unconscious just shared with you. Quickly sketch an image or symbol from what you just saw. This may be an object, a posture, a place, or something similar. Give the image a title. Now give the object a voice in a written response. What does this symbol want to say to you? Let it speak through you, and to you, as you fill a page in your journal. Look back at what you have written and underline any key words that feel significant or fears that you may have uncovered in this writing process. You may choose to write a summarizing statement or phrase about what the meaning of this image is or what you just learned about fear.

SKETCH

Continue listening to your unconscious and exploring your fears with a new series of spontaneous sketches. In your journal, take a pencil and hold it loosely with your hand midway up the shaft. Allow this loose, free grip to guide you through making a series of

marks. Move your pencil without thinking, connecting marks and adding lines, circles, and shapes quickly together. Create three to five images, spending about thirty seconds on each. Place your pencil down and begin to look at each cluster of marks; rotate your page and try to see if any imagery begins to emerge for you. Once you see an image, begin to add, or take away, marks to help clarify the image. Complete this process for each image. Your sketches may look rudimentary, childlike, and quite abstract. This is okay; they are the seeds of images stemming from your imagination.

Explore the meaning of each image further through writing. Begin by writing three to five words next to each image that capture the feeling, essence, or energy of what that image is. Now take those words and write a simple poem, or a set of phrases. Complete this process by giving each image a title or by writing a phrase next to each image that captures your feelings.

FIND A SYMBOL

At this point in the process, you have created a series of images and written responses that came from your unconscious. You may have already uncovered some valuable insight and knowing in this process, but we want to focus on making the connection to fear. Look back at each of your images and writings and ask yourself, Which of these has the most to teach me about fear? Follow your intuition if the choice isn't immediately clear.

Spend some time sketching this image again. You may want to keep the image in a playful abstract form; focus on basic shapes and lines if drawing is an intimidating process for you. Create two to three sketches of this image, feeling free to expand upon, add, or omit any elements. Consider this part of the process as a chance for you to integrate your whole self and really flesh out this imagery into something clear. Once you have a sketch that feels complete, you are ready to write once again.

WRITE

Now you will write a simple one-page fiction story or poem in response to the image you have chosen. Begin with the phrase, "This story is about fear . . .," or "This is my fear . . .," and begin to write freely. Remember to trust the process and let the words flow; allow the words to lead. Trust your imagination to invoke symbols, characters, or imagery that supports meaning to emerge. You can choose to make this as simple or as complex as you like. Once you feel that you have sufficiently explored this, look back and take note

of two to three phrases or points of meaning that speak to you about the essence of the fear that you explored.

DISTILL

Loop back to the initial question that you asked as a start to this process. What have you learned or found in relation to this? Do you see fear in a new way? In what ways can you continue to welcome, accept, allow, and explore how fear functions in your life? Plan for a way to revisit this fear, either through another creative process, in a mindfulness practice, or otherwise. Leave the door open on this insight, offering it acceptance and allowing yourself to continue to let your fear be just as it is.

WITNESS

When you are ready, share the wisdom, insight, imagery, or writing that you found in this process with a trusted person. If you are someone who has been connecting with a therapist or similar professional, you may want to bring some of this imagery or these words back into a process with them to continue to harvest insight. As you allow someone to witness your process and meaning, notice how you may feel pulled to fix, eliminate, or push away fear. Instead set the intention to let this be a chance to simply note it and see it for what it is, nothing more.

Defying Definition (embroidery and wire)

11

IMAGINATION, SYMBOLS, AND NON-REACTING

REGINA CALLED ME one morning looking for help: "Rachel, I was scrolling through Facebook and then I saw this quote that *she* posted . . . it ruined the rest of my day. I couldn't even sleep that night. I just kept thinking about it." Regina was embroiled in a conflict at work. It was especially difficult for her because many of her colleagues were also her friends. Over the course of a few months, she went from feeling like a competent member of the team and considering many of her colleagues as some of her closest friends to being an outsider, facing discipline at work and extreme loneliness in her personal life. It was easy for Regina to launch into stories—various tales of "he said she said" variety—glares, passive aggressive judgments. There was no shortage of drama spilling out from the situation. The way Regina told the story, every person and event fit squarely into boxes of good and bad, right and wrong—there was very little nuance to her version of events. When Regina couldn't find her way out of this constant stream of conflict, she came to me hoping to find some resolution and peace.

Rather than focusing on her story of hurt, we instead focused on her feelings of hurt. In each of our sessions, we began by exploring what she was feeling inside of her body and what emotions she could detect. We would then invite the feelings to come out through shape, line, color, and sometimes movement.

Once we could see her feelings more clearly from this new perspective, I began to ask Regina to question what she could be sure was absolutely real in each of the situations. The more we explored it, the more we found that the only thing concrete about each situation was her emotions. In time, Regina began to see that the hurt she was feeling was real, but the stories and judgments that were feeding the hurt were often pure fiction of her own making.

In one of our sessions, I laid out a series of art cards, each filled with beautifully rich images of people, animals, and plants in assorted scenes. I asked Regina to see if one of these cards had some wisdom for her. She surveyed the images and settled on a card that depicted a naked woman who was part bird, her beak facing toward the sky and her wings outstretched. Regina looked at the image and said that she felt it represented power. She saw it as a reminder that she had a choice in times of conflict: she could be the bird woman and fly above the world and gain a new perspective, or she could react. We worked with this image more, sketching it, imagining it, and talking about it, and as Regina brought forward the symbol of the bird woman more frequently, she found her story about conflict soften. She knew that she could only own her feelings, not the motivations and intentions of others. She found she had more power than she ever thought when she wasn't stuck in a reactionary cycle. Regina began to deeply know that when she reacted, she was perpetuating her own suffering and feeding the drama rather than fulfilling her deepest desire to find peace. Instead, she now knew she could fly above, gain perspective, and then decide what to do next.

Beyond Non-Reacting

One of the greatest gifts of mindfulness is realizing that we are not solely our reactions, feelings, or sensations. We are the grand observer of our lives, the one in the background noticing it all unfold. The observer within us lives in a space that is undefinable, a space that transcends reality where it is capable of recognizing complexity and richness in every moment. When we find this space, we realize that we have the power to choose our actions; they don't choose us.

Reactionary living means we let our agitation drive; we become quick to judge, respond, and insert our thoughts, acting without any pause for reflection.

Our days are spent chasing endless activity as uncertainty and inactivity become the enemy. Or perhaps we are stuck in a cycle, feeling as though life is simply happening to us. For most of us, our days are filled with a constant barrage of reactions to events: "Maybe she doesn't like me?" "I am bad at this." "I will never catch up." Each reaction tricks us into thinking we are the product of our emotions and judgments. In this state of living, we instantaneously declare, define, react, judge, push away, or pull closer in every moment, carving away boxes and labeling ourselves what we are or are not, forgetting that all of this is fleeting and that the part of us observing could have a different perspective to share. The mindfulness principle of non-reacting encourages us to slow down and resist conclusions, to transcend our emotional reactivity, and act from a place of patient wisdom.

Jazz legend Herbie Hancock tells an incredible story about his own personal lessons around non-reacting and judgment in his memoir *Possibilities*.[1] As an up-and-coming jazz pianist, Hancock was part of the Miles Davis Quintet. One can only imagine the honor and nerves a young musician would feel backing a legend. One night, on stage in Stockholm in the mid '60s, just as the band neared Miles Davis's solo in his beloved song "So What," something happens, and Hancock accidently plays, in his words, something "so wrong." In an instant, Hancock launches into an internal reactionary storm, "I think, *Oh, Shit*. It's as if we've all been building this gorgeous house of sound, and I accidently just put a match to it." Meanwhile Davis hears the note and promptly strings something together that somehow makes the accidental note sound good! Hancock says, "I believe my mouth actually feel open."

Afterward, in the dressing room, Hancock "sheepishly" approaches Davis about the incident; he is expecting Davis to acknowledge his mistake, but instead all he receives is a playful wink. What Hancock realizes years later is that while he was so quick to judge the note as wrong, Miles Davis was able to meet it in the moment as it was—a sound just the same as any other that he could follow with whatever he wanted to. There was no need for judgment—that would be the antithesis of jazz. Herbie Hancock beautifully expresses how Miles Davis and this experience taught him that his momentary reactions are powerful, that they have the potential to lead him to damaging judgments that can threaten his career and self. Imagine if he had left that night letting one

moment define him? Of course, that was not the case. Hancock went on to become a master himself, resisting reactionary living and mastering his ability to hold a bigger perspective for each sound, bringing the lessons of jazz into his life and his life into his music.

Like Herbie Hancock and Regina, most of us find ourselves in a place of emotional reactivity: we freak out at problems big and small; we are quick to speak, act, and decide. We leave very little room for uncertainty; without any hesitation, we may react and then shelve our conclusions as complete. Rarely do we pull them out to examine them with patience or to search for another perspective. Some of us are more reactive than others, but even people who pride themselves in being calm are often making snap judgments in their minds. Maybe you don't fly into a meltdown when the server spills hot coffee all over you, but in your head, you are quick to judge that person as incompetent. It may just be that the server was trying to overcome a bad night's sleep, was worrying about their mother's illness, or perhaps just saw a text making them suspect their partner is cheating. Reality usually lives somewhere we can't fully comprehend, but we let our reactions fool us into thinking that we see all and know all in an instant.

As we think on reactivity, we may realize that we already know some of our triggers toward judgments, or we have the self-awareness to recognize when we may have overreacted or been too quick to judge. It's important to have this self-knowledge and continue to develop it. But the bigger question is what we do with the pile of judgments we have accumulated over the course of a lifetime, and how we can begin to dismantle these and discover their impact on ourselves and others.

Each time we fall into the trance of a reaction we are defining ourselves and the world. Each one of these reactions weaves a story, a broader narrative about us and others. I am a victim; she is the bully. I am not good at that; he is so talented. Those people are wrong; I am right. Each reaction becomes part of a chain—a story that becomes so complex we can't even begin to see how we can unravel it or where it even began. Mindfulness teaches us to notice our reactions rather than chase them, to become keen observers and hold broader perspectives of ourselves and the world. When we do this, we see that nothing ever fits into the tidy boxes we are creating moment to moment, that each

story we tell ourselves can be softened or changed, or another angle can be found. Regina wasn't a victim; she was bird woman capable of holding a gaze of the world infinitely large. Herbie Hancock wasn't a newbie making a mistake; rather, he was in the presence of a master who was teaching him how to be in the moment. We are more than the definitions we create for ourselves, and life is more than we could ever define; we just need to allow ourselves the chance to view it as such.

Our Imaginations at Work

In many ways we can view life itself as a creative process, as a dance between reality and our imaginations, unfolding moment by moment. Everyday events unfold in our lives, and instantaneously our emotions and thoughts bubble up in response to them, a process that helps us determine the meaning of our experiences. That observer part of us is like the author of our life stories, determined to make sense of it all, stringing sense and meaning together as our days unfold. Without a narrative to hold the whole thing together, life would be confusing and fragmented, so our imaginations step in to offer us help in making sense of our days. Researchers Pelaprat and Cole suggest that our imaginations "fill in the gaps" for us, explaining why things are the way they are in the world.[2]

Our imaginations are powerful tools of sense-making that help us navigate our lives. Perhaps we begin our day reading a frustrating work email, then lose our keys, and on our way out the door, we receive a loving hug from our partner. These events remain disconnected until our imaginations step in and help us to make sense by connecting the events together in a narrative, perhaps telling us that "our morning is going terribly and the only good thing in our lives is our partner." If we recall Regina and the Facebook post that sent her into emotional turmoil, we might recall that the post itself was removed from the broader context of her life. It wasn't directed toward her, and in essence, it was just information scrolling past her on a screen, but her imagination stepped in and began narrating a story of great insecurity and hurt about it. (As an aside, let this example serve as a cautionary tale about how disconnected and out of context social media can be in our lives.) We tend to think of our imaginations only as wildly playful and stuck in the stuff of science fiction, fantasy, and

whimsy, but our imaginations are an essential tool for living daily life. Imagination is another embodied part of us, alongside our heart and breath, working in the background of our lives, keeping us well.

As with any powerful tool, our imaginations must be treated with respect and utilized with intention. We can choose the default setting—split-second reactions—let our imaginations step in, and be fueled by insecurity, fear, and negativity (as we saw with Regina and the Facebook post), or we can be intentional about how we use our imaginations and have them help us narrate broader perspective and meaning-making that honor ourselves, others, and the planet with respect and dignity. We can challenge our imaginations to continue finding meaning rather than settling on the first thing that pops into our minds, which is often our emotional reactions. We can flex our imaginations like muscles, challenging them and encouraging them to continue to expand our understanding of things, to revisit old narratives, and to hold complexity in high regard.

If Herbie Hancock had let one moment on stage define him, if his embarrassment had become the author of his story moving forward, he might not have become one of the great contributors to modern music. Instead, he revisited this moment, found new meaning for it, and held a perspective for himself that was bigger than just one note. This, too, is the challenge for each of us, to move beyond the reactionary stories of our lives and allow ourselves to find new perspectives that author meaning and sense in our lives with insight and patience.

Our imaginations can help us to conceptualize new ways of being that resist tidy boxes; they can help us to rise above our base reactions and dig deeper for the nuance and richness of life. When we take these hidden nuances and begin making them realized, we are then in the realm of creativity. Whether it's bringing materials together in a new way, expressively moving our bodies, or bringing ideas together through writing, creativity is a verb: it's the action that follows our imaginations. In this way, our creative practice becomes a place to test new ideas, ways of being, and practice living more authentically beyond the reactionary, in a playground of sorts where we actively move, stretch, and grow. Through the practice of creative mindfulness, we can intentionally put our imaginations to work on our behalf. We may choose to take a troubling

experience or event into our creative practice and let our imaginations go to work on redefining, reconstructing, and reimagining the meaning.

For example, we may wake up one morning and experience a sense of hopelessness about the future upon reading the morning news; we may be feeling that the world is full of catastrophes and division and find ourselves left with despair. Instead of letting this story and feeling ruminate in our minds all day, we instead can invite it into a creative realm. Imagine that we sketch our feelings of despair using messy gray lines, sharp black boxes, and scenes of devastation scrawled across our page. We then ask the process to help us find perspective amid this all and see what emerges. Perhaps our image begins to expand; perhaps we add glimmers of hope or comfort, twinges of green, an image of the sun breaking through, two hands held in love. And then finally a poem emerges that reminds us that even in bleakest moments, we can always find light and stillness inside of chaos. In this imagined scene, we can feel the possibility of something more through this intentional act of expanding our awareness with the aid of our imaginations. Through the practice of creativity, we have found nuance in the face of the news and brought levity to our day. Sometimes the way forward involves untethering ourselves from reality for just a moment so we can walk in the infinite. We can't make sense of our experiences without perspective, and it's our imaginations that invite us to new viewpoints, new ways of seeing the world and ourselves.

A Tether to the Beyond

My old friend and I are hiking through the forest. It feels good; a warmth creeps throughout me and I feel his gentle presence. It's been a decade since we have been together—our falling out is irrelevant. Here today, we are friends again. Our warmth is interrupted by a stone falling from the sky that smashes down at our feet. We look up and see an eagle circling overhead; then another swoops over and drops yet another stone nearby. I look up and now see hundreds of eagles are dropping rocks on us. We run around and begin gathering them— I think we are supposed to be collecting them—placing each in a clay dish on the forest floor, but there are too many; we can't keep up. Then I look up at my friend through the chaos and remember he doesn't like me anymore, and since

when do eagles throw rocks from the sky? Nothing is right about this dream; it's all backward. My alarm goes off, my face damp on the pillow, and this backward world recedes away in my mind, making way for the real one.

I sit up and start my morning meditation, but it doesn't look much like it—I sit in the darkness, legs folded, and begin to sob. Today is hard; I touched a well of sadness in my dream, and like a hangover, it's still trapped in my body. I know why my old friend only talks to me in my dreams; he knows firsthand the harm I have done . . . that I can't undo. It's not my only transgression, I tell myself. I am also a terrible mother. I yell; I am forever frustrated at my children. It seems that its always the little things, and then I let the agitation of a moment taint my whole day. I am not much of a friend either; I judge, gossip, don't listen. I know what those rocks are—they are the mistakes I have made, the harms I have caused. Moment by moment, each one unloads on me in a torrent I can't escape.

As the day drones on, I go for a walk with my son and try to enjoy the green pathway as he tells me about his idea for a science fiction story he wants to write. I am agitated; I can't listen. All I can think of is why a child so interested in the real world spends all of his time in made up ones. Last week his teacher told me he has attention problems. I can tell she has written him off; she thinks he needs medication. Just another piece of evidence in the ongoing case of how I am failing in life.

I just want everyone to leave me alone and let me sit in the sun and stitch. I started a meaningless project last week: a pretty little purple moth. It means nothing, just something cute and easy to pass the time. My son sits next to me and reads. He shares an endless stream of interesting facts he finds in his book: "A three-month-old baby can see more detail and color than adults can," "Dogs can smell a single drop of bombmaking chemicals inside twenty Olympic swimming pools," "We have only explored 4 percent of the known universe." His facts never end; each one seems to only confirm how little humans know about the world. Maybe if I was a dog or a baby or living on a faraway planet, I would be a better person. It feels like the rocks are falling again; I can't keep up.

Later, my phone rings to bring me news about my dad. He is headed to the ICU again, and it doesn't look good. I crawl into bed and return to my sobbing; it feels like my world is ending. It's as though the mighty eagle looks down on me and says, "You think you can handle a boulder this time?" No eagle, I can't;

I have decided it's all too much and I need an escape. A therapist would call it disassociation, but it feels safer to go somewhere else right now.

I close my eyes and imagine that my dad is calling me from another dimension; he is trying to tell me that he needs to actually go this time, that something urgent is happening in another time and space, and he is the only one who can fix it. I must trust him; this is bigger than me, this spans dimensions, it's beyond me. And then it occurs to me, What if this were true? What if the reason I can't understand why he is dying is because it's beyond this world? Maybe his dying is bigger than anything I can comprehend. Maybe it's all just part of another fact about what we don't know—babies' exceptional vision, dogs' super smell, the enormous universe, my dad is desperately needed in another dimension. Why not? I can't think of a single reason why this wouldn't be true, and with this thought, a new peace sweeps over me.

With new eyes, I look at my son and his gaze on the horizon of science fiction. It occurs to me that maybe it's because he is so interested in this world that he needs to create another one to help him make sense of it. His imagined world of space wars and time travel is his playground for making sense of this world. He needs a bigger perspective to make sense of it all. I think of his teacher and her pragmatic insistence that he pay attention, and I realize that it's my job as his mother to hold this bigger perspective for him. Many people will give up on him; his world will not be clean and tidy. Will he look up and see his mother, flooded with fear and uncertainty that these critical voices in the world might all be right, or will he look to me and see that I can see a bigger future for him, more than any one single moment or perspective could possibly offer?

I return to my purple moth; the rhythm of the straight stitch going back and forth makes sense. My son peers over my shoulder and asks me, "What's with the moth?" I tell him I don't know; not everything needs to mean something. He tells me that it's hard to define moths; they don't play well with the rules of categorization. Not all are nocturnal—in fact, most aren't. Many have feathery clubbed antennae, but not all. Some are pests, but many are a source of food. And, of course, they give us silk. And what is the romance of their attraction to the light? No one quite knows why they do that. I look up at my son and tell him that every time he starts telling me facts all I really hear is how little we know

about this world. With a wink, I nudge him to go start writing his story before it slips through his fingers and becomes something else.

I look down at my moth, her colors and shape becoming more defined with each stitch, and it occurs to me that maybe it does mean something. This moth wants me to stop with the ego show and wants to remind me that I don't know anything in the grand scheme of it all. She is here as a symbol; she wants to tell me that I should be like her and resist all the boxes that the world keeps trying to create, that I create. Am I really a bad mother just because I yell? Maybe my friend didn't dump me; maybe his life just changed? How do I know I am a bad listener? It's all just stories I tell myself about the moments of my day. My certainty is an illusion: I have been stitching together a narrative moment by moment, but maybe it's not the only narrative. I can hold a firm and trusting perspective for my children that transcends the momentary, so I can try to do the same for myself.

Sometimes meaning comes through the creative process of making, revealing itself bit by bit, and other times it's a slow, sure reveal after it has taken form. My purple moth, once a meaningless excuse to stitch, is now so much more. As I add the last details, wrapping thread around wire and positioning its antenna just right, I wonder what I will do with it next. This creation seems to deserve something more than just a spot on my wall next to all my other art. I play with displaying her. Perhaps in a frame, with a stick to rest on, stitched to an old sweater? All of it feels too restrictive for something so transcendent. Every vessel I place her in will be temporary anyway; she needs to be free, to float through the vastness of the world. All I know is that she wants to lie at the altar of possibility, so I clear a space on a wall and rest her there, knowing that one day she may want to move.

I lie back down and close my eyes, and all at once, my dream with the falling rocks and the eagles rushes back to me. I watch myself frantically trying to collect each stone and place it in the right clay pot. And then I see my purple moth. I nudge my friend; we smile at each other and follow the moth into the untouched meadow ahead, leaving the eagles and stones behind us. I am filled with warmth and connection again, and then my phone makes a buzz, waking me up. It turns out dad will make it this time. His urgent call from beyond will have to wait for another day. Today I am busy dismantling this world, imagining a new one, and somehow, I have never felt more present.

CREATIVE INVITATION:
SYMBOLIC ALTARS

This creative invitation will have you utilizing your imagination as a way of softening your attachment to a story born from the momentary reactions in your life. Once you have identified your symbol, you will create an altar or a creative shrine to honor the wisdom it holds for you. Like my moth, Herbie Hancock's terrible note, and Regina's bird woman, you too will find meaning through a symbol that emerges with the aid of your imagination. This process will encourage you to hold a space in your life that is non-reactionary, embracing the vast spectrum of ways of being and choices that can be made in any moment. Your own personal symbol may emerge at any point in this process. Take note of any significant imagery, metaphors, objects, animals, or similar throughout the process—it may just prove to be the thing you are looking for!

ARRIVE

Arrive to the present moment by intentionally listening to music. Find a piece of instrumental music that you love, and as you listen, close your eyes, take a few deep breaths, and imagine that you are walking in a place that you love. This may be a natural space that you have been to before, or perhaps it is an imagined world you have yet to visit. Allow yourself the pleasure of being in this space. Notice your surroundings, observe your feelings, and welcome any unexpected additions or shifts to the landscape. Immerse yourself in this imagined space for as long as the song plays.

SET AN INTENTION

Ask yourself what direction you would like to move or grow toward in this process and set an intention to guide your process. For example,

I intend to notice my reactions in this process.

I intend to make space for not knowing.

I intend to examine conclusions that I have let define me.

ASK A QUESTION

What insight or wisdom are you hoping to gain from this process? Take a moment to ask a question to anchor your process about how reactions manifest in your life or how you can revisit old stories. For example,

What beliefs am I ready to let go of?

Why am I holding onto this idea?

How can I create space between my reactions and my actions/beliefs?

What can my imagination teach me right now?

PREPARE

To prepare for this creative process, think about a situation that is currently unfolding in your life that is causing you some consternation—perhaps a situation at work, a strained relationship, or a worry about the future. See if you can recall when this situation first emerged in your life. In your journal (or your mind's eye), note some of the initial reactions that popped up for you and early feelings you had about it. Write them out in your own voice as you recall them. For example, "I got the email, felt angry, and then quickly replied," "When she said that thing, I was so hurt by it I decided . . . ," or "I began worrying about my retirement when" The purpose of this part of the exercise is to recall the key feelings and reactions behind the situation, to put yourself back in the thick of it as a starting point for your process. Once you have written out a few of the initial thoughts and feelings, turn to expressing the feelings that you uncover using color, line, shape and so on. For each feeling you identify, choose a color and begin making marks that capture the feeling of it. For example, maybe a deep blue blob depicts the helplessness you felt, or red zig zags symbolize your embarrassment. Create a brief color sketch for each feeling you identified.

WHAT IF?

Now expand upon this situation that you have identified through writing. Move to your journal and begin imagining other outcomes or reasons why the issue or challenge you chose to work with exists. Begin by writing "what if" in your journal, and then imagine eight to ten reasons why this situation is happening as it is, or what else could be causing

it. Challenge yourself to come up with as many realistic or far-flung answers as possible. For example:

> *What if this is happening because it is preparing me to take on a leadership role one day? What if she said that because she is just as scared as I am?*
>
> *What if someone gives me all the money I need for the rest of my life?*
>
> *What if my cat had all the answers I needed?*

SYMBOL

It may be that you have already found a symbol that has wisdom for you. If so, move to the next step. If a symbol still feels elusive, here are some activities to help you identify one. You may choose to do one of these activities or all of them; let the process guide you to your symbol. At the end of each of these activities, ask yourself, What wisdom does this symbol have for me?

- Flip through magazines or old books and notice images. Set aside two to three that you feel drawn to.

- On a blank piece of paper, make three to four big marks with a black marker. Rotate your paper around, see if you can see any imagery in the marks, and if you can, begin to add detail to bring it into the foreground.

- Go for a walk, pay attention to your surroundings, and take note of a few natural occurrences such as the wind, rain, raging river, falling leaves, and so on. You may want to collect an item connected to what you are experiencing if possible.

- Look inside a book of nature or animal photography, or go online and look through photo galleries; find two to three animals that you feel connected to.

By now you likely have one or two symbols. Ask yourself to choose the one that has the most wisdom for you. It may be that you haven't quite made sense of it all and need more time to listen to its wisdom, or it may be that the message feels clear already. If you need more, move to your journal and give the symbol a voice. Begin by writing, "I am _____ and I am here to tell you" Let the words and meaning flow; resolve to write one page in this symbol's voice and see what insight emerges.

CREATE AN ALTAR

Now that you have found your symbol it is time to create an altar or creative shrine for it. This part of the process can manifest in many ways for you. What is most important is that you find an intentional place in your home—a small shelf, windowsill, place on the floor, or similar—and intentionally showcase your symbol. Begin by finding an object or an image that represents your symbol. You may choose to sketch it, find the real thing, or acquire an image that depicts it. This symbol will be the pinnacle of your altar. Continue by adding other objects, textiles, natural remnants, or anything similar that you feel adds to the prominence or meaning of this altar. As you add objects, consider both aesthetics and meaning: Why are you including the object, and how does it serve the greater meaning?

DISTILL

The final step to this process is to take a photo of your altar and offer it a title. If you were to display this photo in a gallery, what would the name next to it be? Finish this process by considering your initial question; write a two-to-three-line poem that shows how your symbol and your altar offer insight to the question. Here is a sample poem about a leaf that was uncovered as a symbol for change.

> *Crusty beneath my feet, yet you were once the shade and wonder of spring.*
> *Perhaps I too change. At times letting go and others holding tight.*
> *The seasons of my life instructing me of the shape to take.*

WITNESS

It is important to share this process and the significance of the symbol and the altar with someone you trust. Plan to share with this person about how this process helped you to hold a bigger perspective in your life and how it will serve you on your journey toward being non-reactionary.

Movement Speaks (ink on paper)

12

THE MARK OF EMBODIED AWARENESS

JENNA WALKED INTO the room wearing a bright red scarf and a marigold yellow jacket with a huge coffee in her hand. She was nearing fifty, had a bubbly personality, and was outgoing and seemingly full of energy, but underneath this all, Jenna was feeling stuck. She had been in her job for fifteen years and was feeling underwhelmed, bored, and ready for a change, but each time she found herself about to quit, she would get scared and decide she should just stay put. A friend of hers recommended she come to me so I could help her find a solution. In typical Jenna fashion, she was excited to try something new, loving the idea that she could make art and figure out her life at the same time.

Eager to jump in, she sat down next to me and launched into the story of her job, the projects she had been working on, and all her colleagues whom she adored. I could tell this was a well-worn track for her, a story she had told a million times. She was both at ease in telling it and a bit detached, almost as if she was on autopilot while talking to me. As she talked, I noticed her hands flipping back and forth like she was tossing an imaginary ball between them. I listened and observed Jenna, wondering what it would be like for her to try to connect with this issue in a different way, one in which she couldn't rely on the comfort of her words. Her arms flipped to a new movement as she shifted to a new part of the story. I interrupted her and asked her if she would mind if we

worked in movement rather than words. Her expression was a mixture of shock and curiosity; then she replied, "Sure, although I don't know what that means!"

I mirrored for Jenna the movement she had been doing while she was talking, flipping my hands back and forth, and then I asked her to join me. We stood across from one another, hands flinging side to side in synchronicity for a few moments. I asked her if the movement felt right, if it felt connected to the feeling she had in this moment. She quickened the pace, staying with the movement for a while before replying, "This is it; it feels like I am spinning plates." I invited her to close her eyes and imagine that she was spinning plates, to feel that movement for a while with the imagery and notice what it felt like. I saw tears well up in her eyes, and she told me that it was exhausting. I encouraged her to stay with the feeling of exhaustion and notice in her body what it felt like. Bravely she stayed with the emotion, her eyes closed, hands spinning at a rapid pace, and then she reported feeling a blockage in her throat and butterflies in her stomach. Again, we stayed with the sensations bringing our awareness to her body and the inner world we had just discovered. We then played with slowing the movement down and changing it, each time feeling how the internal experience shifted. After a few minutes of exploring, Jenna moved her hands rhythmically inward, a mix between a nourishing hug and a washing motion; she said this rhythm and movement felt peaceful, almost like stillness in motion.

In just a few short minutes Jenna went from rapidly talking through well-worn patterns about how her work was impacting her to a newly discovered embodied awareness. When we talked about this shift, Jenna discovered that the movements of the spinning plates were all she had known, and that slowing down was so foreign to her it felt scary. The butterflies, blockages, and uncertain bodily reactions were in response to her feeling any kind of deceleration. Jenna realized that the stories she was telling herself came from only one type of awareness—thinking. She now understood that this was only part of the story, that she could begin to know this challenge in other ways as well. It was this newfound awareness that we decided to work with. During our time together, Jenna would allow her body movements rather than words to offer her wisdom about her situation. With each movement, each intentional act of awareness about what was happening in her body, she and I began to find a new path,

one where she could put down the exhaustive and hectic pace of her work and instead befriend the discomfort of being still. The magic ingredient to finding this space and new approach for Jenna was awareness.

The Theater of Awareness

In 1895 one of the first films ever screened was the Lumiere brothers' film, "The Arrival of a Train at La Ciotat." This short, fifty-three second film depicts a train station with passengers milling about and then a steam train pulling into the station. It's rumored that at one of its early screenings, the audience was so absorbed in the moving images that they fled their seats in a panic fearing a real train was headed straight for them! Film historians have since debunked the reality of this incident, yet the story still endures and has been retold in magazines and film studies platforms again and again. This myth has spurned a broader debate about how audiences view films: Are they truly swept away into another reality as they watch the drama on screen unfold, or can people maintain awareness and hold a space between the sensory experience of the film and reality? Perhaps this mythic story persists because it taps into a bigger question each of us faces daily: whether we can see that "the world exists outside of our minds," as film historian Mathew Abbott says.[1]

Of course, it's hard to imagine people fleeing from a moving image of a train these days. After all, people have a tremendous capacity to understand the complexities of reality, even as technology alters it so profoundly. We know the train isn't coming at us because we can feel that we are indoors, sitting in a chair, with a film reel running behind us. We sense each of these parts of our experience and construct reality with all the information available to us, not just from what's on the screen. We can feel how each part comes together to construct the whole. This story calls into question the idea of discernment—choosing what to pay attention to and what to ignore in our reality. If humans have the capacity to enact differing levels of awareness, when and how do we employ these?

Most of us aren't walking through our days reliving the drama of the last film we saw, but many of us are in our own sort of drama, feelings and stories swirling in our minds as we ruminate on the past and project into the future, our awareness squarely centered on the activity of our minds. Much of the drama

we perceive is imagined, echoes of something once real or of something that may have only ever existed in our perceptions. If we recall Jeff from Chapter 3 and his newfound awareness that he wasn't Godzilla on screen but rather the guy in the audience watching the film, we see how powerful this metaphor of the drama of our lives unfolding like a film is. We can choose to be up on screen in the thick of the story, fleeing trains and living the fury of Godzilla, or we can take a seat in the audience, broaden our awareness, and see the space between us and the drama of our lives. The question for us to follow here is how we perceive our lives, the stories and drama we get caught in, what are we aware of, and perhaps, more importantly, what we are not aware of moment by moment.

In Buddhism, the notion of "monkey mind" is often talked about—a metaphor for the fickle, busy, unsettled, restless, uncontrollable thoughts that race through our mind moment to moment. Monkey mind is the default position for us, a constant chatter in our minds reacting to our circumstances and creating a story that links our past to our future. In a way, it's the narrator of our daily film. For example, we may find ourselves out walking the dog, and as we do so, we are also ruminating about our to-do list, reliving a conflict with our coworker, and thinking about the day's news stories. Before we know it, we have finished our walk and it hardly feels like we were outside. Monkey mind was in charge, and we were on autopilot. We didn't notice the temperature, the birds and wildlife around us, or the sounds of the leaves under our feet. We were so absorbed in the film our monkey mind was putting on for us that our awareness was completely cut off from the physical world. Monkey mind takes us out of our bodies, away from our senses, and has us stuck in our minds. Add to this our increasingly connected world that has us scrolling, watching, and endlessly consuming, and we find that many of us have cleanly divorced our minds from our bodies. We have endless distractions to feed our monkey mind, which in turn numbs our capacity to be aware of what is happening in the present moment.

As we cultivate the intention to bring more awareness to our lives, we may find ourselves feeling frustrated or resentful of our monkey mind. We wish we could control it, quiet it, make it go away so that we can do the thing we think we should—be still and find awareness. This attitude puts us at war with a part of ourselves, which ultimately does very little to quiet our minds; instead it becomes a new tool we use to punish ourselves. If we recognize that monkey

mind is only telling part of the story and that we can intentionally bring our awareness to other parts of ourselves, we can find space in between our fleeting drama and the moment, discovering a more inclusive and vivid experience of life. We can tap into our inner world through awareness and realize that monkey mind is part of that, but not the whole story, that, in fact, the world exists outside of our minds in a much more spacious way.

In my own journey toward befriending my monkey mind I have noticed that it always has me thinking about the future and rarely about the past. When I brought my awareness to my body when I was in this future state, I often discovered a tightness radiating through my shoulders and hips, as though I was always bracing for more. Eventually, I was able to link these sensations to a well of insecurity inside of me that always feels the need to prove myself and do more. My monkey mind was trying to show me a deeper part of myself, but I needed to bring my awareness to all of myself to understand its wisdom. In the example of Jenna, we can see that her frenzied approach to life and work driven by her monkey mind served a purpose; it kept her from facing her fear of what slowing down was like. When Jenna brought kind, gentle awareness to the experience of her body, she was simply redirecting her awareness from her monkey mind to the other physical sensations that were trying to speak to her. In both examples, it was tapping into an awareness of the body and the sensations unfolding in the moment stemming from our inner worlds that helped us find new perspective.

Awareness is, in essence, space, the act of intentionally pushing the pause button between what we sense and what we perceive. Imagine if, as you read this sentence, each word bled together, itwouldbehardtomakesenseofwhatyouareexperiencingasyoureadthis, but when we hold space between each word, thought, and sensation, we punctuate each with a moment of awareness. Awareness happens when we give space and become aware of our senses, noting each experience. Take a moment right now to bring your awareness to each of your five senses; then, in your mind, offer a few words to characterize each experience: What are you seeing beyond the words on this page? What is your body touching? What tastes are in your mouth? What sounds can you hear around you? What smells can you detect? Even before you took a moment to intentionally bring your awareness to each sense, your body was still experiencing these

sensations. Sensation is always running in the background of your experience, but when you stop and decide to bring your intentional awareness to it, you create space for each sensation to speak, and your experience of them shifts.

In this awareness exercise you also added on the sixth sense of the mind, noting your perceptions of each sense. In Buddhist traditions, the mind is considered the sixth sense, recognizing that we perceive and interpret our senses through the mind, as our imagination becomes involved in helping us make sense of the world.[2] Even this categorization of six senses can be seen as limited when we consider current research around proprioception (the sense we have as our bodies move through physical space) and interoception (sensing our heartbeat, hunger cues, pain, and internal experiences).[3] It may be surprising to learn that what we consider to be our senses are in fact culturally constructed. In some African cultures any categorization of our senses is considered fruitless; instead balance is the predominant sense.[4] And Carl Jung theorized that intuition is another sense, while researchers George Lakoff and Mark Johnson theorize that our capacity to communicate through metaphor may be yet another sense.[5] When we let go of the notion that there are five senses, we can see that our awareness opens even more and our experience of the world shifts. We can sense so much more than the perceptions of our mind; we need only open ourselves up to a broader awareness to discover their impact. The more we bring our awareness to our senses, the more we recognize that in each moment a symphony of experience is unfolding, and we may discover that we, too, have been acting as though a real train was barreling toward us, neglecting to recognize all the other parts of ourselves that are telling us there is more to the story than on screen.

Sensory Awareness in Creativity

Creativity, in its essence, is an embodied act full of sensory touchstones, making it an ideal practice for honing our awareness of how the mind and body inform one another. For example, when we paint, our eyes absorb color and texture, and we move our hands and arms as we stroke the brush across the page, feeling them move through space. We mix paint and smell its aromas as they fill the room, and we listen to the sounds of it slop and splash around. Slowly, a picture

begins to form, and our thoughts and perceptions kick in; our mind begins to tell a story, seeing symbols and metaphors emerge, and we feel intuition tug and pull at us, asking us to add more or explore an area in greater depth. Creating art is a deeply sensory experience; it requires our awareness to pivot to a more embodied state. Consider the sensory awareness at play in dance, music making, theater, or other performing arts. Even writing involves a multisensory approach, as famed Zen writer Natalie Goldberg instructs her students: "writing is 90 percent listening . . . Listen with your whole body, not only with your ears, but with your hands, your face and the back of your neck."[6]

We may have tricked ourselves into thinking that the fruits of our creative expressions are born from the mind, but every part of us is required to come together in an embodied act to create. When we begin to broaden our awareness of how our creative expression unfolds, we are recognizing it as an inherently embodied act and expanding our perspective of it. We begin to see that our senses are working together to tell a story—not a story with words but one that speaks in the languages of sensation, emotion, and the body. This means that the fruits of our creative expression hold wisdom from the body; they are tiny artifacts born from our whole beings. It isn't possible for us to create without this integrated response; it is, however, possible for us to take it for granted. Just like anything else in life, we can approach creativity by relegating it to existing only in the context of, and in relation to, our minds. It's almost as if when our mind takes the lead, the lights dim on our other senses, leaving them to work in the shadows. Then, afterward, we look at our creations and only make sense of them through the mind, leaving the other half of the story sitting in the dark. Consider the cliché of someone walking through a modern art gallery and scratching their heads saying, "I don't get it"; perhaps it's because the works weren't meant to be understood fully with the mind; rather, they were supposed to be experienced in a more sensory or embodied way.

A wonderful example of what can happen when we intentionally express ourselves in a way that bridges the mind and the body is the annual Dance Your Ph.D. contest. Every year people with a Ph.D. in any field of science are invited to use dance to explain the findings and implications of their research. At the crux of this challenge is the idea that those deeply immersed in research often find themselves mired in content-specific jargon and stifled by the burden

of their expertise when they are trying to share the significance of their findings more broadly. Some would say that dance is diametrically opposed to this, relying on movement, emotion, and music to be communicated. As founder John Bohannon said in an NPR interview, "the idea is that the public will be engaged with science at a level that they usually don't encounter."[7] The dances are all at once moving, intriguing, educational, and wide ranging. In the winning video from 2014, Uma Nagendra explains her thesis, "Plant Soil Feedbacks after Severe Tornado Damage," using an ensemble of dancers on trapezes each wearing colorful costumes imitating trees and soil.[8] The collective energy and theatrics of the dance capture the hidden drama of soil in a way that words simply can't. This competition can be seen as a redirection of awareness, an intentional act of expanding the sensory experience of a topic beyond that of the mind and into the body.

Creative expression dwells where we place our awareness. If we want it to favor the mind, it will; if we want it to come through movement, it will; and if we want a more integrated response, we can choose that, too. Consider, for a moment, the last few creative projects in which you have engaged: Were they born from an idea or concept, emotions and relationships, or were they embodied acts full of movement, impulse, and rhythm? You likely can identify each of these at play in some way; however, is there usually a dominant approach or theme to how you create? If so, how might you begin to expand your awareness and more intentionally include all parts of yourself in a creative act? Our creative expression is embodied, sensory, emotional, and messy, whether we want it to be or not, so we might as well begin to recognize and listen to the other half of the story trying to speak to us. Our creative expression is our safe sanctuary in which to play, explore, and discover ourselves fully, and once we learn to speak the language of our inner worlds through creativity, we may just learn that we can listen to it in other parts of our lives as well.

The Armored Doll

My father holds my hand and walks me through the wooden doors and up to a glass showcase; he gestures for me to look inside. Under the glass are hundreds

of Russian matryoshka nesting dolls, a compilation of colorful, hand-painted wooden beauties. My eyes barely peek over the counter as I look down on each distinctive woman holding flowers, curvy body dressed brightly, her hands held close to her chest containing a world of secrets inside. The person behind the counter pulls one out, twists her open, and reveals another smaller doll inside, then another and another. Six versions of the same woman are living inside this one doll, each now lined up before me in a row. My eyes must have lit up because they keep showing me dolls with more and more dolls inside, some with dozens of layers, the show always ending with the discovery of a tiny baby inside. I remember seeing the dolls all lined up on the glass counter, side by side, baby at one end and the mother at the other, a long line of replicating selves, almost like time and space had been laid out before me to touch and hold. My father told me I could pick one to bring home, and so I chose her, my red and yellow Matryoshka doll; she has five layers and a radiant red rose at her center. This was 1986, and I was five years old; decades later, I still have her. She is one of the only keepsakes I have held onto from my childhood, perhaps for sentimental reasons, but mostly I think I've kept her as a reminder of the hidden parts of myself.

By the time I was five, the baby inside me was already hidden away. I already knew that parts of myself weren't welcome in this world. My anger concealed, my rambunctious impulses to flip and scream locked down, and a budding new self was beginning to take shape. This new version of me had learned to keep my vulnerability and wildness at bay, but she was still playful and buoyant, always trying to make everyone around her stay happy and like her.

Eventually, this version also proved insufficient, and a new me needed to take shape, this one even more desperate for approval, now stuck in a body that the world thought it could touch, prod, and own. My body's boundaries slowly eroded away for the sake of others' desires. This time it also held a well of shame and fear. This was the case until one day, the hurt and discomfort in this version of myself couldn't hold it any longer. Eventually I needed a new version, this one more in control, tighter, scared of the hurt from all the people pleasing, becoming cold and untouchable. I am not sure when each layer formed—a slow-growing skin on top of a skin, a necessary armoring to keep the baby deep inside safe, I suppose. Each layer of the doll, each version of myself, interlocked

together, nested one on top of another—only in real life, I couldn't just twist myself open to inspect each version; this doll required a gentler touch to open.

I thought it was just life—how I was. I didn't know that there were other ways to be until the first time I felt anger, when I was twenty-nine (remarkably late in life, I know). In the throes of an early-stage divorce after a phone confrontation, I vacuumed the floor and felt a pulsating heat in my lungs, an energy I could not release. I had never felt my body this way before. For a moment, I thought I was sick, and then as I forcefully rage-vacuumed (a technique so many domestic warriors know well), it became clear. This was anger; in fact, I was full of anger not just because of this phone call, but because I felt that everyone I loved tried to control me or minimize my needs. I was also angry at myself for being so out of touch and lost that I didn't even know the language of my own feelings. I wish my epiphany would have happened on a mountaintop or standing in the rain; instead it happened while I was standing on a dirty gray carpet holding a loud, dusty vacuum. Sensing a new awareness birthed, I discovered I was no longer the same person, but this time, instead of adding a new layer, a new protector, on top, I stayed with the anger and found myself peeling down and unearthing more vulnerability.

Before this moment, the comforts of my mind had made it easy for me to cut myself off from my body, which was hidden away under excess weight and clothes, and which tightened upon any touch. My body was part dread and part vehicle, unnoticed unless I stubbed my toe on the table or cut my finger chopping carrots. I found love only through thinking, I found purpose and meaning through the fruits of my mind in work and school—my intellect was my prize and my master. But the longer I stayed with my hot anger, the more fear, resentment, anxiety, sadness, and hurt I found in the hidden pockets of my body. There was a little girl calling to me deep down, asking me to keep digging, and the only way I found I could hear her was through my body.

At first my busy mind was resistant to meditation like so many others, so instead, I began to listen to my body while I painted. I would imagine a part of myself deep down, buried under all the failed versions of myself, trying to speak, and I would ask her to move. To my surprise she would comply, but sometimes an impulse to scribble or splash would come, and other times I would take the

tension in my hips and find the deepest red I could, making messy marks with it, knowing that this was my anger seeping out of me onto the page. My comfort with, and connection to, my impulses began to grow. It didn't even need a page to stay on now; my impulse could speak through movement. I swayed on my floor in the dark, late at night, allowing myself to move to a song or mimic the rhythm of the rain on my belly. I didn't think of it as healing. I heard it as the little girl inside of me, who could only speak through impulse.

Sometimes we don't find conclusions or sense but rather a comfort or peace. Sometimes we hear a whisper from deep down, a hurt that has been found and now wants to be seen. For me, each layer of myself excavated through impulse felt like it reached backward, further in time. Like my little doll, I found myself taking off each layer, one by one, and lining them up next to me ready for inspection. Who is she? Why is she here? Who is this woman underneath her? I began to realize that the cold, controlling version of myself that had touched anger reached backward in time and revealed another scared body, harmed by nearly every man it had encountered. Boundaries blurred in hopes of love, bruises left at times, unwanted advances accepted, the marks of aggression left behind, a body being used and forgotten. When touch always feels like harm and never equates to love, how can a body go on feeling?

And then further back, underneath this hurt woman, was yet another, one who started out naively seeking love and intimacy, one just wanting a chance to be free to express herself without fear of retribution. She was just a child with a love deficit who had already learned to please others, and somewhere, yet deeper, is the baby, the original version of myself I have yet to uncover. My matryoshka dolls nest one inside the other, each trying to keep a safe haven from the harm that had come to the woman before her.

It was my breath and my impulses, the messy marks upon marks and movements that revealed this lineage. Just as I had slowly cut myself off from my body, bit by bit, so too was I able to reestablish a connection, moment by moment, and find the little girl underneath waiting to be unearthed. Now when I feel the impulse to move, scribble, or find just the right yellow, I know that it's my way of touching her, the first witness to my life unfolding, a tiny pure version of myself, just waiting to be noticed.

CREATIVE INVITATION:
DISCOVERING YOUR INNER WORLD
THROUGH MARK-MAKING

In this creative invitation we begin to bravely explore our inner worlds by inviting our impulses out through simple movements and messy mark-making. This process will help you to begin to tune into your body and senses as you begin to identify and follow impulses. We will be cultivating a playful attitude toward our creations, allowing the body to speak first and then observing the marks that result. The creations you make will be messy and energetic rather than controlled or calculated. Each mark you make is a chance to feel the connection between impulse, your senses, and your body as you intentionally bring your awareness to how they work together.

ARRIVE

Begin this process by spending some time with your body, noticing how it responds to rhythms and the environment. Find a song or two that you connect with, ideally without words and featuring varied rhythms. World music, jazz, or dance music are great places to start. The key is for you to find something that you connect with, that literally moves you and captures your attention. In a safe place without distractions, stand or sit on the floor; take a few deep breaths sending your breath to your belly, and begin listening to your chosen music. Give your body permission to move, sway, stretch, or respond to the music. Tune your awareness to the impulses of your body and how your senses respond to the music; it may be easier if you close your eyes to stay connected to your body. It may feel uncertain or unfamiliar to be in your body. Remind yourself that as long as you feel safe, connecting to your body is a relationship that you are developing, and it may take time to build trust. Experiment and play, feel your body move through space, notice how you connect to rhythms, and allow your impulse to take the lead. When the music ends, take a few moments just to connect with your body, bringing your awareness to what it feels like to be alive in this moment, and then check in with each of your senses.

SET AN INTENTION

Set an intention that explores how you want to move in right relationship with your body, senses, or broader awareness through this process. Remember throughout this process that you will be redirecting your awareness beyond the mind and thinking perceptions

into the impulses of your body and the sensory experience of what it feels like to be you. For example,

I intend to trust my body to take the lead.

I intend to expand my awareness to include the sounds around me.

I intend to find space in between me and my monkey mind or thinking sensations.

Your monkey mind will be an active participant in this process. When you find that it has overtaken your awareness, simply go back to your intention and redirect your awareness each time.

ASK A QUESTION

What are you hoping this process will bring you? Ask a question that you are most in need of or interested in exploring through this process. For example:

What is my body trying to tell me?

What can I learn through listening to the sounds around me?

Where is my awareness most comfortable or uncomfortable?

What do my impulses want me to do?

PREPARE

With a pencil or marker in hand and a piece of paper available, close your eyes and take a few breaths. Notice the sensations as your breath comes in through your nose, down into your chest, and into your belly. Stay with this awareness as you take ten in-and-out breaths. Pay attention to the temperature of the air you are breathing in; the movement of your abdomen; the sounds around you; how your mouth, chest, and body feel; or anything else you can note. When you are ready, scan through your body from head to toe, slowly tuning into the sensations happening in every part of your body, one by one. As you do this, place your pencil on the page and imagine the sensations you notice being transcribed or mapped on to the page as you feel them. Perhaps the tightness in your shoulders moves onto the page in tight, short marks, or the tingling in your hands looks like tiny dots. Try to keep your eyes closed during the exercise, letting your pencil move around the page documenting each sensation you notice. Your pencil should feel like a

witness, transcribing the awareness that you are bringing to each part of your body. When you are done, conclude this exercise by taking a few more deep breaths, slowly opening your eyes, and then noticing your perceptions as you observe the marks you made on the page.

MARKS

You are now ready to begin your creative process. You will want to encourage your body to move in ways that it can and explore space, so depending on your own comfort, this can mean setting yourself up anywhere from on the floor to at an easel or attaching your paper to the wall. Prepare a few large pieces of paper and water down black or blue ink or acrylic paint at a 1:1 ratio. Your paint should be able to move and slip across the page with fluidity. Gather a few different paint brushes and mark-making tools such as sticks, wire, feathers, or anything you think might make interesting marks. During this process, you will be following your inner impulse to move, letting your body and the marks follow suit. The marks you will be making will be loose and free; think of them as extensions of your movements, time stamps of what was happening in the moment. You may choose to continue listening to music or to work in silence; trust whatever feels right for you.

Begin by taking a few deep breaths and dipping one of your mark-making tools into the paint or ink. Allow your impulse to lead and make a mark on the page. Throughout the process, notice your body posture; is it loose or tight? Can you move in a different way? Let your body tell you how it wants to move. Notice your desire to plan your next mark or react to the marks that you have made. Stay with each moment, each impulse of the body, and begin filling your paper with marks. Continue with the rhythm of one breath and one mark for five to ten breaths, and then allow your impulse to take the lead, telling you how quick or slow the marks need to come. Switch between mark-making tools, bringing an attitude of curiosity to each. Complete this until you have filled one or two pages.

PLAYING WITH IMPULSE

Once you have established some comfort with letting your body take the lead in making the marks, begin to play with speeding up or slowing down your marking process, exploring specific movements of your body such as circles, moving further away or closer in to the paper, changing your grip, and so on. Explore your senses through the process. What would the sounds you hear right now look like as marks? How about the tastes, physical sensations, thoughts, and intuitions? Explore the process of tuning into one of your senses

and then translating that into marks on the page. Give yourself permission to spend as long as you like exploring your impulses, body, and sensory awareness, making the connection between this awareness and the marks.

POEM

Once your mark-making feels complete, finish this process by selecting one of the pages you've marked up to write a poem in response to. Look at each of the marks that you have made and choose the entire page or one mark to focus on. Recall the experience of what it was like to make this mark in the moment, and then give that mark a voice. If it could speak, what would it say? Consider using the prompt "I came here to tell you . . ." and let the words flow from there. Allow this mark to speak to you through a poetic voice and capture what it is saying. Here is a sample of writing where a thick black mark speaks:

> You cannot ignore me. I am here to be seen.
> My presence is important. I cannot be washed away.
> I won't apologize. I hold space with strength and connection.

DISTILL

Look back at what you wrote and underline two to three key points. Finish by giving this mark-making image and poem a title. Refer back to your intention and question. What wisdom did this process have for you? Have you found any insight or knowing as a result? How could you continue or adapt this process to keep uncovering insight?

Once you have established a comfort with this process, you can replicate it any time you like—as a morning meditation, as a warmup, or as a ritual you go through to tune into your body. You may choose to do something with the pages—turn them into other art projects or simply discard them.

WITNESS

You may want to explore this process several times before you feel ready to share or express this meaning you have found. For some folks, establishing this connection to the body will take longer than it will for others, and of course once it's established, there is no end to the practice of attuning your awareness to it. Although this process may, in particular, feel personal and private, it is still important to share the wisdom, insight, imagery, or writing that you found in this process with a trusted person.

The First Stone (found natural objects)

13

REWRITING OUR
PERSONAL STORIES

MANY PEOPLE COME to creative mindfulness in moments of duress, seeking to alleviate a specific problem, but the benefits of it can be felt at any time in life. A daily practice in creative mindfulness is a way to welcome both the simple joys and the doldrums of life into the light. And in this open exploration is where some of the most significant insights tend to happen. Tina, for example, reveled in learning; she was always reading, taking new classes, and reflecting on her personal growth. She defined herself as a spiritual person, and at times in her life, she had contemplated devoting herself entirely to a spiritual path, choosing to forego romantic relationships or family life. She was personally happy and had meaningful work helping others. Our work together was a chance for her to learn a new way to reflect in life rather than solve a specific problem.

Tina and I would begin our sessions attuning to what was happening for her in the moment. Sometimes she was feeling balanced or grateful, and other times we would discover a stress building within. I could tell that Tina valued the ritual and sacredness of our time together. She relished the process of preparing for our sessions, laying out our supplies with care and always lighting a candle to signify the start. Our shared love of poetry meant that we would begin and close each session reading a poem aloud, the space shifting into something revered and extraordinary as the words filled the room. Together Tina and

I made art and music as well as danced and wrote poems together. Each session revealed a gentle deepening of self, nothing epic, no earthshaking revelations; rather, each was a chance to hold space and make art as Tina got to know herself just a bit more. Like eating a healthy meal, exercising, or receiving the warm care of friendship, this creative work was part of nourishing daily life.

Over time something slowly began to reveal itself with more clarity. It began with an image of a tiger, then a sexual energy discovered in red pastel marks, and a reaching movement found through dance. Tina was beginning to realize that perhaps her commitment to her spiritual life didn't have to exclude romance; perhaps there was a path that brought spirituality and intimacy together for her that she just hadn't discovered yet. For many years, Tina's life had been about work, personal exploration, and committing deeply to her spiritual practice, but her creativity was starting to speak to her, expressing a deeper longing, one that wanted to commit to love and family life as well. The messages and themes in her creative expression all pointed to a new story for Tina. She was ready to let go of the old story about being a celibate spiritual and instead embrace a new one of a spiritual woman seeking love. Tina was, in essence, restorying her life, letting go of an old idea of who she was and moving into a new version of herself. It was her creativity that helped bring this into the light and reveal a path forward for her. Red became a new language for her as she intentionally bought red clothes, baked red cupcakes, and sketched daily in red pastel. She made altars with tigers and passionate flowers, wrote poems about finding love—all a form of creative ritual to embrace this new version of herself. In time, Tina felt more and more ready to embrace this new story of who she was. In the end, our seemingly directionless creative work together became both revelatory and a resource for Tina as she moved into the next chapter of her life, one in which she was ready for love, with the wisdom of her spirituality at her side.

A Story Fifty-Four Years in the Making

Stories aren't just fiction; they are the way we stitch together the complexity of our lives. Our experiences, ideas, and values all come together in the stories we tell ourselves about who we are, who we aren't, and where we are going in life. Some stories are short lived, like being afraid of the dark, which we often leave

behind in childhood, but others, such as being a hard worker, perfectionist, or loving caregiver, we may carry with us through time. At times we author our own stories, and in others, we let the people around us define us. The impact is the same—stories help us to make sense of ourselves and the world helping us find significance and identity in each retelling of them. Stories can be helpful, but they can also be another form of attachment, a way that we can cling to an idea rather than tend to the moment. We may find safety and security in our stories as they anchor us to something in the vast sea of life, but if we don't revisit the stories from time to time and see if they are still needed or helpful, we run the risk of becoming attached to old versions of ourselves that no longer serve us.

During the 1960s in Sweden, there was an enduring story about a destitute Japanese marathon runner who had been roaming the streets of Stockholm for decades. The myth of the lost man began in 1912, when marathon runner Shizo Kanakuri began an arduous eighteen-day trip to Stockholm to participate in the Olympic marathon. His long trip left him exhausted and unwell. He rested for five days, but on race day, he still found himself suffering. At some point during the race, it is said that he became delirious and unwell, suffering from exhaustion and overheat. He stumbled onto a patio along the race line, confused, and joined a family dining. He drank some orange juice and then passed out. No one really knew what happened to Shizo next, and so the myth of the embarrassed and ashamed Japanese runner became like that of Bigfoot, living on through only whispers and stories. There were sightings of him sweeping chimneys or working as a baker, taking up another life in Sweden, afraid to go back home to Japan and face embarrassment.[1]

The myth of Shizo came to an end in 1967 when a Swedish television crew went looking for him. They found him at his home in Japan, completely unaware of the mythic presence he held in Sweden over the years. Shizo had been carrying on with life; after he came to on that patio in 1912, he realized what he had done, and feeling the shame of letting his country down, he simply left the race and disappeared quietly, eventually finding his way back to Japan. Shizo didn't let this moment define him as the Swedish people had believed; he went on to compete in future Olympic races and contribute greatly to the sport of marathon in Japan. When the crew found him, he was living a "placid life of

a pensioned geography teacher." The crew welcomed him back to Sweden to finish the race, and remarkably, Shizo accepted the invitation. At the age of 76 he completed the marathon, his final time being 54 years, 8 months, 6 days, 5 hours, 32 minutes, and 20.3 seconds, the longest ever according to the Guinness book of world records. At the end of the race he humorously remarked, "It was a long trip. Along the way, I got married, had six children and ten grandchildren, and that takes time, you know."[2]

This remarkable true story is a reminder that no story is ever done, that we can always go back and add another chapter—even fifty-four years later! Shizo could have easily let this moment define him—he could have quit running and let the shame become his story—but instead he went back to life, continued to run and compete in marathons, finding joy and meaning all along. Imagine for a moment going back to an old wound from your past and redefining it. To do so you would need to be willing to let go of any attachment or surety you had. Consider the courage it took for Shizo to soften his attachment to winning, to feel the sadness and letdown of a loss such as this, and yet still to go on to run and compete. Shizo embraced the fluidity of life, taking it moment by moment, knowing that the events in Sweden were but one chapter in his life's story. He then found the inner courage to return to the site of his failure decades later, and with the eyes of a country upon him, redefine this troubling event in his life, finding closure and joy in doing so. Shizo's life story in its entirety transcends myth and the narrowing attachment of labels, showing that no version of ourselves is ever fixed, but rather always awaiting redefinition.

Attachment manifests in many ways in our lives. It may happen in the moment as we anticipate how we want our day to unfold, subsequently choosing control over presence. Or it may manifest in how we make sense of a moment and then carry the story forward with us, feeding it and keeping it alive through time. Perhaps we feel attached to a moment from long ago, a test we took, or an experience that caused us to believe "I am bad at math," or "I have two left feet." Or we may find attachment in the disapproval of others as we tell ourselves, "I am too shy for public speaking," or "I'm not beautiful enough to be in front of the camera." We may tell ourselves that we are "too weak," "too old," "not a risk taker," or "don't like that sort of thing," each thought stemming from an attachment, a story we hold onto through time. With each story we tell ourselves, an

attachment is formed causing us to push away or pull into narrower versions of ourselves.

The story you tell yourself matters. Which stories are you ready to soften your attachment to? Are you still the same person you were years ago? If you soften your grip on who you think you are, what will you become next? In the case of Tina, doing this meant a chance at love, and for Shizo, it meant letting an old story fade away and replacing it with a new one, fifty-four years later, that told a more complex and enriched tale about his journey through life. Our attachments have the potential to hold us captive as they define us and our actions. When we hold onto old stories, ideas, and ways of being, we are, in effect, resisting our lives. By recognizing how old stories limit us and embracing new and evolving versions of ourselves, we are finally able to put down the weight that no longer serves us and welcome a new chapter, a new story in our lives, to take shape. After all, every great story never really makes sense until the end.

Creating Identity and Ritual

Creating with intention can help us to identify and name our attachments, supporting us to restory our past or turn a new page on the next chapter in our lives. As we create, we may begin to see themes emerge, showing us common emotions we feel as well as persistent experiences, sensations, or interpretations we give to our daily lives. When we paint, our perfectionism may show up; when we dance our harsh relationship with our bodies may come into focus; or as we stitch, we might realize how much we seem to need safety and predictability. Everything we create, touch, or make reveals more of our stories to us. Each creation is a chance for us to name our story so that we can then examine it and determine if it still serves us or if it's time to let it go.

Once our stories are brought to light through our creative expression, creativity becomes an active place in which we can move toward a new future through creative ritual. We see this dual function at play in the work of artist Mechelle Bounpraseuth, who uses her ceramic creations "as a way to understand and process the loss of my cultural heritage, inherited trauma, childhood memories, and as a way to navigate my own identity."[3] Mechelle is a first-generation Australian of Laotian refugees who was raised Jehovah

Witness. She grew up feeling lost and distanced from her culture: "Growing up as a Jehovah's Witness disconnected me from many aspects of Laotian and Australian culture, as we weren't allowed to observe any customs and rituals interwoven with other faiths."[4] As a young woman, when she broke away from the church in order to pursue a creative life, she found herself going back to memories and objects from her childhood, creating domestic objects such as a ketchup bottle, VHS tapes, or soda cans from clay. The creation of these objects presented a chance for her to "navigate her old and new identities" as she decided which values to carry forward and which she wanted to leave behind. Mechelle's creation of a Lychee fruit soda can is symbolic of her memories of collecting old cans with her mother to help pay for food for the family. In the making of this can, Mechelle is bringing to light a piece of her own history while also ritualistically turning the mundane into something sacred for her. Mechelle, now a mother herself, says, "reclaiming what was taken from me, valuing and honouring what I know, and connecting the past to the present, is a form of decolonizing in my practice and my cultural inheritance for my child."[5] Mechelle has found both insight and ritual through the creative process, helping her navigate the complexity and joy of life through art making.

The experience of Mechelle is similar to countless others throughout history where creative expression became an active process of both identity-making and ritual. We tend to think of creative expression as an end, a product where the making of it is the ultimate purpose; however, in the past, creative expression has always been bound to ritual and ceremony in a culture. Historically, art making and religion evolved side by side, suggesting that for humans, creative expression was a sacred act that connected you to something greater than the end product. Look at any ancient cultures and you will see ceremony and rituals that value storytelling, music, dance, performance, and costume, as well as the adornment of objects and imagery through handicrafts. As scholars Steven Brown and Ellen Dissanayake suggest of the relationship between art and ceremony, "the arts are not ancillary add-ons, but are instead essential components of the ritual."[6] These findings position creative expression as more than a solitary act that serves as an end in and of itself; instead, it becomes another expression in a long line of creative rituals that have been unfolding for millennia, intertwining creativity with spirituality.

When we are engaged in a creative act, in a way we are participating in a collective remembering that is held deep within us. We are enacting what our ancient ancestors have taught us, that our expression is a sacred act that connects us to who we are as well as to each other. Each of our expressions is a ritual bridging our past to our future and connecting us to something larger than ourselves. Ojibway author and storyteller Richard Wagamese asks Old Woman (an elder spirit he often speaks to through prayer and writing) what the purpose of ceremony is, and she replies, "to lead you to yourself ... [to] choose what leads you to the highest vision you can have for yourself, and then [to] choose what allows you to express that. What you express, you experience. What you experience, you are."[7] These words remind us that creative expression is an active process of knowing, one that connects us to ourselves as well as something bigger. Creative expression is a way of softening our attachments to the stories we have been telling ourselves, allowing us to both know and surrender our expressions to something bigger than ourselves. As both Tina and Mechelle found, there is a certain alchemy in the process of making, a sacred process of knowing as well as revealing our place in the world.

A Blossoming Rock

The moment I stepped out of my car and onto the chilly damp trail my stomach began twisting. I ran behind a clump of wild rose bushes and emptied my bowels—a glamorous start to what was supposed to be a bad-ass day of hiking for me. It makes sense to me now that I would need to shed everything extra when going on a trip of this sort. Weight, belongings, old friendships, outdated ideas—I had already let go of so much leading me to this moment. At the base of Sunwapta Mountain, very early one morning in mid-August, I stood skinny, alone, carrying two liters of water, a sandwich, and a raincoat.

At the age of thirty, I was freshly divorced with a young child, and I suddenly found myself without. Without an identity beyond mother and wife, without a home, without many of my friendships, and without purpose. By ending my marriage, I inadvertently ended so much more. I had been purging my life with focus, trimming away everything that used to be me, wondering what would be left afterward. Who would I be after it was all stripped away? The more

disoriented I felt, the more empowered I was to believe I could do whatever I wanted.

In my corner of the world, the Rocky Mountains are a beloved treasure—large enough to absorb each of us and our needs. We can run to them with anything and they are big enough to hold it all and more. I can see now that they were the cradle that transitioned me from one story to the next. In lieu of a church, community, or a family ritual to help me bridge this space, it was the mountains that held me safely, propelling me from one life to the next.

I had already spent years exploring as many mountains as I could, pushing myself on my cross-country skis, and making art in every spare moment in between. This is the part of my transformation when the montage comes in—imagine me in sun and snow, moving to an upbeat song, traveling up and down mountains, and getting physically stronger and braver every day. It was during this time that I first visited the 3,325-meter Sunwapta Mountain. I spent six hours hiking, and with no summit in sight, I turned around. I had become accustomed to the exhilaration of pushing my limits and routinely finding my edge. But this mountain was too big for me, and my ego didn't like that. It wanted to play in the limitless forever. Everything about my new life was upward seeking—climbing mountains, drinking too much, seeking wild friendships, and taking on a new career, complete with a ladder to climb and jockeying egos to fend off as we all sought the spotlight. I can see now, looking back, that when I stepped away from what I knew, it was my ego that took over. An insatiable, insecure creature that only wanted more, bigger, and better.

Here I was, years later, back at Sunwapta, trembling cold, in the bushes below the peak. Maybe I was scared that morning on that trail because I had a close encounter with a bear the day before, or maybe it was because I knew that I was finally ready for what was waiting for me at the top of the mountain. This was day six of my solo ten-day camping trip. I had no cell phone service and no friends to meet up with—just a plan to hike as many mountains as I could, sit beside rivers, drink wine and coffee with only a book and a sketch pad to accompany me. I crawled into my tent early each night absorbed by solitude. I could feel my body beginning to let go and relax, but I still had a striving, deep in my bones. In my mind, I felt like revisiting Sunwapta was going to mark my grand achievement on this trip, that finally I could summit this beast.

Looking back, I can't think of anything more human, more ego driven, than summiting a mountain. What is it that we think we will encounter at the top of the world? Sunwapta was tempting me to its top, and my ego had been taking the bait, but I didn't know what sort of trap it had set for me.

The start of a hike like this is always a bit humbling and meditative. When you know you are in it for the long haul, your mind offers patience. It's easy to find a meditative flow to your steps when you are feeling fresh. I was high enough I could see my car now, just a tiny shiny ant along the road far below. As I looked down on it, I knew that this meant that I would be the only person on the mountain today, a simultaneously exciting and terrifying proposition. I pressed on and moved above the tree line, and as I looked up, I saw a vast field of sandy colored rocks laid out before me.

Four hours in, and I was still optimistic. An endless staircase of dimpled fat stones lay before me—this was the boring montage where the same scene loops again and again. Another two hours in and I could feel it (maybe it was there all along and I just didn't want to feel it): my knee was in pain. It was telling me that I was vain and reckless. I had felt this pain before—an old overuse injury that had shut me and my ambitions down before. I knew I needed to get down, and I also knew that going down was the hardest on my knee. I looked up and saw that I had another hour, at least, to go, and then I looked down and saw the glimmer of my car, kilometers away, still alone on the side of the road.

I could have had a temper tantrum or cried all alone below the summit of Sunwapta, but I didn't. I stopped and took a deep breath, and then I felt an odd rushing feeling zip through my head and my chest. I stumbled backward, threw my backpack off, and fell slowly down to the ground. I placed my hands to my sides, gripping the stones, and felt my chest fling wide open. I was completely absorbed by this bizarre sensation. Sunwapta knew what this was. She anchored me tightly, allowing me to hold her close. I held on to her stones until the bifurcation was complete. My ego was abandoning me; it knew the decision I had made, and it looked at me, disgusted at my weak, tired shell, and decided to fly away. Maybe it was mad at me for quitting, or maybe it just wanted to see what was at the top; I don't know. Either way I could feel peace sweep through me in its retreat. I loosened my grip and then looked out and saw dozens of other peaks around me. I knew in that moment that I could summit each one

and that it still wouldn't matter—that it would never be enough, they would never offer me the depth I needed to sustain myself in this life.

I can't remember if I cried, but I do know that this was the point that, after years of floating and pushing myself recklessly upward, Sunwapta caught me and held me close. I looked out across the valley and settled into the view my back had been enjoying for the past few hours, a stunning panorama of peaks and valleys and a serpentine river carving its way through the trees below. After a few moments, the winds intensified, and Sunwapta whispered something to me; she told me to take a rock home to help me remember this moment. I looked around me. Every stone was huge—somewhere between the size of a basketball and a football. I thought I must be crazy to think of dragging a boulder that size home. Then, just a few steps above me, I saw it: a stone roughly the size of my shoe, tawny brown and covered in crevasses, a sturdy character to serve as a souvenir of sorts. I placed the stone in my backpack, looked upward to the peak once more, and then began my descent.

Pain is the great equalizer; no matter who we are, it carries us all away to the same plane, forcing us to leave this world and be with it instead. My knee was screaming with each step I took. I was completely unprepared for this; I didn't have poles, or a bandage, or even a plan for what I would do if I was injured. I hobbled along, moving slowly. The steeper the terrain, the more excruciating the pain. When I reached the tree line, I found a stick to support me, but it wasn't enough. Over eight hours into this day, and I began to cry. Every bit of my ambition, confidence, and zeal was gone. My ego was probably basking in the sun at the peak, my heart was tender, and all I could do was cry. I knew that I wasn't really in danger, just dumb. I pressed on, digging deeper and deeper down the familiar trail, past my anxious rose bush, and then at last back to my car.

The next night I sat by the river with my stone. I knew that something remarkable had happened to me, that my days of living without and flitting after my ego's whims were done. I had let go of so much. I was done with cutting things away; it was time for me to be intentional about building. It seemed like I should have come down the mountain and been met by a community of support, one that was ready to walk me past the sacred threshold in a ceremonial ritual. But I am a woman without traditions or culture, so I needed to make my own. Sunwapta had offered me the first stone to begin building my

new life, and now it was up to me to decide what came next. I took stock of my surroundings and found some wildflowers. With reverence, I picked a few, thanking the mountains for playing witness to my ritual. I placed each flower on a dimple in the stone, an affectionate beatification of the first building block in my new life—each flower ornately adorning my new life with more intention and less ego. Tears streamed down my cheeks, and one by one, I picked up each flower and sent it down the stream. My ritual now complete, I took my stone and crawled into my tent, holding it tight through the night until the first beams of dawn light shone on us, signaling to me that a new day had come.

CREATIVE INVITATION: TRANSFORMING ATTACHMENT WITH CREATIVE RITUAL

In this invitation you will choose an object and create a ritual as a way of putting down the weight of the past and finding a new story for what is emerging for you. In my creative journey of moving from my old life to a new one, the process of adorning the rock became the anchor for my ritual. You too will find something on which to anchor your ritual. In this process you will trust your impulses and ask yourself what this anchor can be, and then you'll design your own ritual to help you let go, restory, or move toward what comes next.

ARRIVE

Spend some time arriving at the present moment as you explore the sensory experience of shaping clay or another moldable material. For this process you will need a fist-sized block of clay, Fimo, Play-Doh, salt dough, bread dough, or similar. If you cannot access a moldable material, you may also use wire, paper strips, or anything that you can explore shaping.

Begin by closing your eyes, taking a few breaths, and feeling the weight and temperature of your material. Imagine each of your breaths moving through your body and coming out through your hands as you shape, move, squish, and play with the material.

See if you can find a rhythm of your breath and the shaping process. When it feels right, see if you can shape the material into an intentional shape. You may see an image begin to emerge or choose to create something you like. Spend a few minutes shaping it. Once you feel it has reached its desired form, take a few breaths and begin squishing and reforming the creation. Notice what it's like to have something emerge and then dissolve. Complete this process by laying the clay down and returning to a few deep breaths. Offer the clay a gesture of gratitude such as placing your hands on your heart, offering it a bow, or anything that feels right.

SET AN INTENTION

Now that you have primed yourself to begin this creative ritual, set an intention for what you would like to explore in this creative process. What is it that you want to lean into, stretch toward, or hope to have happen because of this creative process? For example:

I intend to let the process take the lead.

I intend to use this process to soften my attachment to . . .

I intend to surrender to something bigger than myself in this process.

ASK A QUESTION

You may already have an idea of what weight or attachment you are ready to put down, something you are ready to restory, or a place you are ready to move toward in life. Write a question that you would like to explore through this creative process. For example:

What about _____ is no longer serving me?

How can I best honor and respect _____ while moving past it?

I am ready for what comes next. What is it that I should do?

PREPARE BY FINDING YOUR ANCHOR

Look back at your question and brainstorm three to five symbols, images, ideas, or similar that feel connected to this. For example, it may be that you are ready to let go of your perfectionism and you identify the symbols of a ruler, scissors, and a messy drawing from your childhood. Or perhaps you are ready to let go of being a caregiver for others and start

caring for yourself, and you identify the symbols of a washcloth, a cutting board, and a pay stub from your work. The symbols you come up with will be your own and have meaning for you. Once you have come up with your list, settle on one that seems to have a deeper resonance or meaning for you. You will work with this symbol in your ritual.

CREATE A RITUAL

You have the grand opportunity to create your own meaningful ritual to help you make this transformation of letting go and moving to what comes next. Decide how your ritual will unfold, what part your anchor will play in it. Will you create the anchor as part of the ritual, destroy it, adorn it, or leave it behind? Don't be afraid to make it big and grand; the more this feels separate from regular life, the more power it will have for you. You can customize each component of it to meet your needs. Your ritual should feel otherworldly, not like everyday life, and it should give you the chance to do something remarkable. Ask yourself, What are some essential elements for this ritual to have the most power and meaning for me? You may want to include any or all of the following:

- Going to a special location or place.
- Choosing a specific time or day.
- Beginning with a meditation or breathwork.
- Including movement or your body in some way.
- Making the area special by using candles or plants (or other living things) or by creating a scene or altar with treasured objects.
- Reading a poem or writing something.
- Including music or even making your own.
- Inviting someone to witness or help you.

COMPLETE YOUR RITUAL

Once your ritual has been planned, it's time to carry it out. Take your time as you move through the ritual; you will likely feel uncomfortable or scared. Encourage yourself to be in this liminal space; try to revel in the process as much as you can. Notice any feelings, sensations, or thoughts that show up for you. How has this changed from before the ritual to after it?

DISTILL

As always, you will want to be intentional about harvesting the meaning and insight from this process. At the end of your ritual, take the time to write a poem or do some expressive journaling to explore some or all of these questions:

Today marks . . .
Now that I am no longer . . .
The past can't control me any longer.
Welcome, _____. You are now a part of me.

WITNESS

It is important that you share this transformation with someone you trust. Rituals can be private, but they often include your community so they are witnessed and the transformation is made apparent. How can you make this shift known to others? It may not feel right to tell everyone, but it is important that you share what the creative process and what your anchor symbolize with at least one other person. Make it real and share the richness and intention of what you experienced with a trusted person.

A Temporary Gift (found objects)

14

THE IMPERMANENCE
OF THE PRESENT

OFTEN PEOPLE COME to me in urgent moments of their lives. They have just separated from their significant other; their anxiety has reached a new fever pitch; or they are trying to decide if they should take a job in a new city. This was the case with Jasmine, who was in her mid-thirties and had been coming to my workshops for a few months. Her creations were always rooted in deep emotion, but she maintained a private, guarded approach with me. After class one day, she pulled me aside and asked if we could do a one-on-one session soon to talk about her increasing anxiety. Our session began with Jasmine telling me that her anxiety was relentless now, interrupting her sleep and work, and she felt that she needed to do something immediately to address it. I felt the panic and sadness in her voice, and I could see her exhaustion as she sought reprieve. I almost went down the path of focusing on her anxiety, trying to figure out its causes, triggers, and meaning, but instead I stopped.

I looked at Jasmine, took a deep breath, and conveyed to her that I could see the depth of her pain and distress. I then asked her if she would be interested in pressing the pause button and being still with me for a few moments to see if we could locate her anxiety right then. She was open to this, so we began. We both closed our eyes, took a few deep breaths, and let the world and the pain fall into the background. We sat for a few minutes with our breath, bodies, emotions, and energy. Siting with the activation, not speaking, holding ourselves in

vulnerability for just a moment was like lying low in a meadow, tucked below the long grass as the wind whipped above us. It was as though we took ourselves out of the steady flow of life and found a pocket of stillness as the wind carried on above us.

When we reconvened, both of us had experienced a palpable shift in energy. Jasmine was surprised to discover that she couldn't find her anxiety in that shared moment, just her breath and the comfort of our joint presence. This was a key discovery for her; for at least a few moments, her anxiety wasn't there! This meant that it was changing and shifting, sometimes present with a vengeance and other times lurking in the background depending on the moment. This place of stillness was important; it was the reprieve that she had been looking for. She went from feeling an escalating activation to finding a softer, gentler inward gaze, and it was this inner strength that she needed to find a path forward. Her anxiety was complex, messy, and filled with emotion; it was going to take a tremendously calm and resourced approach to find a way through it, or any solution she found would be born of panic and desperation.

Jasmine and I wrote a poem about the place of pause and respite she had found, and it was in this that the image of lying down in a meadow with the wind tearing above emerged. She sketched this image, invited it into her meditations, and wrote about it when she felt herself becoming anxious and disconnected. Eventually, Jasmine found a path forward that was tempered and strong. She credited this moment and the image of lying low in the meadow with helping her to continue to find moments of calm where she could tap into the nuance of her anxiety rather than feeling it as an all-consuming force. Often the urgent problems that appear in our lives require an approach that is just the opposite—slow, patient, and nuanced, where we focus on subtlety and stillness rather than action.

The Paradox of Patience

In the mid 1800s Emily Dickinson wrote the poem "Forever- Is Composed of Nows," a poignant composition reminding us that the present moment is all we truly ever have.[1] Known to be ahead of her time, Dickinson has endured as one

of the most compelling, original, and elusive poets in history. Her poetry and life story have much to teach us about patience and trust as we contemplate the unfolding nature of life. Dickinson wrote over 1,800 poems in her lifetime, often exploring the themes of nature and death, sewing each poem together with care into a handmade book once it was complete. Despite being a prolific poet, only a handful of her poems were ever published in her lifetime, and those that did see publication were subject to heavy edits and alterations to stay with the style of the time. Yet, Dickinson didn't appear to be impatient with her lack of success; she wrote because that's who she was and that's how she lived. Her craft was poetry, and her muse was everyday life. She had instructed her sister to burn all her writings after her death, but instead her sister decided to hold onto her stitched books of poems. In time, the poems began to be seen and understood with greater depth, eventually positioning Dickinson and her contributions to literature with an enormity that is still being understood today.[2]

Dickinson's life story teaches us that to live a meaningful life, we must have patience and embrace the paradox that the moment is all we have and yet it doesn't define us. Each moment is always in motion, part of a slowly unfolding flow of living. If Dickinson would have let her lack of publications or success define her, she would have never been so able to be fully present in the moment and create the work she did. Although she died over 140 years ago, from this vantage point we can now see that her life and insights have carried on long after her passing. She didn't know the full context of her life at the time (no one ever can); she simply lived day by day, moment by moment, absorbing her life and writing about it without receiving praise or having greater ambition. She found meaning in life by capturing the subtleties and shifting nuances in the moment through her poems. At the core of her life and poetry we can see a profound patience at play; it resists the desire to define, name, or judge the meaning of a moment, and instead trusts it to something bigger, the unfolding nature of life. Today Dickinson continues to live on through her poems, lovingly stitched together so long ago, connecting to each person who reads and studies her work.

In mindfulness, cultivating an attitude of patience and trust in our lives requires us to embrace a paradox that every moment is both sacred and not as important as we think it is. Each moment is fluid, in motion, always becoming

something else. We can think of patience as a quiet, steadfast demeanor we hold when our expectations go adrift or notice irritation welling up inside of us. And we can practice patience as we watch winter slowly melt into spring, when we remind ourselves that it takes time to learn a new skill or remember that some work can't be forged overnight. But patience is also a perspective, built in trust, a deep recognition and confidence that life unfolds in fleeting, temporary moments, each one sacred; yet each moment sits within a context so much larger than we can understand. This paradox asks us to zoom into the micro of our lives and savor each moment while also zooming out to the macro, recognizing that each moment is connected to many others. We can hold a paintbrush and be absorbed by the marks they make, but these marks aren't good or bad; rather, they're one more momentary expression made in a lifetime. The paradox of patience asks us to hold ourselves in the now and forever at the same time.

The present moment is special and sacred, but it is also fleeting and gone before we can even grasp it. We can tune into the sacred, take a breath, look around, and know this is it, right now. Everything else is either a memory of the past or a projection into the future, so let's truly be here now. If we rush through this moment thinking we can get to a better one, then we miss out on life because it only happens in the now. And here is the crux of the challenge that we face as humans: if we only cared about the present moment, we would spiral into chaos, our actions wouldn't matter, the past would be simply forgotten in a moment's time. We need only think of a single act of harm done in a moment to recognize why we need to hold a bigger perspective. What we do, and what happens to us in the present moment, matters down the line. And so, we must tether ourselves to the present moment knowing that this is the only place we can truly live, while also holding onto something bigger, a trust in the unfolding nature of life that is beyond anything we can know now.

This is the paradox of patience, forever and now stitched together, a recognition that this moment is everything, and yet so too is the big picture. So, we do just as Dickinson did. We attune ourselves earnestly to the profound experience of being present in the moment—the idea that now is all we have—and then we trust the unfolding nature of life, knowing that this

moment is part of the monumental big picture at the same time. For example, in any day, we may encounter a moment that bring us agitation. We may think to ourselves, "I am running late again," "He was so rude to me," "My back hurts," and so on. We feel the agitation in the moment, and then we have a choice: we can stay mired in it and let it spill over into the future, or we can bring a perspective of patience and trust to it and remember that everything is fleeting and always in a state of flux. Yes, this moment matters, but it is only temporary, just like everything else. Eventually you won't be late, the rude man will depart, and your pain will dissipate, shift, or morph into something else. When we open ourselves up to the possibility that even suffering is in motion rather than stagnant, we begin to see that nothing is permanent, that everything, everyone, and every situation is always in a state of transformation, becoming something else.

When we pay mindful attention to the moment and tap into the perspective that life is unfolding on a grander scale, we see that everything is always in a state of transformation, that nothing stays the same. Even chronic challenges such as pain, depression, and anxiety are always shifting. Perhaps it's human nature, or maybe it's just the conditioning of our world full of extremes, but we tend to focus on the presence of a thing more than the nuance of it or the context it sits within, our minds quick to fill in the gaps and declare things as just so. Next time you are in pain, try to observe the subtle changes and nuances of it; focus on the gradients of how it moves and shifts moment by moment, and put it into the broader context of the life that it is unfolding within.

The paradox of patience also allows us to expand our view of the present moment, to find joy and suffering, hope and despair, all coexisting at the same time and space. We begin to see the vastness of life at play in any given moment and expand our world to hold the spectrum of human experience. Perhaps our suffering is heavy today—it was hard to get out of bed, we are annoyed at the long list of emails we must respond to, today's news is full of tragedy, and we feel alone. But the birds are also flying in the sky, we witness an act of kindness as someone holds the door for us, our coffee steam glistens in the sun, and our breath fills our lungs, keeping us alive. In this moment we are safe. All of this is happening at the same time, and our attitude of patience helps us to recognize that we can be with what is happening now and

also link into the greater picture. Life unfolds in infinite ways, never just one, and we can choose to be with it all. In our own way, we can offer patience to the moment as Jasmine and Emily Dickinson have shown us. We can pause, breathe, and attune to what is, find stillness in the now, while trusting our own unique forever to blossom in its own time.

Forever and Now in Creativity

In 2014 artist Katie Paterson set into motion the "Future Library" art project. This project began with planting one thousand trees outside of Oslo, Norway, which will reach maturation and be cut down in the year 2114 to print the written works of 100 writers. Each year for one hundred years, a different author is invited to submit a written work into trust, the work never to be read or seen until the conclusion of the project. Most stewards of this project will never live to see the fruits of their labor; they will never know how their work was received, or what the overall impact of the library is in the end. The writers' creative process will be long past, the writers mostly deceased, and the architect of the project long gone.[3] This is an endeavor with a long gaze in mind, transcending the self, trusting that the moments creatively captured now will serve the future without understanding exactly how. Many will scratch their heads and wonder why people would invest so much time and energy into a creative project they will never see in the end. Each participant's answer will be varied and steeped in their own personal belief in creativity and patience. Most of us will never engage in a project with such a clearly defined future scope; however, each of us will endeavor in the creative moments of now, which hold meaning in the grander scale of our lives.

Many times, in our creative lives there is an unspoken assumption that we know why we are engaging in creativity. We have notions about making something for some specific purpose or fulfilling a deeper need within ourselves, but seldom do we actually examine or name why we engage in our creative practice. In the uncertain, rocky territory of making something new, we bump into so much of our own stuff that we may find ourselves moving between elation and misery within the same minute. We may be unhappy with what we have made, wishing it was more beautiful or skilled. We may find ourselves

quick to abandon or switch projects or perhaps critical of our project when it doesn't seem to go as planned. As we swing between extremes, it helps to know why we are engaging in creativity so that we don't find ourselves burnt out, confused, or lost. Once again, creativity offers us a microcosm of life. In our creative expressions, we can notice the feelings that well up, we can find a place to reorient our perspective and follow a process that helps us make sense of, and become comfortable with, ourselves, knowing all along that the work we do here in the creative process will trickle out and inform other parts of our lives.

We may think that we sat down to make an art journal spread today in service of our mental health, but our pages are a soggy mess, and somehow, we feel worse off than when we began. If, however, we start by connecting to the moment with patience and trust, remind ourselves of our big-picture why before we create, then we can hold that all in the foreground as we let ourselves revel in the details of our messy process and emotions. If we are creating for our mental health because we know making something nourishes us, then the end product doesn't matter. Our ugly art wasn't trying to be beautiful; it was a chance for us to be with ourselves in the sensory bliss of the moment, so why are we measuring it against a different stick?

If we find ourselves attached to making beautiful, skilled, praiseworthy creations, one of the simplest ways we can remove our expression from the gaze of this all is to create in such a way that we focus on the now and trust the rest to the unfolding nature of life. One such form of expression is known as *ephemeral art*, a creation that is designed to be temporary and exist for only a short period of time. Examples of this include art that is created in, and with, nature, subject to natural forces like wind and rain that destroy it; performance art, which can only be expressed and seen in the moment; and street graffiti that is subject to the whims of the public domain. We can play with the ephemeral when cutting paper collages by lifting our pages to watch the pieces fall. Or we can make installations that come together for a short period of time before being dismantled. We can destroy or burn our sketchbooks, writings, sculptures, or fiber art, or we can take our creations outside and let mother nature have her turn with them. In each creation, we are with the process in the now, recognizing that the reason we are engaged in this creative act transcends the moment; its meaning

is bound to a purpose that we can't see or understand from this vantage point in life. A patient approach to creativity does two things: it gives us permission to move slowly, thoughtfully being with our body, sensations, and emotions in the creative process, and it allows us to hold our big-picture why with reverence, recognizing that creating something isn't a checkbox to fill today, but rather a part of a purpose that takes time to unfold.

The Land Speaks

I have only recently realized that the land speaks to those who listen. Maybe I had an inkling as a child when I would lie on the damp grass and it would encourage me to say bravely what I wanted out loud, or in my twenties when, on the top of Pakakos Mountain, I heard a creek tell me that it believed my story. Now the words of the land filter through my body slowly, meanderingly, and with more clarity. I think I just kept listening, believing that the soil, rocks, and plants could speak to me, and they did. I hear people speak about the land from time to time, but usually it's just about the ways that nature has intruded upon their lives. What I am talking about is a different type of listening—the land I know speaks to me and through me with intimacy and wisdom. Perhaps it sounds absurd, but the land helps me live my life and in return, I help it, or so I hope.

My home sits at the bottom of a bluff on a flood plain next to a river, wild at heart yet still inner city, a bridge between both worlds. Many of my neighbors' homes were damaged in 2013 when the great one-hundred-year flood ripped through. That flood seems to define this place, for now. People tell stories, relive the anniversary, and often harken back to the trauma and the community building that it yielded. I suppose you could say it's what connects many people around here to the land; it was a time when people collectively awakened and listened to the river and the saturated soil as it demanded to be seen and respected. But I just went for a walk, and I heard more than the flood; I heard the river say it might be dying—that it's getting too warm for its glacier mother. The plants told me they are growing today because of the sediment left here in the great glacial retreat, and the bluff whispered to me that it was once

a buffalo jump used by Indigenous peoples to hunt bison in mass quantities in preparation for the long winter.

Even though I live in an urban center, I try to stay connected to, and aware of, the land—the bluff, the river, and the natural entities that shape my home. I try to remind myself that I am a visitor here, a temporary steward, that I am only here because of settler force, both past and present. The more my heart softens, the more I practice being still and present, the more important it feels to name this position I hold and to listen to the land. This sounds noble, like something to aspire to, but to be honest, mostly I just reel in the drama of my regular life, occasionally recalling the land I occupy. The moments when I do listen and find myself bowing down to the great elder of elders, it feels like I have touched infinite grace, which permits me to see beyond my own petty shit so that I can take the next breath with greater peace and maybe give back. Often, the land's wisdom comes to me in fleeting moments, but every now and then, I can reach out and grab onto a souvenir, a time-stamped ticket that proves I was once there, listening to the land speak. A handful of dried flowers pinned to my wall serves as a memento of my temporary anger, or a poem transcribed from the wind reminds me of how infinite my love is. These are transitory creations I made as I listened to the land. The land helps me in my strife; it never expects anything in return, but I know how reciprocity works.

A few years ago, I was in an overwhelming battle with my toddler son; both of us were yelling, things were escalating, and a loss of control was imminent. In my frustration I picked him up and put him in his baby sister's stroller; I remember he was barefoot and almost too big for it. We left the house and started walking in the hot sun, farther and farther, until we escaped the reverberations of both of our wailing. We looked out onto the wetlands where we had found refuge and saw a blue heron, still, unbothered by our drama, patiently scanning the water for fish. I picked up my son and held him close so we could both watch. We saw the patient longing of the bird, and our frustrations faded with the sun. I kissed him on his cheek and apologized, and then he, barefoot in the grass, reached down and grabbed me a handful of wildflowers. I took them home and tied them to a frame; downward facing, droopily folding into a prayer, they were already speaking to me.

I hung this on my wall. I knew the flowers were a temporary gift, their impermanent lives fading already. I heard them say, "Everything is mortal, after all." I watched them wither over the days, each morning telling me, "Nothing ever stays the same, Rachel, not even suffering." One day my son and I won't be locked in a battle of wills; we'll be maneuvering around his budding independence or perhaps my fading life and my increasing dependance on him. It will all change; it always does. The flowers have long since faded, but I keep them almost like one would a time capsule, a reminder of how far he and I have come, and how far we still must go.

Then it was the flowers, but today it's the bluff that speaks to me. I walk along the top of the once buffalo jump, now a popular lookout for selfies, first dates, sweaty runners, and loud cars. I am feeling sad. Another wrinkle in the life of my marriage today, a miscommunication, and I am left with an incongruence with my husband that needs remediation. The wind is cold up here. It whips my face, making me squint; my energy is spent keeping warm, and for a moment, I forget my bruised, tender heart. I had managed a lukewarm goodbye kiss to my husband before I left, just enough affection so that I could escape the claustrophobia of our fight. Now I quicken my pace and start rehearsing all the things I am going to say when I get home. I am done with it, fed up; my sadness turns to anger, and I decide that today I will right what has been wrong. My high school drama teacher will be proud I have memorized all my lines by heart, and today I will share each one loud and proud to the back of the room. The ground is slippery, and my feet start to slide. The bluff sets me off my course, and I lose my train of thought for a few moments. But I am resilient, back on track with my dramatic play. Then the wind whips some snow off the ground onto my face, and I see now that the bluff means business: it wants me to quiet my inner turmoil and listen to it.

I stop and take a seat under the giant elm tree, maybe a hundred years old, probably planted by one of the early cattle barons trying to claim this land for their own. I look across the distance, down at my home; it looks like a miniature doll house from up here. I imagine my husband at home perhaps doing the dishes or lying on the couch. All at once the wind and the bluff begin to sing; they start to give me words, a poem. I can't keep up; the gusts of the cold

air and the ancient energy in the hill flow my way, and the words are at once powerful and connected. I grab my phone and begin to transcribe them (a silent thank-you to the unnamed computer programmer who created the note pad function on my phone).

I didn't kiss you to say I wasn't mad anymore,
or to pretend like it would go away or that it was gone.
I didn't kiss you because you wanted it, or to say sorry, or I forgive you.
I kissed you because when I am the most angry, the most lost,
I need to remind myself that I love you.
I need to put my lips on yours and remember for a mini lifetime
that my love for you is big.
This is how I keep it alive. I feed it when it's most dead.
When I am tightly clenched within, and you are far away.
When you are insensitive, and I am spitting mad.
I kiss you to remember, because when I remember I can see it all—not just now.
My anger is temporary, but our love is boundless.

I place my phone back in my pocket, pull my mitts back on with my teeth, and feel myself on top of this frozen, time-worn hill. I say a silent thank-you to the bluff that has felt the scarring of iron tools by the farmers who were once here; that has swallowed the blood of the buffalo carved with reverence by the first stewards of this land; and that is full of geologic tales of dinosaurs, oceans, and glaciers. My feet walk along the icy soil today, but I am just a mayfly to it, fleeting and seemingly gone upon my arrival in geologic time. I am a visitor, a student learning about longevity and patience, just one more person touching the vast epoch of time in order to know the now. A feeling bigger than reverence overtakes me, my eyes fill with tears that begin to freeze, and then I walk home, my kiss now warmed and ready, in part for my husband, and in part for the land in thanks.

CREATIVE INVITATION:
PATIENCE THROUGH EPHEMERAL ART

In this creative invitation we will explore something in our lives that feels permanent through the creation of something impermanent and ephemeral. This is a chance for you to explore the nuance of change where you feel stuck while also seeking a larger perspective from which to view this moment. You will choose your ephemeral process (either creating outdoors or destroying something you make) as a way of creating in the now and naming your big-picture why.

ARRIVE

Begin by taking a few moments to be with something that is in the process of changing or shifting. Find a quiet space where you can see the clouds moving, feel the wind blowing, hear the water flowing, or perhaps even watch a pet move or observe people in motion. Set a timer for 5 minutes. Tune into the rhythm of your breath moving in and out, and when you are ready, cast your gaze toward the object in motion. Focus on its movement, changes, pace, rhythm, and so on; you do not need to interpret it or try to make sense of it; just observe it as it is in the moment in motion. When your timer goes off, take a moment to offer what you observed some reverence and gratitude with a simple word or motion of acknowledgment; perhaps say "thank you" out loud or extend your arms in a gesture of love.

SET AN INTENTION

Begin by setting an intention to explore something that you feel is persistent in your life, such as pain, patterns, or feelings. In this process we will be tuning into the nuance and subtly of it, seeking to discover the ways it is changing and shifting, rather than fixating on how permanent it feels. Try to frame your intention and focus this way. For example,

> I intend to feel into the way the pain in my hand shifts.
>
> Today, I intend to let go of my belief that I am stuck, even just temporarily, and see what emerges.
>
> I intend to notice the nuance and subtlety in my creative process, trusting that the big-picture why will emerge if and when it needs to.

ASK A QUESTION

This process will give you a chance to attune to the nuance and subtlety of the process as well as the experience you have of feeling stuck positioning both in a broader, more patient perspective. Ask a question that explores what your greatest curiosity about this is right now. For example:

Why do I create?

What does patience related to _____ look like for me?

What happens or shifts for me when I focus on the unfolding and changing nature of_____?

What does it mean to tune into the big picture of_____ for me?

PREPARE

In this warmup exercise, you will be drawing a series of circles (or any mark you like) in repetition. With a pencil and paper in hand, take a few breaths and slowly draw ten circles in a row. Tune into the movement of your hand, the way the marks move around the page, and your impression of each one as you create it. Once you have made ten, decide if you would like to make fifty or a hundred circles in total. Continue making circles by either counting out each one or by making a grid to complete it (for example, ten on top, ten down the side). As you complete them, slowly tune into the creation of each one as you did at the start. Once you are finished, look back at your circles; what do you notice about them? Can you see flow between them? Differences? Is anything else distinguishing among them? You may want to write out three to five words about any meaning you found in this process as a close.

CREATE SOMETHING EPHEMERAL

Decide what sort of ephemeral art you would like to make. I recommend making something outside with natural materials or creating a sketch, collage, art journal page, piece of writing, or similar with the intention to destroy it in the end by burning it, washing it with water, or leaving it outside somewhere.

Once you have selected your ephemeral medium, begin by creating something that explores the following questions:

What is the most urgent or pressing thing in my life is right now?

What does it feel like? How does it impact me? What is the hardest part about it?

Pay attention to shape, line, color, space, and texture. What imagery, metaphors, symbols, or objects can help you to tell the story of this urgent thing in your life through a visual medium? Remember that this process isn't about getting it right; rather, it's about creating something to move the process forward. Give yourself 10 to 15 minutes to complete this process without belaboring it; just see what comes in that timeframe and work from there. Create with the materials you have on hand attuning your sensory experience in the creative process.

When your creation feels complete, take a few moments to just be with the final product. Observe it; recall how it came to being, where it started, and how it has ended.

PHOTOGRAPH AND VOICE

You may choose to capture a lasting impression of your creation in this time and space through a photograph, by giving it a voice through writing, or both.

To photograph it, play with taking images that explore a few different perspectives and angles. See if you can use the camera to further capture the essence or significance of this creation through a still image.

To give it a voice, imagine that it is speaking to you and through you; what does it want to tell you? In your journal allow it to speak freely through you as you transcribe its words. The following is a sample piece of writing where braided grass strands speak to and through the creator:

I felt vulnerable and weak and then you brought me together.

Woven with my kin, I feel a strength and connection that makes me safe.

A trinity of strands; home, connection, and family.

RELEASE YOURSELF FROM IT

You are now ready to release yourself from your creation. You can choose to do this by either leaving your natural object where you found it, now subject to undoing from the

elements, or, if you created an object in your home, you can choose to destroy it by burning it, soaking it in water, or tearing it up, or, if you like, by taking it outside and burying it or leaving it somewhere it is likely to be destroyed. Trust yourself to find a way to let this creation come apart in a way that respects its origins and meaning for you.

DISTILL

Once you have released yourself from your creation, complete the process by looking back at your intention, question, and the urgent thing you were depicting. Move to your journal and explore what insights or wisdom you have found to help you with any of this. You may choose to continue to write from your creation's perspective or your own as you unravel what the creation can show you in this moment about your urgent issue.

WITNESS

As a close to this process, create a plan to share the process, creation, and meaning you found through this creative process with someone. Is there someone who would value what you found here or how you found it? Speak about this process as a way of having someone witness your important work.

Conclusion:
Knowing Life through Art

AS WE END this chapter in our journey using creative knowing to build a practice in mindfulness, it is important that we remember to hold ourselves with gentle care. Most journeys don't end up how we think they will, and it may be that this journey for you has unfolded in ways that you didn't expect.

We began this journey by recognizing our holes—the pain and suffering that we each carry around. Along the way, we discovered that we could know in more ways than we could have imagined, and that creative knowing lets us live life in full color. We have also welcomed the attitudes of mindfulness into our lives, as well as its tools, to help us relate to our suffering and the world with more clarity and peace. We will never complete this practice, never arrive at a place of mindfulness and knowing, but we can reach a place of nourishment, abundance, and stillness.

As a close, I want to offer you one last story steeped with wisdom—Aesop's fable of the Raven and the Pitcher—to help guide you in what comes next and to help you celebrate joy when it comes trickling in.

A thirsty raven finds a clay pitcher with a tiny amount of water at the bottom of it. The bird places its beak inside only to find that the water is just beyond its reach. Raven tries and tries to drink the water, but it can't quite get its beak to the bottom of the pitcher. Instead of giving up clever Raven looks around and sees a pile of small pebbles and decides to take one and place it in the pitcher. Then Raven does so again and again and again, until, one by one, Raven has placed all but one pebble into the pitcher. When Raven drops in the last pebble,

the water finally rises to the top, spilling over the edge. Raven places its beak inside at last, relieving its long-held thirst as the pitcher has transformed from scarcity to abundance.

Creative knowing is your pitcher, and your practice in mindfulness is the pebbles, each coming together, moment by moment, bit by bit. Some days it may feel easy to find the pebbles and place them in, and other times we may find ourselves distracted, or too tired to lift a pebble. But slowly, over time, if we stay with the practice, we add more acts of mindfulness and creative expression to our pitcher. We find that the waters begin to flow, not just for us but for the parched world around us also in need of nourishment. Creative mindfulness keeps us well, helps us process our emotions and experiences, offers us perspective, and helps us see our impact and relationship with both the people and the planet. When we know who we are and where we stand in this world, we can begin to make an intentional impact in it and shape it with love. As each of our pitchers reaches this tipping point, our cup literally runeth over, and we find the nourishment that we need and that the world needs most. The world needs you; it needs you to be at peace, filled with compassion, open, and ready to take action on its behalf and on the behalf of many others in pain right now.

My hope for you is that this book is your permission slip to create with confidence, knowing that your own unique creative expressions are showing you something that transcends thinking. I hope creative expression has become a resource for you, something you know is there to help you intentionally welcome mindfulness into your life and turn toward your own whispers, callings, and intuitions, and to help you find your own distinctive way. I know that in doing so, your mark on this world will be filled with love and care. You will never outrun suffering, but you can know how to find nourishment and a place of stillness so that you can get back to the work of helping the rest of us make the world anew.

Notes

INTRODUCTION

1 Bach, *Adventure of a Reluctant Messiah.*
2 Stuckey and Nobel, "Connection between Art, Healing, and Public Health," 254–63.

CHAPTER 1

1 Wade Davis, "Web of Belief and Ritual."
2 Behan, "Benefits of Meditation and Mindfulness," 256–58.
3 Gunaratana, *Mindfulness in Plain English,* 4.

CHAPTER 2

1 Menakem, "It Sounds Goofy."
2 Horst, "The Body in Adult Education."
3 For the Wild, "Power of Humility."
4 Edwards, "Knowledge Goes Underground," 19–35.
5 Menakem, *My Grandmother's Hands.*
6 Belenky et al., *Women's Ways of Knowing.*
7 Garland et al., "Dynamic Horizontal Cultural Transmission," 687–91.
8 Simard, *Finding the Mother Tree.*
9 Dr. Worksbook, "Racism Defined."
10 Knill et al., *Principles and Practice,* 9–74.
11 Kimmerer, *Braiding Sweetgrass,* 300.

CHAPTER 3

1 Levine and Levine, *Foundations of Expressive Arts Therapy.*
2 Kabat-Zinn, *Full Catastrophe Living.*
3 Kabat-Zinn, *Full Catastrophe Living.*

CHAPTER 4

1 *Online Etymology Dictionary*, s.v. "intention."
2 McNiff, *Trust the Process*.

CHAPTER 5

1 Firestein, "The Pursuit of Ignorance."
2 Dunning, "The Dunning–Kruger Effect," 247–96.
3 Plohl and Musil, "Do I Know as Much?" 20–30.
4 Resnick, "Expert on Human Blind Spots."
5 Kleon, *Keep Going*.
6 Suzuki, *Zen Mind, Beginner's Mind*.
7 Leonard, *Mastery*.
8 Pirsig, *Art of Motorcycle Maintenance*, 170–71.
9 Pirsig, Art of Motorcycle Maintenance, 170–71.
10 Camus, *The Myth of Sisyphus*.
11 Beck and Smith, *Nothing Special*.

CHAPTER 6

1 *The Late Late Show with James Corden*, "McCartney Carpool Karaoke."
2 Williams, *The Nature Fix*.
3 White et al., "Spending at Least 120 Minutes."

CHAPTER 7

1 ArtFundUK, "Henri Matisse."
2 Turturro and Drake, "Does Coloring Reduce Anxiety?"
3 Kaimal et al., "Functional Near-Infrared Spectroscopy." 85–92; Kaimal, et al., "Reduction of Cortisol Levels," 74–80; Curry and Kasser, "Can Coloring Mandalas Reduce Anxiety?" 81–85.
4 Abbing et al., "Art Therapy for Anxiety in Adults," e0208716.
5 Abbing et al., "Art Therapy for Anxiety in Adult Women."

CHAPTER 8

1 "Miss Lala at the Fernando Circus," Getty Museum Collection.
2 Fei, "As Above, so Between."
3 Nelson, "Miles Davis."
4 Clinton, *It Takes a Village*.

CHAPTER 9

1 Carroll, "Anonymous Woman: Demise."

2 Carroll, "Anonymous Women."

3 Vonnegut, "We Are Here on Earth."

CHAPTER 10

1 Blumstein, *Nature of Fear*.

2 Beschta and Ripple, "Large Predators and Trophic Cascades," 2401–14.

3 Tift, *Already Free*.

4 Asma, *Evolution of Imagination*.

5 Robinson, "Chemistry's Visual Origins."

6 Anderson, "When Keith Richards Wrote 'Satisfaction.'"

CHAPTER 11

1 Hancock and Dickey, *Possibilities*.

2 Pelaprat and Cole, "'Minding the Gap,'" 397–418.

CHAPTER 12

1 Abbott, "On Film in Reality."

2 Brazier, *Buddhist Psychology*.

3 Chen et al., "Emerging Science of Interoception," 3–16.

4 Geurts, *Culture and the Senses*.

5 Pilard, *Jung and Intuition*; Lakoff and Johnson, *Metaphors We Live By*.

6 Goldberg, *Writing Down the Bones*.

7 All Things Considered, "Scientists' Bodies in Motion."

8 Nagendra, "Plant-Soil Feedbacks."

CHAPTER 13

1 S. I. Staff, "Scorecard."

2 S. I. Staff, "Scorecard."

3 Marks, "Domestic Ceramics by Mechelle Bounpraseuth."

4 Chun, "Mechelle Bounpraseuth."

5 Chun, "Mechelle Bounpraseuth."

6 "The Synthesis of the Arts.

7 Wagamese, *Embers*.

CHAPTER 14

1 Dickinson, "Forever – Is Composed of Nows."

2 Habegger, *My Wars Are Laid Away*.

3 Paterson, "Future Library."

Bibliography

Abbing, Annemarie, Erik W. Baars, Leo de Sonneville, Anne S. Ponstein, and Hanna Swaab. "The Effectiveness of Art Therapy for Anxiety in Adult Women: A Randomized Controlled Trial." *Frontiers in Psychology* 10 (May 29, 2019). https://doi.org/10.3389/fpsyg.2019.01203.

Abbing, Annemarie, Anne Ponstein, Susan van Hooren, Leo de Sonneville, Hanna Swaab, and Erik Baars. "The Effectiveness of Art Therapy for Anxiety in Adults: A Systematic Review of Randomised and Non-Randomised Controlled Trials." *PLOS ONE* 13, no. 12 (December 17, 2018): e0208716. https://doi.org/10.1371/journal.pone.0208716.

Abbott, Mathew. "On Film in Reality: Cavellian Reflections on Skepticism, Belief, and Documentary." In *The Thought of Stanley Cavell and Cinema*, ed. David LaRocca, January 1, 2020. https://www.academia.edu/43041436/On_Film_in_Reality_Cavellian_Reflections_on_Skepticism_Belief_and_Documentary?.

All Things Considered. "Contest Puts Scientists' Bodies in Motion." *NPR*, November 22, 2008. https://www.npr.org/templates/story/story.php?storyId=97356050.

Anderson, Stacey. "When Keith Richards Wrote '(I Can't Get No) Satisfaction' in His Sleep." *Rolling Stone*, May 9, 2011. https://www.rollingstone.com/music/music-news/when-keith-richards-wrote-i-cant-get-no-satisfaction-in-his-sleep-236461/.

ArtFundUK. "Henri Matisse: The Cut-Outs." YouTube video. April 16, 2014. https://www.youtube.com/watch?v=rLgSd8ka0Gs.

Asma, Stephen T. *The Evolution of Imagination*. Chicago: The University Of Chicago Press, 2017.

Bach, Richard. *Illusions: The Adventure of a Reluctant Messiah*. London: Arrow Books, 2011.

Beck, Charlotte Joko, and Steve Smith. *Nothing Special: Living Zen*. New York: Harperone, 1995.

Behan, C. "The Benefits of Meditation and Mindfulness Practices during Times of Crisis such as Covid-19." *Irish Journal of Psychological Medicine* 37, no. 4 (May 14, 2020): 256–58. https://doi.org/10.1017/ipm.2020.38.

Belenky, Mary Field, Blythe Mcvicker Clinchy, Nancy Rule Goldberger, and Jill Mattuck Tarule. *Women's Ways of Knowing: The Development of Self, Voice, and Mind.* New York: Basicbooks, 1997.

Beschta, Robert L., and William J. Ripple. "Large Predators and Trophic Cascades in Terrestrial Ecosystems of the Western United States." *Biological Conservation* 142, no. 11 (November 2009): 2401–14. https://doi.org/10.1016/j.biocon.2009.06.015.

Blumstein, Daniel T. *The Nature of Fear: Survival Lessons from the Wild.* Cambridge, MA: Harvard University Press, 2020.

Brazier, Caroline. *Buddhist Psychology: Liberate Your Mind, Embrace Life.* London: Robinson, 2003.

Brown, Steven, and Ellen Dissanayake. "The Synthesis of the Arts: From Ceremonial Ritual to 'Total Work of Art.'" *Frontiers in Sociology* 3 (May 15, 2018). https://doi.org/10.3389/fsoc.2018.00009.

Camus, Albert. *The Myth of Sisyphus.* Éditions Gallimard, 1942.

Carroll, Patty. "Anonymous Woman: Demise." Pattycarroll.com, 2022. https://pattycarroll.com/demise/.

———. "Anonymous Woman: Heads." Pattycarroll.com, 2022. https://pattycarroll.com/heads/.

Chen, Wen G., Dana Schloesser, Angela M. Arensdorf, Janine M. Simmons, Changhai Cui, Rita Valentino, James W. Gnadt, et al. "The Emerging Science of Interoception: Sensing, Integrating, Interpreting, and Regulating Signals within the Self." *Trends in Neurosciences* 44, no. 1 (January 1, 2021): 3–16. https://doi.org/10.1016/j.tins.2020.10.007.

Chun, Matt. "Interview #135—Mechelle Bounpraseuth." Liminal, May 6, 2020. https://www.liminalmag.com/interviews/mechelle-bounpraseuth.

Clinton, Hillary Rodham. *It Takes a Village: And Other Lessons Children Teach Us.* New York: Simon & Schuster, 1996.

Curry, Nancy A., and Tim Kasser. "Can Coloring Mandalas Reduce Anxiety?" *Art Therapy* 22, no. 2 (January 2005): 81–85. https://doi.org/10.1080/07421656.2005.10129441.

Davis, Wade. "The Worldwide Web of Belief and Ritual." www.ted.com, February 2008. https://www.ted.com/talks/wade_davis_the_worldwide_web_of_belief_and_ritual?language=en.

Dickinson, Emily. "Forever – Is Composed of Nows." Poetry Foundation, December 2, 2020. https://www.poetryfoundation.org/poems/52202/forever-is-composed-of-nows-690.

Dr. Worksbook. "Racism Defined." dRworksBook, May 2021. https://www
.dismantlingracism.org/racism-defined.html.

Dunning, David. "The Dunning–Kruger Effect: On Being Ignorant of One's Own
Ignorance." *Advances in Experimental Social Psychology* 44 (2011): 247–96. https://
doi.org/10.1016/b978-0-12-385522-0.00005-6.

Edwards, Ashley. "When Knowledge Goes Underground." *Pathfinder: A Canadian
Journal for Information Science Students and Early Career Professionals* 1, no. 2 (May
8, 2020): 19–35. https://doi.org/10.29173/pathfinder14.

Fei, Elizabeth. "As Above, so Between: Configuring Miss Lala as a Mixed Race Sub-
ject." Thesis, College of Liberal Arts and Sciences, DePaul University, Chicago,
IL, 2017.

Firestein, Stuart. "The Pursuit of Ignorance." TED Talk, 2013. https://www.ted.com
/talks/stuart_firestein_the_pursuit_of_ignorance.

For the Wild. "Transcript: TIOKASIN GHOSTHORSE on the Power of Humility
/237." Interview with Ayana Young, *For the Wild* podcast, June 9, 2021. https://
forthewild.world/podcast-transcripts/tiokasin-ghosthorse-on-the-power
-of-humility-237.

Garland, Ellen C., Anne W. Goldizen, Melinda L. Rekdahl, Rochelle Constantine,
Claire Garrigue, Nan Daeschler Hauser, M. Michael Poole, Jooke Robbins, and
Michael J. Noad. "Dynamic Horizontal Cultural Transmission of Humpback
Whale Song at the Ocean Basin Scale." *Current Biology* 21, no. 8 (April 2011):
687–91. https://doi.org/10.1016/j.cub.2011.03.019.

Geurts, Kathryn Linn. *Culture and the Senses: Bodily Ways of Knowing in an African
Community* (Berkeley, CA: University of California Press, 2009).

Goldberg, Natalie. *Writing Down the Bones: Freeing the Writer Within.* Boulder, CO:
Shambala, 2016.

Gunaratana, Henepola. *Mindfulness in Plain English.* Somerville, MA: Wisdom Publi-
cations, 2015.

Habegger, Alfred. *My Wars Are Laid Away in Books: The Life of Emily Dickinson.* New
York: Modern Library, 2002.

Hancock, Herbie, and Lisa Dickey. *Possibilities.* New York: Viking, 2014.

Horst, Tara. "The Body in Adult Education: Introducing a Somatic Learning Model."
Conference paper presented at the Adult Education Research Conference,
St. Louis, MO, 2008. https://newprairiepress.org/cgi/viewcontent
.cgi?referer=&httpsredir=1&article=2912&context=aerc.

Kabat-Zinn, Jon. *Full Catastrophe Living: Using the Wisdom of Your Body and Mind to
Face Stress, Pain, and Illness.* New York: Bantam Books, 2013.

Kaimal, Girija, Hasan Ayaz, Joanna Herres, Rebekka Dieterich-Hartwell, Bindal
Makwana, Donna H. Kaiser, and Jennifer A. Nasser. "Functional Near-Infrared

Spectroscopy Assessment of Reward Perception Based on Visual Self-Expression: Coloring, Doodling, and Free Drawing." *The Arts in Psychotherapy* 55 (September 2017): 85–92. https://doi.org/10.1016/j.aip.2017.05.004.

Kaimal, Girija, Kendra Ray, and Juan Muniz. "Reduction of Cortisol Levels and Participants' Responses Following Art Making." *Art Therapy* 33, no. 2 (April 2, 2016): 74–80. https://doi.org/10.1080/07421656.2016.1166832.

Kimmerer, Robin Wall. *Braiding Sweetgrass: Indigenous Wisdom, Scientific Knowledge and the Teachings of Plants*. Minneapolis, MN: Milkweed Editions, 2013.

Kleon, Austin. *Keep Going: 10 Ways to Stay Creative in Good Times and Bad*. New York: Workman Publishing, 2019.

Knill, Paolo J., Ellen G Levine, Stephen K Levine, and Inc Netlibrary. *Principles and Practice of Expressive Arts Therapy: Toward a Therapeutic Aesthetics*. Philadelphia: Jessica Kingsley Publishers, 2005.

Lakoff, George, and Mark Johnson. *Metaphors We Live By*. Chicago: University Of Chicago Press, 1980.

The Late Late Show with James Corden. "Paul McCartney Carpool Karaoke." YouTube. June 21, 2018. https://www.youtube.com/watch?time_continue=46&v=QjvzCTqkBDQ&feature=emb_logo.

Leonard, George. *Mastery: The Keys to Success and Long-Term Fulfillment*. Google Books. Penguin, 1992.

Levine, Stephen K, and Ellen G Levine. *Foundations of Expressive Arts Therapy: Theoretical and Clinical Perspectives*. Philadelphia: Jessica Kingsley Publishers, 1999.

Marks, Anna. "Domestic Ceramics by Mechelle Bounpraseuth Infused with Culinary Life and Family Memories." Colossal, May 18, 2020. https://www.thisiscolossal.com/2020/05/mechelle-bounpraseuth-food-ceramics/.

McNiff, Shaun. *Trust the Process: An Artist's Guide to Letting Go*. Boston: Shambhala, 1998.

Menakem, Resmaa. "I Know It Sounds Goofy." Instagram post, February 9, 2022. https://www.instagram.com/tv/CZwuM8pjfEO/.

———. *My Grandmother's Hands: Racialized Trauma and the Pathway to Mending Our Hearts and Bodies*. Las Vegas: Central Recovery Press, 2017.

"Miss Lala at the Fernando Circus." The Getty Museum Collection. Accessed April 8, 2022. https://www.getty.edu/art/collection/object/1097QZ.

MoMA. "Henri Matisse: The Cut-Outs." Moma.org, 2014. https://www.moma.org/interactives/exhibitions/2014/matisse/the-cut-outs.html.

Nagendra, Uma. "Plant-Soil Feedbacks after Severe Tornado Damage: Dance Your PhD 2014." Vimeo, 2014. https://vimeo.com/107412178.

Nelson, Stanley, dir. *Miles Davis: Birth of the Cool*. FirelightMedia, February 22, 2019, Film.

Online Etymology Dictionary. s.v. "intention." Accessed December 22, 2021. https://www.etymonline.com/search?q=intention.

Paterson, Katie. "Future Library, 2014–2114."futurelibrary.no, n.d. https://www.futurelibrary.no.

Pelaprat, Etienne, and Michael Cole. "'Minding the Gap': Imagination, Creativity and Human Cognition." *Integrative Psychological and Behavioral Science* 45, no. 4 (June 23, 2011): 397–418. https://doi.org/10.1007/s12124-011-9176-5.

Pilard, Nathalie. *Jung and Intuition*. London: Routledge, 2018. https://doi.org/10.4324/9780429476327.

Pirsig, Robert M. *Zen and the Art of Motorcycle Maintenance: An Inquiry into Values*. London: Vintage Books, 2014.

Plohl, Nejc, and Bojan Musil. "Do I Know as Much as I Think I Do? The Dunning-Kruger Effect, Overclaiming, and the Illusion of Knowledge." *Horizons of Psychology* 27, no. 27 (2018): 20–30. https://doi.org/10.20419/2018.27.481.

Poetry Foundation. "Emily Dickinson." Poetry Foundation, 2015. https://www.poetryfoundation.org/poets/emily-dickinson.

Resnick, Brian. "An Expert on Human Blind Spots Gives Advice on How to Think." *Vox*, June 26, 2019. https://www.vox.com/science-and-health/2019/1/31/18200497/dunning-kruger-effect-explained-trump.

Robinson, Andrew. "Chemistry's Visual Origins." *Nature* 465, no. 36 (May 2010). https://doi.org/10.1038/465036a.

Simard, Suzanne. *Finding the Mother Tree: Discovering How the Forest Is Wired for Intelligence and Healing*. Toronto: Penguin Canada, 2021.

"The Synthesis of the Arts: From Ceremonial Ritual to 'Total Work of Art,'" *Frontiers in Sociology* 3 (May 15, 2018), https://doi.org/10.3389/fsoc.2018.00009.

Sooke, Alastair. *Henri Matisse: A Second Life*. London: Penguin Books, 2014.

Staff, S. I. "Scorecard." *Sports Illustrated* Vault, 1967. https://vault.si.com/vault/1967/04/03/scorecard.

Stuckey, Heather L., and Jeremy Nobel. "The Connection between Art, Healing, and Public Health: A Review of Current Literature." *American Journal of Public Health* 100, no. 2 (February 2010): 254–63. https://doi.org/10.2105/ajph.2008.156497.

Suzuki, Shunryu. *Zen Mind, Beginner's Mind*. Ed. Trudy Dixon. Boston: Shambhala, 2011.

Tift, Bruce. *Already Free: Buddhism Meets Psychotherapy on the Path of Liberation*. Boulder, CO: Sounds True, 2015.

Turturro, Nicole, and Jennifer E. Drake. "Does Coloring Reduce Anxiety? Comparing the Psychological and Psychophysiological Benefits of Coloring versus Drawing." *Empirical Studies of the Arts* 40, no. 1 (January 1, 2022): 3–20. https://doi.org/10.1177/0276237420923290.

Vonnegut, Kurt. "We Are Here on Earth to Fart Around." YouTube. Case Western Reserve University, 2004. https://www.youtube.com/watch?v=nxpITF8fswE.

Wagamese, Richard. *Embers: One Ojibway's Meditations.* Madeira Park, BC: Douglas and Mcintyre, 2016.

White, Mathew P., Ian Alcock, James Grellier, Benedict W. Wheeler, Terry Hartig, Sara L. Warber, Angie Bone, Michael H. Depledge, and Lora E. Fleming. "Spending at Least 120 Minutes a Week in Nature Is Associated with Good Health and Wellbeing." *Scientific Reports* 9, no. 1 (June 13, 2019). https://doi.org/10.1038/s41598-019-44097-3.

Williams, Florence. *The Nature Fix: Why Nature Makes Us Happier, Healthier, and More Creative.* New York: W.W. Norton & Company, 2018.

Index

Italic page numbers indicate illustrations

A

Abbott, Mathew, 169
abstract art, 68–71
abstract marks, 70
acceptance
 creative invitation: sketching your way
 to acceptance, 145–149
 using acceptance in the face of
 suffering, 137–139
Aesop fable of the Raven and the Pitcher,
 215–216
aesthetic knowing, 8. See also creative
 knowing
Already Free (Tift), 138–139
altars, 161–164
anchoring to intentions, 51
 asking questions, 98, 113, 162
 finding anchors in surprising
 places, 104
 setting intentions, 82–83, 130, 146
anchors for rituals, 193–195
anger, 26–28, 135–136, 176
 symbol of Godzilla, 26–29, 170
animals and plants' ways of knowing,
 20–21
anxiety, 87–97, 199–200
 creative invitation: finding trust in
 paper cuts, 97–101
 ghosts, 93–97

trust in creativity, 91–93
trusting ourselves, 87–91
"The Arrival of a Train at La Ciotat", 169
arriving, 48
 connecting to breath, 130
 connecting to changing objects, 210
 connecting to clay/moldable
 material, 193-194
 connecting to music and rhythm, 68,
 97, 112, 161, 178
 connecting to nature, 82
 sketching and mark-making, 146
art way of knowing, 21–22
artistic knowing, 8. See also creative
 knowing
artistic skill level, 10
asking questions, 49, 69, 83, 98, 113, 130, 146,
 162, 179, 194, 211
attachment
 creating without attachment to
 outcome, 78
 creative invitation: transforming
 attachment with creative ritual,
 193–196
 letting go, 59
 personal stories, 186–187
 softening attachment through
 ritual, 48
 surrendering, 62, 69

attention, and mindfulness, 32–34
awareness, 168. *See also* embodied
 awareness
 creative expression, and where we
 place our awareness, 174
 monkey mind, 170–171, 179
 theater of, 169–172
 transcribing awareness of your body, 180

B

Bach, Richard, 3
bears, 93–94
beaver chips, *118*, 128–129
Beck, Charlotte Joko, 64
beginner's mind, 57–68
 creative invitation, 68–71
 mindfulness principle, 61
 original seeing and creative
 expression, 62–64
 Sisyphus and the boulder, 64–68
Belenky, Mary, 20
benzene ring, 141
A Bifurcation, *118*, 125–129
big picture
 connecting with, 205, 210–213
 paradox of patience, 200–204
binaries, 44
body
 connecting to music and rhythm, 68,
 97, 112, 161, 178
 transcribing awareness of your body, 180
 trusting one's body, 178–179
Bohannon, John, 174
Braiding Sweetgrass (Kimmerer), 24
breathing, 193–194
 connecting to breath, 130
 connecting to nature, 82
Bubble Gum Ghosts, *86*, 96–97
Buddhism, 11
buffalo jump, 207–209
building repertoire of practices to enter
 present moment, 28

C

capturing/documenting creations, 85, 111,
 115, 212

Carroll, Patty, 121, 123
change, 103–104
 and creativity, 107–109
 creative invitation: letting go through
 found objects, 112–116
 in-between, 104–107
 inviting holey objects into creative
 process, 109–111
childhood trauma, 73
chronic stress, 73–74
Cinderella, 126
clay, 193–194
Clinchy, Blythe, 20
Cole, Michael, 155
collages
 creating, 132
 found poetry and embroidery, *118*,
 125–129
A Collection of Holes, *102*, 109–111
collective remembering, 189
color dump, 99
color of knowing, 22
connecting with big picture, 205, 210–213
Covid-19 pandemic, 66–67, 143
creating
 identity and ritual, 187–189
 without attachment to outcome, 78
creative expression
 original seeing, 62–64
 safe space, 92
 supporting creating living, 46
 where we place our awareness, 174
creative invitations, 9–10
 creating with nature, 82–85
 discovering your inner world through
 mark-making, 178–181
 finding trust in paper cuts, 97–101
 letting go through found objects,
 112–116
 movement and abstract art, 68–71
 patience through ephemeral art,
 210–213
 redefining judgment with found
 poetry, 129–133
 sketching your way to acceptance,
 145–149

symbolic alters, 161–164
transforming attachment with creative
 ritual, 193–196
creative knowing, 3, 8, 22–24, 33, 51, 112
 building muscle of, 114
 definition of, 8
 found objects, 112
 poiesis, 23
 Raven and the Pitcher fable, 215–216
 supporting creating living, 45–46
creative living, 43–53
 arriving, 48
 asking questions, 49
 creating rituals, 47–48
 influencer culture, 44–45
 multiple mediums, 50–51
 noticing impulses, 49–50
 productivity, 44
 setting intention, 48–49
 sharing experiences, 52
 trusting the process, 50
 two branches in practice, 45–46
 writing, 51–52
creative mindfulness, 10–13, 25–28
 attention and mindfulness, 32–34
 cultivating awareness and new
 perspectives of oneself, 29
 definition of, 29–32
 entering present moment, 28–29
 Expressive Arts, 30–31
 mindfulness, 31–32
 non-judgmental, 37–40
 present moment, 35–37
 purposefulness, 34–35
 vulnerability, 40–41
creative process
 resistance to judgment, 123–125
 trusting, 41, 50, 51–52, 84, 95, 131–132, 148
creative writing. See writing
creativity, 2–3, 31
 and change, 107–109
 forever and now, 204–206
 making meaning of our holes, 2–3
 non-striving, 77–79
 partnering with, 7–13
 sensory awareness, 172–174
 trust in, 91–93
 way of knowing, 21–22
 why we engage in creativity, 204–205
cutting paper, 97–101

D

Dance Your Ph.D. contest, 173, 174
Davis, Miles, 108, 153
Davis, Wade, 11
Defying Definition, 150, 158–160
Degas, Edgar, 104–107
Dickinson, Emily, 200–204
disassociation, 159
distilling wisdom from your art works, 51,
 71, 85, 100, 116, 132, 149, 164, 181, 196, 213
documenting creations, 85, 111, 115, 212
Dog Man painting, 95–97
dreams, 141, 143–144, 157–158
 identifying symbols, 147
Dunning, David, 59–60
Dunning-Kruger effect, 59–60
Dunning-Kruger Prayer, 60

E

elders, Indigenous cultures, 60
embodied awareness, 167–177
 creative invitation: discovering your
 inner world through mark-making,
 178–181
 nesting dolls, 174–177
 sensory awareness in creativity, 172–174
 theater of awareness, 169–172
embodied knowing, 19–20
embroidery, 129, 145
 A Bifurcation, 118, 125–129
 Defying Definition, 150, 158–160
 An Intimate Fear, 134, 143–145
ephemeral art, 205–206
 creative invitation: patience through
 ephemeral art, 210–213
 land speaks, 206–209
 releasing yourself from your creation,
 212–213
 A Temporary Gift, 198, 206–208
expertise, 60
expressing the unconscious, 139–141

Expressive Art Therapy, 18
Expressive Arts, 30–31
expressive writing, 8. *See also* writing

F

Facebook, 52, 151, 155, 156
fear, 135–145
 beginning a creative project, 108
 creative invitation: sketching your way
 to acceptance, 145–149
 expressing the unconscious, 139–141
 An Intimate Fear, *134*, 143–145
 living alongside fear, 137–139
 mice, 141–145
 · nesting dolls, 174–177
 using acceptance in the face of
 suffering, 137–139
feelings, working with, 151–152
fiction writing, 148–149
films, 169–170
Firestein, Stuart, 59
The First Stone, *182*, 189–193
fog of anxiety. *See* anxiety
forever and now in creativity, 204–206
found objects
 A Bifurcation, *118*, 125–129
 A Collection of Holes, *102*, 109–111
 creative invitation: letting go through
 found objects, 112–116
 ephemeral art, *198*, 206–208
 finding objects, 114
 The First Stone, *182*, 189–193
 A Temporary Gift, *198*, 206–208
 Wasp Paper Wonder, *72*, 81
found poetry, *118*, 129
 creative invitation: redefining
 judgment with found poetry,
 129–133
"Future Library" project, 204

G

Ghosthorse, Tiokasin, 18–19
ghosts, 93–97
 Bubble Gum Ghosts, *86*, 96–97
Godzilla, symbol of anger, 26–29, 170
Goldberg, Natalie, 173

Goldberger, Nancy, 20
Goldilocks, 125–126
Graveline, Fyre Jean, 15, 18–19
Gunaratana, Bhante, 11

H

Hancock, Herbie, 153–156
Hansel and Gretel, 127
Heidi, 126
holes in our hearts, 1–2
 inviting holey objects into creative
 process, *102*, 109–111
 making meaning of our holes, 2–4
 recognizing our holes, 2, 215
hope at beginning of a creative
 project, 108
Humpty Dumpty, 129

I

"(I Can't Get No) Satisfaction", 141
identity and ritual, 187–189
imagination, 141, 151–152, 155–157
 creative invitation: symbolic alters,
 161–164
 imagining symbols, 147
 tether to the beyond, 157–160
impermanence of the present, 199–209
 creative invitation: patience through
 ephemeral art, 210–213
 ephemeral art, 205–206
 forever and now in creativity, 204–206
 "Future Library" project, 204
 land speaks, 206–209
 paradox of patience, 200–204
 why we engage in creativity, 204–205
impulse
 noticing, 49–50
 playing with, 180–181
in-between, 103–111
 creative invitation: letting go through
 found objects, 112–116
 creativity and change, 107–109
 Degas and Miss La La, 104–107
 inviting holey objects into creative
 process, 109–111
Indigenized Art Therapy, 18

Indigenous cultures
 buffalo jump, 207–209
 elders, 60
 Expressive Arts, 30–31
 languages, 18–19
 relationship and reciprocity, 18–19
 Spirit Bear, 94
influencer culture, 44–45
inner voice, 13, 20, 87–92
 color dump, 99
 creative invitation: finding trust in
 paper cuts, 97–101
inspiration, 13
Instagram, 52
intention
 imagination, 156
 setting, 48–49, 69, 82, 98, 113, 130, 146,
 161, 178, 194, 210
An Intimate Fear, *134*, 143–145
intuition, 172

J

Jigornō, Kanō, 61
Johnson, Mark, 172
journaling, 84–85, 99, 115–116, 132, 162–163, 213
judgement
 creative invitation: redefining
 judgment with found poetry,
 129–133
 creativity as resistance, 123–125
 internalizing script of judgment,
 121–123
 letting go of judgments, 69, 71, 123
 non-judgmental creative mindfulness,
 37–40
 parallel myths, 125–129
 why we engage in creativity, 204–205
Jung, Carl, 172

K

Kabat-Zinn, Jon, 32, 37
Kanakuri, Shizo, 185–187
Kekulé, August, 141
Kermode bear, 94
Kimmerer, Robin Wall, 24
Kleon, Austin, 60

knowing, 13, 15–24. *See also* creative
 knowing
 art and creativity, 21–22
 color of knowing, 22
 creative knowing, 22–24
 embodied knowing, 19–20
 Indigenous cultures, 18–19
 plants and animals, 20–21
 poiesis, 23
 women's ways of knowing, 19–20
Kruger, Justin, 59

L

Lakoff, George, 172
languages, 18–19
languages of knowing, 15–24
 art and creativity, 21–22
 creative knowing, 22–24
 embodied knowing, 19–20
 Indigenous cultures, 18–19
 plants and animals, 20–21
 women's ways of knowing, 19–20
Leavy, Patricia, 21
Leon, George, 61
letting go, nudge of the creative process,
 109
life hacks, 122
The Little Red Hen, 127
Little Red Riding Hood, 128

M

magazine images, 69, 70
marathon runner Shizo Kanakuri, 185–187
mark-making, 166, 176–177, 211
 arriving through sketching and mark-
 making, 146
 creative invitation: discovering your
 inner world through mark-making,
 178–181
Matisse, Henri, 90–91
Matryoshka nesting dolls, 174–177
MBSR (mindfulness-based stress
 reduction), 32
McNiff, Shaun, 50
meditation, 176
 breathing, 193–194

Menakem, Resmaa, 15
mice, 141–145
 An Intimate Fear, *134*, 143–145
Miles Davis: Birth of the Cool, 108
mindfulness, 3, 10–13, 25–28, 31–32
 attachment, 62, 69
 attention, 32–34
 beginner's mind, 61
 creative mindfulness. *See also* creative
 mindfulness
 cultivating attitude of patience and
 trust, 201–202
 letting go of judgments, 123
 non-judgmental, 37–40
 non-reacting, 152–155
 non-striving, 76–79, 82
 Raven and the Pitcher fable, 215–216
 using acceptance in the face of
 suffering, 137–139
mindfulness-based stress reduction
 (MBSR), 32
Miss La La, 104–107
mixed media
 beginner's mind, 63
 Bubble Gum Ghosts, *86*, 96–97
 Pandemic Play, *56*, 67
 working with multiple mediums, 50–51
monkey mind, 170–171, 179
moths, Defying Definition, *150*, 158–160
movement and abstract art, 68–71
Movement Speaks, *166*, 175–177
multiple mediums, 50–51
music, 68, 88, 97–98, 112
myths, 125–129

N

Nagendra, Uma, 174
nature
 bears, 93–94
 A Bifurcation, *118*, 125–129
 A Collection of Holes, *102*, 109–111
 creating with nature, 82–85
 Defying Definition, *150*, 158–160
 The First Stone, *182*, 189–193
 found objects, 72, 81, *102*, 112–116, *118*,
 128, 129, *182*, 189–193, *198*

An Intimate Fear, *134*, 141–145
 land speaks, 206–209
 Movement Speaks, *166*, 175–177
 A Temporary Gift, *198*, 206–208
 Wasp Paper Wonder, 72
 wolves in Yellowstone National Park,
 137–138
 woodpecker, 79–81
nesting dolls, 174–177
non-judgmental creative mindfulness,
 37–40
 letting go of judgments, 69, 71, 123
non-reacting, 151–155
 creative invitation: symbolic alters,
 161–164
non-striving, 76–77, 82
 and creativity, 77–79
Nothing Special (Beck), 64
noticing impulses, 49–50
novels, 21–22

O

Old Woman, 189
original seeing, 62–64
outcome, creating without attachment
 to, 78

P

pain, 135–136
 creative invitation: sketching your way
 to acceptance, 145–149
 great equalizer, 192
 using acceptance in the face of
 suffering, 137–139
painting
 Movement Speaks, *166*, 175–177
 writing for painters, 63–64
Pakakos Mountain, 206
pandemic, 66–67, 143
Pandemic Play, *56*, 67
paper cuts, 97–101
parallel myths, 125–129
partnering with creativity, 7–13
 creative knowing, 8–12
 creative mindfulness, 10–13
Paterson, Katie, 204

patience
 creative invitation: patience through
 ephemeral art, 210–213
 ephemeral art, 205–209
 paradox of patience, 200–204
Pelaprat, Etienne, 155
photographing creations, 85, 111, 115, 212
Pirsig, Robert, 62–63
plants and animals' ways of knowing,
 20–21
poetry, 209
 Dickinson, Emily, 200–201
 found poetry, 129–133
 reciting in class, 135–136
 writing, 71, 84–85, 115, 148–149, 164, 181
poiesis, 23
Possibilities (Hancock), 153
practices, 45–53
 arriving, 48. *See also* arriving
 asking questions, 49, 69, 83, 98, 113, 130,
 146, 162, 179, 194, 211
 creating rituals, 47–48
 growing two branches, 45–46
 multiple mediums, 50–51
 noticing impulses, 49–50
 setting intention, 48–49, 69, 82, 98, 113,
 130, 146, 161, 178, 194, 210
 sharing experiences, 52, 71, 85, 101, 116,
 133, 149, 164, 181, 196, 213
 trusting the process, 50
 writing, 51–52. *See also* writing
present moment
 arriving/attuning to, 48
 building repertoire of practices to
 enter present moment, 28
 connecting with big picture, 205,
 210–213
 creative mindfulness, 35–37
 entering present moment, 28–29
 impermanence of the present. *See*
 impermanence of the present
 mindfulness and attention, 32–34
 paradox of patience, 200–204
 vulnerability, 41
productivity, 119–129
 being wrapped up in "should", 119–120

creative invitation: redefining
 judgment with found poetry,
 129–133
creative living, 44
creativity as resistance, 123–125
internalizing script of judgment,
 121–123
parallel myths, 125–129
purposefulness of creative mindfulness,
 34–35

Q

questions, asking, 49, 69, 83, 98, 113, 130, 146,
 162, 179, 194, 211

R

Raven and the Pitcher fable, 215–216
reactivity, 152–155
reciting poetry in class, 135–136
recognizing our holes, 2, 215
relationship and reciprocity, Indigenous
 cultures, 18–19
rewriting our personal stories, 183–193
 attachment to stories, 186–187
 creating identity and ritual, 187–189
 creative invitation: transforming
 attachment with creative ritual,
 193–196
 marathon runner Shizo Kanakuri,
 185–187
 mountain summiting, 189–193
Richards, Keith, 141
rituals
 creating, 47–48
 creating identity and ritual, 187–189
 creative invitation: transforming
 attachment with creative ritual,
 193–196
The Rolling Stones, 141
Russian nesting dolls, 174–177

S

"Satisfaction", 141
scissors, 90
script of judgment, 121–123
script of productivity. *See* productivity

senses, 168–169, 171–172
 creative invitation: discovering your
 inner world through mark-making,
 178–181
 sensory awareness in creativity, 172–174
setting intentions, 48–49, 69, 82, 98, 113, 130,
 146, 161, 178, 194, 210
sharing experiences and creations, 52, 71,
 85, 101, 116, 133, 149, 164, 181, 196, 213
"should", 119–120. *See also* productivity
Simard, Scientist Suzanne, 21
Sisyphus, 64–68
sixth sense, 172
sketching your way to acceptance, 145–149
skill level, 10
Spirit Bear, 94, 96
stillness, 3, 69
 nature, 80
 non-striving, 76–79
stones, The First Stone, 182, 189–193
stories, rewriting, 183–193
 attachment to stories, 186–187
 creating identity and ritual, 187–189
 creative invitation: transforming
 attachment with creative ritual,
 193–196
 marathon runner Shizo Kanakuri, 185–187
 mountain summiting, 189–193
stress, 73–74
 asking questions, 83
 creative invitation: creating with
 nature, 82–85
 striving, 75–77
striving, 75–77
 creative invitation: creating with
 nature, 82–85
 definition of, 75
 non-striving, 76–79, 82
Sunwapta Mountain, 189–192
surrender, 57–68
 attachments, 62, 69
 creative invitation: movement and
 abstract art, 68–71
 original seeing and creative
 expression, 62–64
 Sisyphus and the boulder, 64–68

Suzuki, Shunryū, 61
The Swiss Family Robinson, 118, 126–128
symbolic alters, 161–164
symbols, 151–152
 creative invitation: symbolic alters,
 161–164
 fear as a mouse, 144
 finding, 148, 163
 Godzilla, 26–29, 170
 identifying, 194–195
 identifying in dreams, 147
 imagining, 147
 moths, 160
 tether to the beyond, 157–160

T

Tarule, Jill, 20
A Temporary Gift, *198*, 206–208
Tift, Bruce, 138–139
transcribing awareness of your
 body, 180
trauma in childhood, 73s
trusting
 creative process. *See* trusting the
 creative process
 cultivating attitude of patience and
 trust, 201–202
 in creativity, 91–93
 one's body, 178–179
 ourselves, 87–91
*Trust the Process: An Artist's Guide to Letting
 Go* (McNiff), 50
trusting the creative process, 41, 50, 95
 finding poems, 131
 paper cuts, 97–101
 writing, 51–52, 84, 132, 148

U

unconscious expressing, 139–141
 creative invitation: sketching your way
 to acceptance, 145–149

V

vocabulary of inner world, 28–29
Vonnegut, Kurt, 124–125
vulnerability, 40–41

W

Wagamese, Richard, 189
Wasp Paper Wonder, 72, 81
ways of knowing
 animals and plants, 20–21
 art and creativity, 21–22
 creative knowing, 22–24
 embodied, 19
 Indigenous cultures, 18–19
 women, 19
whispering ghosts, 93–97
why we engage in creativity, 204–205
wildflowers, 198, 207–208
witnesses, sharing experiences and
 creations, 52, 71, 85, 101, 116, 133, 149, 164,
 181, 196, 213
wolves in Yellowstone National Park,
 137–138
women's ways of knowing, 19–20
woodpecker, 79
writing, 8, 51–52, 62, 99, 114–115, 132, 148–149
 collective remembering, 189
 expressive writing, 8
 fiction, 148–149

"Future Library" project, 204
journaling, 84–85, 99, 115–116, 132,
 162–163, 213
multisensory approach, 173
novels, 21–22
painters, 63–64
poetry, 71, 84, 85, 115, 148–149, 164, 181
transcribing awareness of your
 body, 180
trusting inner voice, 99
trusting the process, 51–52, 84, 132, 148
Zen writing, 173

Y

Yellowstone National Park wolves, 137–138

Z

Zen
 koan, 43, 46
 Nothing Special (Beck), 64
 Shunryū Suzuki, 61
 writing, 173
Zen and the Art of Motorcycle Maintenance
 (Pirsig), 62

About the Author

RACHEL ROSE is an educator, writer, and contemplative artist fusing mindfulness practices with the creative arts. She holds a master's degree in adult education with a focus on arts-based research and transformative learning and is a registered Expressive Arts consultant/educator with the International Expressive Art Therapy Association. Through her education portal, Workshop Muse, Rose has created a place for people to come to learn about creative knowing, as well as learn how to practice creative mindfulness in their own lives. She continues to champion and explore these concepts in her workshops and writing, sharing with intimacy about how her own creative practice brings her awareness and insight. Her favorite tools for creation are textiles, paper, the natural world, and words. Rachel makes her home on the traditional territories of the people of Treaty 7 and Metis Region 3 in Calgary, Alberta. Learn more at www.workshopmuse.com.

About North Atlantic Books

North Atlantic Books (NAB) is a 501(c)(3) nonprofit publisher committed to a bold exploration of the relationships between mind, body, spirit, culture, and nature. Founded in 1974, NAB aims to nurture a holistic view of the arts, sciences, humanities, and healing. To make a donation or to learn more about our books, authors, events, and newsletter, please visit www.northatlanticbooks.com.